Physics *and* Chemistry *of* Photochromic Glasses

The CRC Press
Laser and Optical Science and Technology Series

Editor-in-Chief: Marvin J. Weber

Andrei M. Efimov
Optical Constants of Inorganic Glasses

Alexander A. Kaminskii
Crystalline Lasers:
Physical Processes and Operating Schemes

Valentina F. Kokorina
Glasses for Infrared Optics

Sergei V. Nemilov
Thermodynamic and Kinetic Aspects
of the Vitreous State

Piotr A. Rodnyi
Physical Processes in Inorganic Scintillators

Michael C. Roggemann and Byron Welsh
Imaging Through Turbulence

Hiroyuki Yokoyama and Kikuo Ujihara
Spontaneous Emission and Laser Oscillation
in Microcavities

Physics *and* Chemistry *of* Photochromic Glasses

A.V. Dotsenko
S.I. Vavilov State Optical Institute
R&D Technology Institute for Optical Materials
St. Petersburg, Russia

L.B. Glebov
University of Central Florida
Center for Research and Education in Optics and Lasers
Orlando, Florida

V.A. Tsekhomsky
S.I. Vavilov State Optical Institute
R&D Technology Institute for Optical Materials
St. Petersburg, Russia

CRC Press
Boca Raton New York

Library of Congress Cataloging-in-Publication Data

Dotsenko, A. V. (Alexander Victorovich). 1948-
 Physics and chemistry of photochromic glasses / by A. V. Dotsenko,
L. B. Glebov, V. A. Tsekhomsky.
 p. cm. — (The CRC Press laser and optical science and
technology series)
 Includes bibliographical references and index.
 ISBN (invalid) 0-8493-3780-X (alk. paper)
 1. Glass. 2. Photochromic materials. I. Glebov, L. B. (Leonid
Borisovich), 1948- . II. Tsekhomskii, Viktor Alekseevich.
III. Title. IV. Series.
TP858.D67 1997
666'.156—dc21
 97-20870
 CIP

The Authors

Alexander Victorovich Dotsenko was born in Leningrad (St. Petersburg), Russia, USSR in 1948. He graduated from the St. Petersburg State University (Department of Mathematics and Mechanics) in 1971. Since then he has worked for the S.I. Vavilov State Optical Institute in St. Petersburg. He obtained his Ph.D. degree in physics and mathematics in 1976 from the Estonian Institute of Physics, and his diploma of Senior Researcher of Theoretical and Mathematical Physics in 1981 from Vavilov State Optical Institute.

The directions of Dr. Dotsenko's research are the theoretical investigation and computer simulation of the optical properties of heterogeneous media, analysis of the photoinduced processes in glasses, and optical properties of glasses and glass-based planar waveguides. He has more than 70 publications in scientific journals and more than 60 presentations at conferences. He is a member of the Council of the St. Petersburg Physical Society (Russia), the Rozhdestvensky Optical Society, and on the editorial board of *Opticheskii Zhurnal* (*Journal of Optical Technology*). He is also the Russian representative in Technical Committee TC10, "Optical Properties of Glasses," for the International Commission on Glass.

Leonid Borisovich Glebov was born in Smolensk, Russia, USSR in 1948. He graduated from St. Petersburg Polytechnic Institute (Department of Physics and Mechanics) in 1971. He has been affiliated with Vavilov State Optical Institute for 24 years. Dr. Glebov worked for the Glass Research Center of Ford Motor Company in 1995 (Dearborn, MI) and then joined the Center for Research and Education in Optics and Lasers (CREOL) at the University of Central Florida (Orlando, FL). He obtained his Ph.D. degree in physics and mathematics in 1976, Doctor of Science degree in 1987, and his diploma of Professor of Optics from Vavilov State Optical Institute in 1989.

Dr. Glebov's research includes absorption and luminescence spectra of glasses in the UV, visible, and near IR regions, radiation defects generation under ionized and optical irradiation, nonlinear photoinduced processes in glasses, laser induced breakdown of glasses, optical properties of planar waveguides in glasses, and information recording in glasses. He has more than 160 publications in scientific journals and more than 150 presentations at conferences. He has been a member of the program and organizing committees for a number of international conferences, and the Russian regional editor for the *Journal of Non-Crystalline Solids*. He is a member of SPIE — International Society for Optical Engineering, and the American Ceramic Society.

Victor Alekseevich Tsekhomsky was born in St. Petersburg, Russia, USSR in 1937. He graduated from St. Petersburg Technological Institute (Department of Technology

of Silicates) in 1960. Since then he has worked for Vavilov State Optical Institute. He obtained his Ph.D. degree in chemistry in 1966, Doctor of Science degree in 1978, and the diploma of Professor of Chemistry in 1990 from Vavilov State Optical Institute.

The directions of Dr. Tsekhomsky's research are physical chemistry and optical properties of heterogeneous glasses and analysis of the photoinduced processes in glasses. He has more than 150 publications in scientific journals and more than 60 presentations at conferences and has been a member of program and organizing committees for a number of conferences.

Table of Contents

Preface

Photochromic glasses are now one of the most widespread types of optical glasses, due largely to their popularity among people who wear spectacles with photochromic lenses, which vary their absorption depending on the illumination level. This feature provides comfortable conditions for the human eye, especially in high surrounding illumination (in the highlands, by the sea, or among the snows of the Arctic and Antarctic high latitudes). Such glasses find application not only in spectacles, but in various opto-electronic devices now developed and produced in many countries of the world. Their annual output reaches several thousand tons.

Photochromic glasses possess both the homogeneity of common optical glasses and the photosensitivity of photographic materials. However, the specific features of the structure and physical processes of photochromic glasses differ significantly both from those in common optical glasses and in photographic materials. Information on photochromic glasses has been dispersed in hundreds of original papers published in various scientific journals. A great number of such papers were published in Russian and, therefore, were inaccessible to the majority of Western readers. While it should be noted that a significant portion of Soviet scientific journals were translated and published in English, unfortunately these have a very small circulation and are absent even in the libraries of large universities. Here, all existing English translations of the cited Russian papers have been revealed, and references to the English versions are available. Such references provide English-speaking readers an opportunity to gain access to the original Russian sources of information through the system of interlibrary loan. Some of the books published in the West have sections dedicated to various problems of inorganic photochromic glasses, but this book is apparently the first attempt to present from a unified viewpoint the totality of the problems of structure, optical properties, coloration and bleaching mechanisms, technology, and metrology of these materials.

Though this book contains a vast bibliography (nearly 300 references), it is not a comprehensive survey of all available publications on photochromic glasses. Our main purpose is not to compile the complete set of publications, but to describe the total knowledge on these materials from a unified viewpoint. It should be noted that almost all photochromic glasses manufactured on a commercial scale in the former Soviet Union were developed at the S.I. Vavilov State Optical Institute, the largest optical research center in Russia. The study of photoinduced processes in solids and the creation of photochromic glasses are specific examples of the State Optical Institute approach — a complete package, from basic research to industrial technology and metrology. Therefore, the authors dared to pay significant attention to the works of the Vavilov Institute as well as to the most prominent works carried out in other research centers of the former USSR, that we feel had not received proper attention in the West for a variety of reasons.

Despite the popular meaning of "photochromic glasses" (glasses that darken in the sunlight), the exact scientific definition causes a certain difficulty. There is the need to distinguish many closely associated photochemical and photophysical processes occurring in crystals and glasses under optical radiation and the complicated structure of materials exhibiting the best photochromic properties.

Generally, the term *photochromism* may be thought of as any variation of color induced by optical radiation, but in this book we shall use a narrower definition which excludes irreversible color changes. So, photochromism is a variation of color (i.e., of the absorption spectrum or spectrum of attenuation) of a material under optical radiation that is reversed when the exposure stops. Naturally, when experimental conditions are changed (e.g., temperature), the magnitude of the photochromic effect can vary (up to complete disappearance).

Therefore, we shall define photochromic material as that which, under specified operational conditions, becomes colored under optical radiation and restores its transparency after radiation ceases. This limitation is necessary because all condensed media exposed to irradiation with photon energy higher than the average energy of chemical bonds change their structure and hence their absorption spectrum. In the present book the photoinduced processes in glasses and crystals connected with spatial transport of electrons or atoms will be considered in detail only for those materials that perform effective reversible coloration. Obviously, any sort of condensed materials (solid and liquid, organic and inorganic, crystalline and vitreous) may possess photochromic features. Interest in reversible photoinduced coloration extends not only to various types of homogeneous materials, but to composite materials as well, e.g., impregnated porous structures or particles dispersed in a homogeneous glassy host.

Glasses with small concentrations of microcrystals of silver and copper halides became most widely used for reversible photoinduced coloration. The size of these particles is usually in the nanometer region, and they are now called nanocrystals. At the same time, glass coloration by small particles has been well known for a long time and has been referred to as colloid coloration. A peculiarity of these materials is that they are produced by glass-making technology, whereas the photochromic properties are defined by the processes occurring in microcrystals. This book, to a significant degree, is devoted to the latter type of glass–crystalline materials.

Accordingly, the principal factors regulating the coloration and bleaching of glasses and crystals exposed to optical radiation are described in Chapter 1. This is necessary for the unified description of photoinduced processes. The basic parameters of photochromic materials and the main principles of their measurement are presented in Chapter 2. The third chapter dwells on the problems of microcrystalline phase precipitation and formation in heterogeneous photochromic glasses. As has been mentioned, this microcrystalline phase, when dispersed in a glass host, determines the photochromic properties of a material.

Chapter 4 presents data on the absorption spectra of silver halide and copper halide photochromic glasses, both in their virgin state and after exposure to light. Attention is paid to the problems of color centers structure simulation and computation of the spectra on the basis of various structure models and theories of radiation

interaction with heterogeneous media. The problems of the kinetics of darkening, thermal relaxation, and optical bleaching processes in heterogeneous photochromic glasses are discussed in Chapter 5. The results of experimental and theoretical study of the kinetics at various stationary and pulse irradiation regimes are given.

The sixth chapter describes the effect of melting and heat treatment schedules, basic glass composition, and different photosensitive components on the photochromic properties. The applications of photochromic glasses in the development of photocontrolled elements of integrated optics are considered in Chapter 7. The comparison of photochromic material properties in bulk and in thin subsurface layers provides an important basis for understanding the photoinduced processes in planar optical waveguides. Special attention is paid in Chapter 8 to the problems of non-linear coloration of photochromic glasses. The phenomenon of image amplification under long wavelength stimulation is also described.

This book is designed first of all for the researchers, developers, and manufacturers of photosensitive glasses. It will be useful as well for engineers and researchers who deal with photophysics, photochemistry involving the technologies of variable-transmittance optical materials, and with the development of photocontrolled components and devices. At the same time, the authors expect that the materials presented will be helpful for a wider range of readers, especially students and postgraduates interested in photoinduced phenomena in solids, in heterogeneous media optics, in nanotechnologies, and nonlinear optical materials.

Being aware that this first attempt to narrate fairly diverse material is not free from faults, the authors would appreciate readers' remarks and will do their best to integrate these into their future work. Contact Dr. Leonid Glebov, CREOL/UCF, P.O. Box 162700, Orlando, FL 32816-2700; Tel. (407)823-6983; E-mail: leon@mail.creol.ucf.edu.

We wish to thank Dr. Marvin J. Weber for his kind invitation to write this book, and a large number of our colleagues for helpful discussions and for the great pleasure of sharing the hopes and troubles of joint research efforts. We appreciate a number of very useful comments made by Dr. R.J. Araujo that we used to improve the presentation of some complicated problems. We also wish to express our gratitude to Ms. Alexandra E. Yakuninskaya for the translation of this book into English and for her useful remarks, and to Mrs. Larissa N. Glebova and Mr. Boris L. Glebov for their help in preparing the computer version of the book.

List of Designations

a_{ex}	Bohr radius of exciton
c	Color center concentration
c_∞	Equilibrium color center concentration
c^*	Microcrystal concentration
c_{phph}	Photosensitive phase concentration
c_{nuc}	Nucleation particles concentration
C^*	Average concentration of microcrystals
d	Microcrystal diameter
d	Density
d_{Z3}	Thickness of dead layer for the Z_3 exciton
$d_{Z1,2}$	Thickness of dead layer for the $Z_{1,2}$ exciton
D	Optical density
D_o	Initial optical density (before irradiation)
D_{exp}	Optical density at the moment of exposure cessation
D_t	Optical density in t second of fading
D_{dif}	Diffusion coefficient
D_m	Optical density of matrix
D_e	Equilibrium optical density
D^*	Residual photoinduced optical density
D_{ij}	Matrix of photoinduced optical density (in Chapter 6)
ΔD	Photoinduced optical density
ΔD_e	Equilibrium photoinduced optical density
E	Energy
$E(r,t)$	Electric field
E_b	Position of absorption edge
E_o	E_b at room temperature
E_T	Lowest band energy
E^*	Energy parameter in formula (1)
ΔE_{LT}	Longitudinal-transverse splitting
ΔE_{Z3}	Shift of Z_3 band maximum
$\Delta E_{Z1,2}$	Shift of $Z_{1,2}$ band maximum
h	Distance from the irradiated surface
h	Planck constant
H	Thickness of sample
ΔH_{melt}	Enthalpy of crystal melting
I	Intensity of light beam
I_a	Intensity of darkening radiation

I_b	Intensity of bleaching radiation
j_l	Spherical Bessel function
J	Nucleation rate
k	Wave vector
k_a	Color center generation coefficient
k_b	Color center bleaching coefficient
k_f	Color center fading coefficient
K	Boltzmann constant
K_{rel}	Criterion of relaxation
K_{Tr}	Criterion of thermal relaxation in formula (72)
K_{Sr}	Criterion of bleaching in formula (73)
L	Length
m	Relative complex refractive index
m_o	mass of electron
M	Molecular mass
M^*_{eff}	Effective mass of exciton
n	Refractive index
n_m	Refractive index of glass matrix
n_{eff}	Effective refractive index
δn_{TM}	Variation of refractive index in the ion-exchange layer
N_{av}	Avogadro's number
Q	Total intensity of radiation (in Chapter 6)
Q_e	Attenuation efficiency factor
r	Particle radius
r_0	Average radius of particle distribution
R	Reflection coefficient
s	Parameter in formula (10)
s_l	Speed of light in vacuum
t	Time
T	Temperature
T_{melt}	Melting temperature
T_m	Bulk material melting temperature
T_{vap}	Vaporization temperature
v, V	Volume
w_1, w_2	Relative volume in formulae (10), (11)
Z	The number of electrons per atom or molecule
α	Absorption coefficient
α_{att}	Attenuation coefficient
α_{\parallel}	Attenuation coefficient for parallel electric vector orientation
α_{\perp}	Attenuation coefficient for tangential electric vector orientation
β	Constant of radiation propagation

$\gamma,\ \gamma_l$	Luttinger constants in formulae (22), (23)
$\gamma_1.\ \gamma_2$	Absorption coefficients of layers in formulae (90)–(94)
Γ	Resonance halfwidth
Γ_0	Homogeneous width of the exciton band
Γ_{inhom}	Inhomogeneous width of the exciton band
Γ_{las}	Width of exciting radiation line
δ_i	Step in thickness
Δ_i	Step in time
Δ_e	Photon energy difference
Θ	Volume fraction
κ	Image part of complex refractive index
λ	Wavelength
μ	Parameter in formula (1)
ρ	Electron density
ρ_{dif}	Diffraction parameter
σ	Surface tension coefficient
σ_{ov}	Coefficient proportional to oversaturation in formula (9)
σ_{sc}	Scattering cross section
σ_{cc}^{abs}	Absorption cross section of color center
σ_{mc}^{abs}	Absorption cross section of microcrystal
σ_{cc}^{att}	Attenuation cross section of color center
σ_{mc}^{att}	Attenuation cross section of microcrystal
τ	Transmittance
τ_0	Transmittance of nonirradiated glass
$\varphi\,(z,t)$	Concentration of cupric ions in formula (28)
$\Phi\,(E)$	Faraday rotation spectrum
ω	Frequency

a, b	Langmuir constants in formulae (22), (23)
K_i	Absorption coefficients of layers in formulae (30)-(39)
Γ	Resonance half-width
Γ_{homo}	Homogeneous width of the exciton band
Γ_{inhom}	Inhomogeneous width of the exciton band
Γ_{lum}	Width of exciton radiation line
δ	Step in thickness
Δt	Step in time
ΔE	Photon energy difference
θ	Volume fraction
κ	Image part of complex refractive index
λ	Wavelength
μ	Parameter in formula (1)
n	Electron density
p	Diffraction parameter
σ	Surface tension coefficient
σ_0	Coefficient proportional to averaged atomic formula (8)
σ_{sc}	Scattering cross section
σ_{abs}^{col}	Absorption cross section of color center
σ_{abs}^{mic}	Absorption cross section of microcrystal
σ_{att}^{col}	Attenuation cross section of color center
σ_{att}^{mic}	Attenuation cross section of microcrystal
T	Transmittance
T_0	Transmittance of nonirradiated glass
$[NO_3^-]$	Concentration of nitric ions in formula (28)
$\rho(\lambda)$	Photoluminescence spectrum
ω	Frequency

Foreword

Photochromism in glasses which contain silver halides has been reviewed in a brief chapter in each of two books on photochromism and in a book on glass science. Otherwise, the only literature available is in the form of original research papers, many of which are contained in the Russian literature and are not easily available in the Western world. This book by Dotsenko, Glebov, and Tsekhomsky fills this serious void.

The book is well balanced in that it treats practical technological topics as well as measurement techniques and the theoretical aspects of the subject. It serves an especially useful function because it discusses in considerable detail several topics that have not been included in previous reviews, namely, the melting and recrystallization of the halide phase and the hysteresis observed, quantum confinement, and an apparently autocatalytic effect. The influence of thickness is also discussed more extensively than it has been in the past.

This book will be a welcome addition to the library of anyone interested in optical phenomena, photochemistry, or glass.

<div align="right">

Roger Araujo
Corning, Inc.

</div>

1 Photoinduced Generation of Defects and Photochromism in Homogeneous Silicate Glasses

For a long time photoinduced processes in different materials were a subject of thorough investigation by researchers working in many branches of science. As a result, the same or similar phenomena are described using different terms and classifications. In particular, there are striking terminological discrepancies in the descriptions of dielectrics and semiconductors, crystals and glasses, and electrical and optical phenomena. This book considers mainly photoinduced transfer of charge and optical phenomena in glasses and microcrystals distributed in vitreous dielectric hosts. So there emerges a need for a brief and uniform description of the basic information on the spectroscopic characteristics and photochemical processes in solids.

The most detailed analysis of the phenomena of interest was made for ionic crystals. The main photosensitive component of the majority of photosensitive materials is AgCl. The basis of the majority of practically used photochromic glasses are multicomponent silicate glasses. Therefore, the description here is based on the comparison of the well-studied properties of halide crystals (including AgCl) with analogous ones in oxide crystals (crystalline quartz) and glasses (vitreous quartz and multicomponent, mainly alkali-silicate glasses). The analysis also will allow us to consider the collection of works dedicated to photochromism, both in homogeneous and heterogeneous glasses, from a common viewpoint.

The photochromic process, the reversible variation of an absorption spectrum under optical irradiation, is usually due to the fact that the electron subsystem of solids absorbs photons. That is why the main types of electron absorption spectra in crystals and glasses should be briefly described at the outset.

1.1 INTRINSIC, EXTRINSIC, AND INDUCED ABSORPTION SPECTRA

Optical absorption spectra of the electron subsystem in solids may be conventionally divided into three groups. The absorption due to electron transitions in a defect-free substance of stoichiometric composition is called *intrinsic*, *basic*, or *fundamental*

1

absorption. The absorption in atoms or molecules present as small additives is called *extrinsic* absorption or *dopant* or *impurity* absorption. The absorption by defects of the host substance created by chemical or physical effects is called *induced* or *additional* absorption.

Let us begin with the fundamental absorption in alkali-halide crystals. We will not give a detailed reference list on this subject, but we encourage the reader to refer to the classical books of Mott and Gurney,[1] Lushchik,[2] and Fowler.[3] The intrinsic electron absorption in alkali-halide crystals appears as a series of narrow intense bands with the absorption coefficients attaining 10^5 to 10^6 cm^{-1}. For this reason, the analysis of the shape of those bands and their maximal positions are possible either in thin films or by mathematical treatment of the reflectance spectra. As a rule, the first and the longest-wavelength absorption band corresponds to the exciting of a bound *electron-hole* pair (an exciton). At low temperature, at the short wavelength edge of that band a hydrogen-like spectrum is observed that corresponds to electron movement in the Coulomb field of the hole. A number of bands in the shorter wavelength region correspond to electron excitation from the valence band to the conduction band.

The absorption spectrum of the thin film of an AgCl single crystal, the basic substance for most photosensitive materials, is shown in Figure 1, curves 1–3. The properties of silver halides will be given in this section and based not on original works but on Meiklyar.[4] As it is in alkali-halide crystals, the long wavelength band with the maximum at 5.2 eV (λ = 240 nm) corresponds to exciton absorption. With a rise in temperature, this band broadens noticeably and overlaps the neighboring bands, its maximum being shifted to 4.8 eV (260 nm).

The optical properties of various modifications of quartz are summarized by Silin and Trukhin.[5] Four bands are observed in the reflectance spectrum of crystalline SiO_2. The bands with maxima at 10.4 eV (119 nm) and 11.6 eV (107 nm) are attributed to exciton transitions. The bands at 14 eV (89 nm) and 17.5 eV (71 nm) are attributed to valence band-conduction band transitions. Reflectance spectra of vitreous SiO_2 have similar bands, however broadened and shifted to the long wavelength side for 0.1 to 0.2 eV. Alkali-silicate glasses, according to Glebov et al.[6] (see Figure 2a, curve 1) essentially possess bands shifted to the long wavelength side in the reflectance spectra with the peaks at 7.2 eV (172 nm) and 9.0 eV (138 nm).

The edge of intrinsic absorption in crystals is actually the long wavelength part of the first exciton band. Urbach[7] studied the intrinsic absorption edge of AgCl crystals and found that the absorption coefficient (a) depended exponentially on photon energy (E) (Figure 1a, curve 4). As temperature (T) rises, the absorption edge shifts to the long wavelength end of the spectrum according to the following dependence, later called the Urbach rule:

$$a = a_0 \exp\left(-\mu \frac{E^* - E}{kT}\right) \tag{1}$$

where a_0, μ, and E are parameters and k is the Boltzmann constant. It appeared that, in most alkali halide and oxide crystals, the intrinsic absorption edge obeyed the

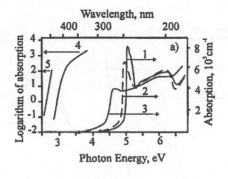

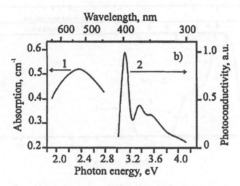

FIGURE 1 Spectral properties of AgCl crystal: a) Absorption spectra of thin films (1–3) and bulk samples (4,5) of pure AgCl (1–4) and doped with 0.1% AgI (5) crystals at different temperatures, K: (1) 20, (2) 80, (3–5) 293. b) Spectra of photoinduced absorption (1) and photoconductivity (2).

Urbach rule. The shape of the fundamental absorption edge in vitreous silica is also well described by formula (1), analogous to crystalline quartz. A vitreous substance is distinguished by less slope and some shift to the long wavelength region.[5] The exponential dependence of the absorption coefficient on photon energy is also observed in multicomponent silicate glasses (Figure 2a, curve 2), but as temperature rises, parallel shifting of the spectrum in the long wavelength direction takes place:

$$a = \exp \frac{E - E_b}{\Delta_e} \qquad (2)$$

where $E_b = E_0 - \alpha T$, E_0, α, and Δ_e are parameters and T is the temperature in °C. The physical sense of the parameter E_0 is E_b at $T = 0$°C (the position of the absorption edge at room temperature), that of the parameter Δ_e is the photon energy difference at which the absorption coefficient changes e times, and α is the temperature coefficient of the shifting absorption edge.

In crystalline SiO_2, the fundamental absorption edge E_0 appears at 7.8 eV (159 nm),[5] in Na_2O–$3SiO_2$ glass at 5.7 eV (218 nm),[8] and in AgCl crystal at 2.9 eV

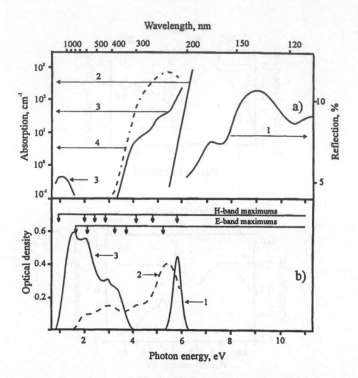

FIGURE 2 Spectral properties of $Na_2O-3SiO_2$ glass: a) (1) reflection spectrum, (2–4) absorption spectra in logarithmic scale, (2) intrinsic, (3) 0.1% Fe^{2+}, (4) 0.1% Fe^{3+}. b) (1) spectrum of color center generation (photoinduced optical density of glass sample versus photon energy of exciting radiation), (2) γ-induced absorption after exposure at room temperature, (3) UV-induced absorption after exposure at 77 K. Vertical arrows indicate the positions of maximums of electron and hole color center absorption bands. Sample thickness is 1 mm.

(428 nm).[4] The intrinsic absorption edge slopes in glasses and crystals differ from each other: Δ_e is 0.03 eV for **AgCl** and crystalline SiO_2, 0.04 eV for vitreous SiO_2, and 0.1 eV for $Na_2O-3SiO_2$ glass. The temperature coefficients are similar in all of these materials and occur in the region of 10^{-3} eV/K.

The presence of small concentrations of elements different from those of the basic composition of crystal or glass, both in the form of impurities and specially added dopants (activators), may result in the appearance of new absorption bands. These bands are called extrinsic bands or bands of dopants and impurities. The bands can be observed if they fall into the range of the original material's transparency. As examples, consider two cases.

When elements from the same group of the Periodic Table, but heavier than the base components, are introduced into ionic crystals additional exciton bands are observed in the long wavelength part of the basic exciton. For example, the iodine exciton band was obtained in **KCl** crystal. Mahr[9] has shown that this band, for the absorption coefficient $a > 0.01a_{max}$ (a_{max} is the band maximum absorption coefficient), is described by a Gaussian curve, while at $a < 0.01a_{max}$ by the Urbach equation (1).

According to Meiklyar,[4] in **AgCl** crystal the **AgI** exciton band also demonstrates the exponential edge (Figure 1a, curve 5).

TABLE 1

Spectroscopic Parameters of the Absorption Bands of Iron in Na$_2$O–3SiO$_2$ Glass

Peak Position, eV	Peak Position, nm	Halfwidth ΔE, eV	Specific Absorption, cm^{-1}/mass%	Valence State
1.1	1100	1.2	8.7*/21	2+/(3+)$^-$
3.3	370		1.8	3+
4.4	280	0.8	100	2+
5.1	240	0.5	265	2+
5.5	225	1.7	7800	3+
6.5	190		1300/2300**	2+/(3+)$^-$

* In glasses synthesized under rigid reducing conditions, the absorption coefficient is 22 cm^{-1}/mass% Fe^{2+}.

**Measurement made at 6.0 eV, not at the band maximum.

In silicate glasses, iron is both a widely used activator and one of the main coloring uncontrolled impurities. Iron can exist in glass in the forms of Fe^{2+} and Fe^{3+}, depending on synthesis redox conditions. Usually both valence states are present in glass. The absorption spectra of iron in Na$_2$O–3SiO$_2$ glass obtained by Glebov et al.[8,10-12] are shown in Figure 2a (curves 3 and 4). The spectroscopic parameters of these bands are given in Table 1. One can see that these bands practically mask the fundamental absorption even in high-purity glasses (with an impurity content in the range of several ppm). Near the long wavelength edges of the Fe^{3+} band with the peak at 5.5 eV (226 nm) and the Fe^{2+} band with the peak at 4.4 eV (282 nm) one can assume the shape alteration from Gauss-like to exponential type. Unfortunately the absorption of a number of small bands of iron in this spectral region does not allow us to check this assumption.

It is known that the appearance of new absorption bands in a material can take place not only when introducing some additions into it but under irradiation as well. The additional absorption induced by ionizing radiation is associated, as a rule, with the formation of various radiation defects called *color centers*.[1-3] Mobile electrons and holes are generated by actinic irradiation. One elementary radiation defect (i.e., color center) is an electron localized at a halide vacancy (*F*-center). The absorption spectrum of an *F*-center is a wide structureless band in the visible spectrum range. This band's position depends upon the crystal type and drifts to the long wavelength end as ion radii increase for both the anions and cations of the crystal.

The total spectrum of induced absorption in alkali-halide crystals is rather complicated. To the short wavelength side of the *F*-band, a series of *K* and *L* bands are observed that correspond to transitions to *F*-center upper excited states. A bit farther, *a* and *b* bands are observed near the exciton absorption band of the crystal. These bands are responsible for electron transition from an *F*-center to a neighboring

halide atom. To the long wavelength side of the F-band, R, M, and N bands are observed that correspond to the absorption of various conglomerates consisting of several F-centers situated close to each other. Besides those described above, one can identify several bands in the short wavelength part of the spectrum that belong to hole centers resulting from a positively charged hole migrating and being trapped by a halide ion. All such color centers are called *intrinsic*.

Doping a crystal with additives leads to changing the absorption spectra of electron and hole centers localized near the impurities. In addition, the varying valences of the dopants may also lead to the appearance of new absorption bands. Thus, in alkali-halide crystals, upon exposure to ionizing irradiation, practically all visible and UV regions are covered by absorption bands of various types of color centers that are formed by trapping one or a few electrons (or holes) at the defects of the crystal lattice.

In crystals that are characterized by the high mobility of their ions, e.g., silver halides, radiation can create defects not only of atomic or molecular dispersion order but of far greater sizes as well (up to 100 nm, which corresponds approximately to 10^{10} silver atoms).[4] In this case the photoinduced absorption spectrum represents a wide structureless band (see Figure 1b, curve 2) attributed to colloidal silver particles.

The appearance of additional absorption spectra in various glasses after ionizing irradiation is also well known.[5,13,14] The comparison of radiation defects in crystalline and vitreous states was carried out in detail on SiO_2 by Silin and Trukhin.[5] They showed that the most frequent radiation defect type, the so called E'-center, was observed in both SiO_2 modifications and possessed similar spectroscopic and ESR parameters. That was due to the fact that a structural defect in the crystal lattice at which the E'-center was created (i.e., oxygen vacancy) had a similar one in the vitreous state, namely, 3-coordinated silicon.

Alkali-silicate glasses also have a complicated structure of induced absorption spectra.[13,14] As an example, we will take only the induced absorption spectrum of Na_2O–$3SiO_2$ glass (see Figure 2b). The first data for high purity glasses were obtained by Mackey et al.[15] Four bands of stable color centers (Figure 2b, curve 2) and four bands of color centers unstable at room temperature (Figure 2b, curve 3) were observed in the spectrum of additional absorption of such glass exposed to X-ray or γ radiation at room temperature.

A series of experiments undertaken later by Glebov et al.[10-12,16-22] allowed us to resolve experimentally induced absorption bands belonging to intrinsic color centers (see Table 2), to determine their charge states, and to describe them mathematically. Arrows in Figure 2b indicate the positions of the band maxima. Using the band spectroscopic parameters listed in Table 2, one can describe the additional absorption spectra of soda-silicate glass with a precision of not less than 1 % under any conditions of irradiation, bleaching, and fading. The data provide a sufficient description of color centers created in soda- and other alkali-silicate glass.

The study has shown that the majority of bands presented in Table 2 pertain to different types of radiation defects which can be selectively created and destroyed. It should be noted that the long wavelength group of bands is due to the presence of various alkali ions. The comparison of spectroscopic and luminescent parameters of the short wavelength region H_6 and H_7 hole bands with the data on radiation

defects in quartz described by Silin and Trukhin[5] has shown that they are similar to well-known intrinsic hole centers in vitreous quartz, O^0_1 and E'. Electron band E_5 was found analogous to the absorption band of electron E'_2-centers belonging to microimpurities of alkali ions in vitreous quartz.

TABLE 2
Spectroscopic Parameters of the Absorption Bands of Intrinsic Color Centers in Soda Silicate Glass

Peak Position, eV	Peak Position, nm	Halfwidth ΔE, eV	Charge State	Designation
0.9	1380	0.4	+	H_1
1.6	770	0.7	−	E_1
2.0	620	0.5	+	H_2
2.1	580	0.8	−	E_2
2.4	517	0.45	+	H_3
2.85	435	1.1	+	H_4
3.2	388	0.45	−	E_3
3.7	335	0.8	−	E_4
4.1	302	0.9	+	H_5
4.75	261	0.9	+	H_6
5.2	238	1.05	−	E_5
5.8	214	0.8	+	H_7

The changing of the valence state of rare-earth and transition elements plays an essential role in the radiation coloration of glasses. Stroud[23] studied the induced absorption in glasses doped by cerium. It was found that Ce^{3+} could trap a hole and then transform into $[Ce^{3+}]^+$. The absorption band of this center was similar to that of Ce^{4+} (λ_{max} = 250 nm, $h\nu$ = 4.96 eV) though shifted to the long wavelength end by 10 nm. In addition, Ce^{4+} can trap an electron and transform into $[Ce^{4+}]^-$ which is analogous to Ce^{3+}. One of the most active electron acceptors is Fe^{3+}. It was shown by Glebov et al.[10] that, under ionizing irradiation, intrinsic electron centers were not formed in glass until all Fe^{3+} was converted into $[Fe^{3+}]^-$. Iron valence alternation results in the disappearance of the Fe^{3+} absorption band with $h\nu$ = 5.5 eV (226 nm) that leads to glass bleaching in the UV range, found by Weller[24] and by Glebov et al.[8] In their later works Glebov et al.[11,12] showed that several bands in the IR and UV regions, similar to those of Fe^{2+} but of higher specific absorption coefficient, were created by ionizing radiation (Table 1).

1.2 COLOR CENTER GENERATION BY INTRINSIC AND EXTRINSIC ABSORPTION BAND EXCITATION

As was pointed out in the previous subsection, optical excitation in the range of ionic crystal fundamental absorption corresponded to the generation of excitons or

nonbound electron hole pairs. Many photoinduced processes may take place as a result, but we will confine ourselves only to examples that illustrate the mechanisms of color center generation under optical excitation of crystals and glasses.

Lushchik[2] studied the dependence of F-center generation efficiency in **KI:Tl** crystals on the exciting radiation photon energy. Efficiency was estimated by the luminescence intensity at the excitation to the F band of irradiated crystal. It was found that F-centers were created at the excitation to both exciton and band-to-band absorption regions. This enabled the authors to conclude that color centers were formed both by thermal decomposition of excitons and direct generation of electron hole pairs. According to Meiklyar,[4] the maximum efficiency of mobile charge carrier formation in **AgCl** crystal is observed in the region of the long wavelength edge of intrinsic absorption. A sharp fall in efficiency with increasing quantum energy is ascribed to the decrease of the thickness of the excited layer caused by the increasing absorption coefficient and the high relaxation rate due to the atoms' high mobility in the subsurface area.

Silin and Trukhin[5] showed that in crystalline and vitreous quartz the maximum efficiency of radiation intrinsic defect generation, as evaluated by the value of Cu^+ center luminescence or by Cu^0 center absorption, corresponded to the exciton band maximum. The analysis of the temperature dependence of the process allowed one to conclude that defect formation was connected with exciton decomposition.

Only $E_1 - E_4$ and $H_1 - H_5$ centers are generated under UV radiation in multi-component silicate glasses (see Table 2). The dependence of the optical density of induced absorption on exciting photon energy (color center generation spectrum) is the same for all these centers (Figure 2b, curve 1) and is shaped as a narrow band with the maximum at 5.9 eV (210 nm). Figure 2 shows that this band is located in the region of the intrinsic absorption long wavelength edge but does not conform to any absorption band of the glass. Glebov et al.[25] revealed that the long wavelength edge of the color center generation spectrum was connected with a decrease in the efficiency of movable charge carrier creation. In this spectral range, electrons are excited to levels lower than the mobility threshold. The short wavelength edge was determined by a decrease in the thickness of the layer in which color centers were formed because of the exponential growth of the absorption coefficient with quantum energy.

The study of color center generation efficiency at different temperatures has shown that, at excitation in the long wavelength part of the color center generation spectrum, thermal activation takes place which is similar to that at excitation of the exciton bands of crystals. At excitation in the short wavelength part of the color center generation spectrum, no thermal activation is recorded which is similar to an excitation of delocalized levels in the conduction band of crystals. It is important to note that, at intrinsic state ionization, electron and hole centers are created in equal concentrations. It should especially be stressed that at photon energy less than 5.2 eV ($\lambda > 240$ nm), intrinsic ionization in soda-silicate glasses is not obtained, and color centers are not generated.

When variable valence dopants in oxidized form (i.e., at higher valence state) capable of trapping electrons are introduced into glass, at excitation in the spectral range of fundamental absorption, intrinsic hole centers and extrinsic electron centers

are formed. These extrinsic centers are dopants reduced by electron trapping, e.g., $[Fe^{3+}]^-$ (Glebov et al.[8]) or $[Eu^{3+}]^-$ (Arbuzov et al.[26]). Concentration of intrinsic electron centers decreases in this case and is defined by the ratio of electrons trapping dopant ions to intrinsic structure defects. The introduction of such oxidized dopants does not vary the position of the color center generation spectrum, because it is determined by the position of an intrinsic absorption edge.

However, it is possible to generate color centers when photon energy of exciting radiation is insufficient for ionization of the intrinsic states of crystal or glass. Lushchik[2] and Feofilov[27] showed that in alkali halide crystals, extrinsic ionization was obtained if the donor excited levels were placed above the threshold of charge carrier mobility. In this case, a mobile electron can be trapped either by a crystal lattice defect, with intrinsic electron center formation, or by another dopant, i.e., to recharge the activators.

Similar processes are known to occur at photon energies below the intrinsic ionization threshold in silicate glasses doped with variable valence ions in their lower valence state. Arbuzov et al.[28,31] showed that a dopant ion was ionized if it was excited to the upper level above the mobility threshold. The result was that dopant ion was oxidized, and the released electron created an intrinsic electron center or reduced another dopant ion. The depths of dopant ground level in $Na_2O-3SiO_2$ glass are: 5.2 eV for Fe^{2+}, 5.0 eV for Tb^{3+}, and 3.6 eV for Ce^{3+}. The comparison of these values with Figure 2a shows that the ionization threshold of Fe^{2+} corresponds to the long wavelength edge of the peak with maximum at 6.5 eV (191 nm).

It was found by Arbuzov et al.[28-31] that dopant ionization could occur not only when the excited upper level was above the mobility threshold, but also by tunnel transitions. Tunnel ionization efficiency is about 1 to 2 orders of magnitude lower than that of over-barrier ionization. The thresholds of the tunnel ionization of dopants in $Na_2O-3SiO_2$ glass are: 3.5 eV for Fe^{2+}, 3.1 eV for Tb^{3+}, and 3.1 eV for Ce^{3+}. Referring to Figure 2a, one can see that the tunnel ionization of Fe^{2+} is obtained at excitation of the long wavelength bands with peaks at 5.1 and 4.4 eV (243 and 282 nm), up to 3.5 eV ($\lambda = 350$ nm). Unlike the case of intrinsic ionization that inevitably produces electron and hole centers, at the excitation to dopant absorption bands, the only hole center generated is the same (but oxidized) dopant ion. All newly created centers are electron ones (either intrinsic or extrinsic).

1.3 THERMAL FADING AND OPTICAL BLEACHING OF COLOR CENTERS

Radiation defects in crystals and glasses represent metastable states arising when electrons and holes are localized at structure defects. Therefore, they can be destroyed as a result of the transition in the system a stable state under thermal or optical effect that excites the charge carriers above the mobility threshold. Normally, the radiation defect destruction is followed by fading of the color centers and recombination luminescence. This luminescence is caused by a recombination of mobile charge carriers at radiation defects of the opposite charge. In case of a radiation defect thermal decomposition, recombination luminescence is called

thermoluminescence. Dependence of thermoluminescence intensity on varying temperature in the heating process is called the *thermoluminescence curve* (see Lushchik[2]).

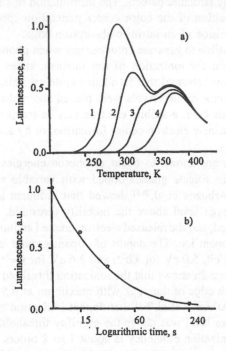

FIGURE 3 Thermal decomposition of radiation defects in soda-silicate glass. a) Thermoluminescence curves of a glass exposed to X-ray radiation at room temperature and cooled down abruptly to 200 K after being kept at room temperature for different periods: (1) 10 s, (2) 20 min, (3) 210 min, and (4) 72 h. b) Decay of recombination luminescence of a glass exposed to UV radiation at room temperature (solid line); circles indicate the values of derivative by time of color center optical density at 2.05 eV (605 nm).

Mackey et al.[15] found that when heating soda-silicate glasses that were irradiated at low temperatures, a peak of recombination luminescence appears at about 130 K which has been attributed to thermal decomposition of E_1-centers (see Table 2) having their absorption maximum at 1.6 eV (775 nm). Robinson[32] and Landry et al.[33] have determined that at room temperature those centers fade in less than a second and, consequently, bring no appreciable contribution to the additional absorption under stationary irradiation.

A higher temperature thermoluminescence peak found by Mackey et al.[15] is ascribed to decomposition of E_2-centers (with the maximum at 2.1 eV, 591 nm), and it appears at temperatures about 300 K. This peak can also be caused by the irradiation at room temperature if the sample is cooled quickly after exposure cessation (see Figure 3a). Increasing exposure time before cooling leads to a thermoluminescence peak intensity decrease and shifts it to a high temperature region. Glebov and Tolstoi[16] have found that during exposure at room temperature the decomposition

of E_2-centers proceeded slowly and was followed by recombination luminescence. The luminescence decay kinetics coincided near band maximum with the derivative of the induced absorption density in time (see Figure 3b). It is seen that, for a glass of high purity, a typical time scale of the decay is a few minutes. Evaluation of the depth of the traps where E_2-centers are captured gives the value of 0.6 eV. As temperature rises, E_2-center thermal fading first accelerates and, only when a deeper defect stability threshold is reached, does slow fading of the last color center begin.

Not only can electron color centers be unstable at room temperature but hole centers can too. Usual hole centers caused by ionizing or UV irradiation are practically stable at room temperature. However, Glebov et al.[34] found that, when H_1-centers were excited by polarized light in the range of the absorption band maximum (2.85 eV, 435 nm), not only did optical anisotropic optical bleaching occur but also the orientation of those centers changed. Reoriented hole H_1-centers thus obtained become unstable at room temperature and decompose in a few hours by recombination with stable electron centers.

Above room temperature, three more thermoluminescence peaks were observed by Glebov et al.[35] at 375, 450, and 550 K. These are connected with thermal decomposition of electron and hole centers absorbing in the visible and UV spectral ranges. However, explanation of the causes of the additional absorption instability at high temperature requires more study.

1.4 PHOTOCHROMIC PROPERTIES OF HOMOGENEOUS SILICATE GLASSES

The results stated above allow us to make a general conclusion about the possibility of photochromism in silicate glasses. Intrinsic ionization of silicate glasses is possible only under short wavelength UV irradiation with $E > 5.2$ eV ($\lambda < 240$ nm) and inevitably results in stable induced absorption in the visible spectral range that is caused by the presence of hole color centers. Consequently, the ionization of a silicate matrix is not of interest from the viewpoint of reversible coloration.

To shift the range of photochromism excitation to long wavelengths, it is necessary to use dopants in their lowest valence state that can be ionized by near UV irradiation. When under such excitation, mobile electrons can produce unstable color centers. These centers decompose at room temperature, thus producing a photochromic effect. The only intrinsic center which is promising for reversible coloration at room temperature is the electron E_2-center with absorption peak at 2.1 eV (580 nm). In addition to the intrinsic center, impurities may give rise to reversible photoinduced coloration.

From the viewpoint discussed above, a considerable number of earlier works describing photochromism phenomena dealt with the excitation of uncontrolled Fe^{2+} impurities in commercial glasses. Byurganovskaya et al.[13] pointed out that under UV irradiation with ($\lambda = 254$ nm (4.9 eV) nearly all colorless inorganic optical glasses showed wide bands of induced absorption including that in the visible range. This coloration fades upon heating or under the effect of illumination in a spectral region coinciding with the induced absorption bands. It is natural to associate this

phenomenon with the optical ionization of Fe^{2+}, which is always present in optical glasses in concentrations above $10^{-3}\%$, and unstable electron color center generation and bleaching.

Cohen and Smith[36] and Swarts and Pressau[37] observed the utmost photochromic effect in alkali-silicate glasses synthesized under reducing conditions. It was assumed that under these conditions a relatively high concentration of defects was produced in glass and these defects could trap photoelectrons. However, Hosono et al.[38] found that such photochromism was typical for a large group of rather diverse glasses having no variable valence ions as basic components but containing electron donors as impurities in their reduced forms. Figure 4 shows a radiation reversible absorption

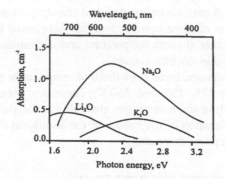

FIGURE 4 Photoinduced reversible absorption spectra of alkali-silicate glasses melted under reducing conditions.

spectrum induced by UV irradiation of alkali-silicate glasses melted under reducing conditions. One can see that in soda-silicate glass the band maximum is close to that of the E_2-center.

Photochromism in a reduced soda-silicate glass purposely doped with iron ions was investigated by Bukharayev and Yafaev.[39] They found that, after UV irradiation at $\lambda = 300$ nm (4.1 eV) with 30 mW/cm^2 intensity, photoinduced absorption was obtained, with peaks about 270, 320, and 470 nm (4.6, 3.9, and 2.6 eV). Photoinduced optical density at 400 nm (3.1 eV) runs into 0.5. After actinic irradiation exposure has been stopped, photoinduced green-yellow coloration persists in darkness for some time but vanishes quickly when exposed to 400 to 500 nm (3.1–2.5 eV) range light. It has been determined by the ESR method that, in those glasses, Fe^{2+} works as an electron donor. The coloration process has a photothermal nature because at liquid nitrogen temperature no photochemical processes occur.

At first sight, that result seems to disagree with the data obtained by Arbuzov et al.[29,30] on the tunnel mechanism of Fe^{2+} ionization under long wavelength excitation, presented in subsection 1.2. Although it should be noted that in Arbuzov's work[29, 30] the luminescence method was used for the detection of the ionization, and it is far more sensitive than the absorption method used in Bukharaev's work.[39] This circumstance allowed Arbuzov and co-workers[29,30] to observe Fe^{2+} ionization at low temperatures. In this way, it is possible to connect photochromism in reduced and

undoped silicate glasses with thermoinduced or tunnel photoionization of uncontrolled Fe^{2+} impurities.

To raise the photosensitivity, Cohen and Smith[36] and Swarts and Pressau[37] used double-charged europium ions and triple-charged cerium ions which, taken in small concentrations (0.005% Eu^{2+} and 0.12% Ce^{3+}), serve as electron donors in alkalisilicate glasses. Figure 5 exhibits the shift in photosensitivity toward the long wavelength when Eu^{2+} and Ce^{3+} are added to glass. The spectral sensitivity curves show maxima near 315 and 330 nm (3.9 and 3.75 eV), which coincide with Ce^{3+} and Eu^{2+} absorption band maxima. It was pointed out in subsection 1.2, that under excitation with $hv > 3.6$ eV ($\lambda < 345$ nm) Ce^{3+} ions go to levels above the mobility threshold. The electrons released from rare-earth elements are captured by traps and create E_2-centers that are responsible for photochromic effects.

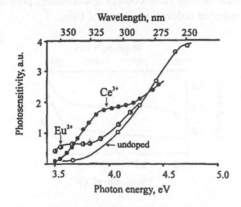

FIGURE 5 Photosensitivity spectra of silicate glasses melted under reducing conditions.

A relatively low sensitivity is typical for silicate glasses containing sensitizers such as Eu^{2+} and Ce^{3+}. Nizovtsev et al.[40] noted that after exposure for 5 minutes to UV radiation with an intensity of 10^{16} quanta/cm^2, an optical density of 0.2 to 0.3 was induced in photochromic absorption band maximum in a glass sample 2 mm thick. One of the factors defining the low sensitivity of such glasses is their comparatively high color center fading rate. Nearly complete thermal fading is attained at room temperature in just a few minutes. The thermal fading rate increases with a rise in temperature and sensitizer concentration. Therefore, at pulse radiation (0.1 μs) at the same exposure dose as above, the magnitude of photoinduced optical density increases up to 1.0. According to the estimations of Nizovtsev et al.,[41] the maximum photoinduced optical density that can be obtained in such glasses is about 1.2 to 1.3.

Investigators suspect that one more reason for the low photosensitivity of photochromic glasses doped with Eu^{2+} and Ce^{3+} is the two-step mechanism of the activation.[41] This explains a drastic decrease in the photosensitivity of glasses at temperature variations from 300 to 90 K. The dopant excited level is assumed to be below the bottom of the conduction band, therefore the ionization proceeds in the photothermal way. However, according to the data of Arbuzov et al.,[30-31] Ce^{3+}

ionization in the UV region proceeds according to the over-barrier mechanism, while the tunnel mechanism is involved only at a quantum energy of $hv < 3.6$ eV ($\lambda > 344$ nm). These results taken in their totality allow us to conclude that Ce^{3+} photoionization (see Figure 5) results from excitation to levels in the region of the intrinsic localized states under the mobility threshold. Thus, electrons need additional activation energy to migrate. That is the cause of the decreasing coloration efficiency in Ce-containing glasses when temperature decreases.

One of the disadvantages of glasses melted under reducing conditions is that they suffer from "fatigue" that manifests itself as a decrease in photosensitivity caused by repeated darkening-bleaching cycles. This is related to the fact that electrons can be captured not only by small traps, E_1 and E_2, but also can form E_3 and E_4 color centers that are stable at room temperature (see Table 2). As those centers and their corresponding hole centers accumulate, photochromic properties worsen because the induced coloration does not fade.

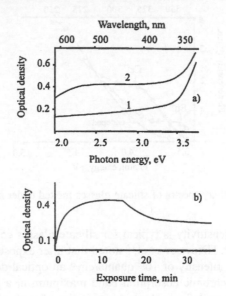

FIGURE 6 Photochromic properties of $CdO-B_2O_3-SiO_2$ glass. Sample thickness is 5 mm. a) absorption spectra: (1) nonirradiated, (2) irradiated ($\lambda = 320$ nm, 40 min); b) kinetics of darkening and fading.

Interesting photochromic properties were obtained in glasses containing cadmium as a basic component. Caslavska et al.[42] found photoconductivity in glasses of a $CdO-B_2O_3-SiO_2$ system. Later, photoconductivity, photoluminescence, and photochromism were found in a $CdO-B_2O_3$ system by Zyabnev et al.,[43] Choundhury,[44] and Meiling[45] and in a $CdO-B_2O_3-Al_2O_3$ system by Zyabnev et al.[43] According to the latter source, composition regions may be distinguished in which photochromic properties are observed under either reducing or neutral or both conditions in a $CdO-B_2O_3-SiO_2$ system.

 The initial transmittance of cadmium-containing glasses is about 80 to 90%, but after irradiation it is about 25 to 65% depending on the composition. Absorption spectra of **60CdO–25B$_2$O$_3$–15SiO$_2$** glass before and after irradiation and the kinetics of darkening and fading are presented in Figure 6. The glass was exposed to radiation of 310 nm (4 eV) wavelength and 10^{-3} W/cm^2 intensity. The photoinduced absorption spectrum represents a wide band or bands covering practically the entire visible range. One can see that such glasses are of relatively low photosensitivity. Meiling[45] has pointed out that a certain increase in the photosensitivity is achieved by adding copper to glass composition. An advantage of such glasses is the absence of fatigue after multiple darkening-bleaching cycles.

 Thus, photoinduced processes obtained in homogeneous glasses provide reversible coloration, but the photosensitivity and relaxation rate are insufficient to warrant their wide practical applications.

2 Basic Parameters of Photochromic Materials and Methods for Their Measurement

Photochromic glasses represent a new class of materials with properties of both optical and photographic media. Common optical and photographic materials are characterized by a number of operational parameters. Devices and units for measuring these parameters have been developed. Data concerning optical glasses and photographic materials were summarized in the former Soviet Union by Demkina[46] and Gorokhovsky.[47] Those methods and devices formed the basis for the creation of photochromic glasses metrology.

The main feature of photochromic glasses, variable optical density observed during exposure and upon its cessation, necessitates the creation of special methods for studying and testing those glasses. This feature has to be taken into account for the correct determination of characteristics such as integral and spectral sensitivity, darkening degree and rate, thermal fading, and optical bleaching rates. Each of these is a complex function composed of many factors — the chemical composition of glass, the sample's geometric parameters and its optical and thermal prehistory, the spectrum and intensity of actinic and probing radiation, exposure, and temperature, etc. These considerations require a special formulation of the basic principles of photochromic materials.

2.1 PHENOMENOLOGICAL DESCRIPTION OF THE PROPERTIES OF MATERIALS WITH UNSTABLE PHOTOINDUCED ABSORPTION

To start with let us determine the basic concepts that we will use for the characterization of photochromic materials. The structural element of a photochromic material that absorbs actinic radiation, similar to that found in photographic materials, is conventionally called the "center of photosensitivity." The structural element responsible for photoinduced absorption is called the "color center." Light absorption, or more exactly, light attenuation or loss, that is the sum of absorption and scattering, is characterized by the transmittance, $\tau = I_{tr}/I_0$ (where I_{tr} and I_0 are the intensities of transmitted and incident light, respectively), or the optical density, $D = -\log_{10} \tau$.

Optical density is convenient for its proportionality to the total number of color centers. The relevant literature in Russian characterizes optical materials with the decimal absorption coefficient $a = D/H$ (H is sample thickness). Let us consider the simplest phenomenological model of coloration of a material with changeable light transmittance, implying no special physical or chemical sense of the parameters but using them just in the formal description of material properties. Smith[48] was the first to use this approach to photochromic glasses. Taking into account the processes of color center formation under short wavelength irradiation, destruction under long wavelength irradiation (i.e., bleaching), and thermal destruction (i.e., fading), the dependence of color center concentration on time can be described by the simplest formal kinetic equation[49]:

$$\frac{dc}{dt} = k_a \sigma_{mc}^{abs} I_a (C^* - c) - k_f c - k_b \sigma_{cc}^{abs} I_b c \qquad (3)$$

where c and C^* are the concentrations of and photosensitivity, respectively; I_a and I_b are the intensities of actinic and bleaching radiation, respectively; σ_{mc}^{abs} and σ_{cc}^{abs} are the corresponding cross-sections of photosensitivity and color centers; k_a, k_b and k_f are the kinetic parameters that characterize the probabilities of color center formation, bleaching, and fading, respectively. A stationary solution of equation (3), when $\frac{dc}{dt} = 0$ gives a simple expression for the equilibrium concentration of color centers:

$$c_e = \frac{k_a \sigma_{mc}^{abs} I_a}{k_a \sigma_{mc}^{abs} I_a + k_b \sigma_{cc}^{abs} I_b + k_f} C^* \qquad (4)$$

Strictly speaking, Equations (3) and (4) are justified for two monochromatic sources of radiation. The first radiates in the range of original photochromic material sensitivity, and the second in the range of color center absorption bands. However, for the qualitative analysis, one can use Equation (4) for an emitter with a broad emission spectrum (e.g., sun radiation), because the spectral ranges of color center generation and bleaching usually differ considerably.

It is clear from Equation (4) that when there is no thermal fading or optical bleaching (when $k_b = k_f = 0$) the equilibrium concentration is defined solely by photosensitivity center concentration C^*. However, the actual equilibrium concentration of color centers is determined by the dynamic equilibrium between their generation and fading. When k_b and/or k_f are rising, the equilibrium concentration of color centers decreases.

One can also see from Equation (4) that for photochromic glasses with a high thermal relaxation coefficient k_f, compared to the other two items in Equation (4) that describe color center generation and optical bleaching, the equilibrium concentration c_e is proportional to the intensity of actinic radiation. In other words, a higher k_f means higher I_a values, for which the linear dependence described above is valid.

Obviously, the fading rate increases with temperature. Therefore, other conditions being equal, when the temperature rises, the range of linear coloration increases. However, at the absolute value of equilibrium, induced absorption falls abruptly.

The solution of Equation (3) gives simple dependencies of color center accumulation and decay as exponential functions. Nevertheless, such simple dependencies are not sufficient to provide a description of real kinetic curves in photochromic glasses. Therefore, the common concept of lifetime τ cannot be used to characterize those glasses. For accurate quantitative description of darkening and fading kinetics, various sophisticated mathematical models have been developed and will be presented in Chapter 5.

At the same time, simpler approaches can be applied to the practical estimations. For that reason the concept of "the criterion of relaxation" has been adopted and is widely used in Russia (see the review of Tsekhomsky[50]) to characterize the relaxation process:

$$K_{rel} = \frac{D_{exp} - D_t}{D_{exp} - D_0} \tag{5}$$

where D_{exp} is the optical density of the sample at the moment of exposure cessation; D_0 is the optical density of the sample before irradiation (this photochromic glass characteristic is to some degree analogous to the "veil" of photographic emulsions); and D_t is the optical density in t seconds of the thermal fading process.

The criterion of relaxation characterizes the degree of thermal fading at a certain time interval in relaxation. The length of that time interval is selected depending on the practical applications of a particular photochromic glass. Thus, for photochromic lenses used as sunglasses, a time interval of 180 s is recommended. From Equation (5) it is obvious that, if in that interim a glass has faded completely, $K_{rel} = 1$. On the other hand, if in that interim the induced absorption has not reduced at all, $K_{rel} = 0$. There are photochromic glasses with K_{rel} that varies through the whole range from 0 to about 1. The same range of K_{rel} for one particular glass can also be achieved by temperature variation.

2.2 INTEGRAL AND SPECTRAL PHOTOSENSITIVITY

It is conventional in sensitometry to plot characteristic curves in equal-scale coordinate systems of $D = f(lgE)$, where D is optical density and E is exposure.[47] But unlike common photographic materials, photochromic glasses exhibit induced absorption varying with time. Therefore, it is more appropriate to plot optical density along the ordinate axis, and the logarithm of time, not of exposure, along the abscissa. Going from E to t allows one to envision both darkening and relaxation processes in the same coordinate system.

Presented in such coordinates the darkening kinetic curve (Figure 7, curve 1) appears S-shaped, similar to the sensitometry curves of common photographic materials.[47] The curve consists of the initial part AB, an approximately linear part BC, a transitional part CD, and a saturation part DE. It should be noted that a curve of

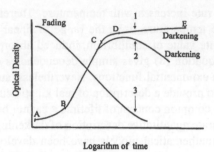

FIGURE 7 Characteristic curves of darkening (1, 2) and fading (3) of silver halide photochromic glass. (1) and (3) were obtained by IFS-2 unit (see Figure 9) will illumination directed along the normal to the sample surface, and (2) by IFS-1 unit with illumination directed at 45° angle.

this kind can be obtained only when all the conditions of exposure and, most importantly, the sample temperature have been held constant. It should be noted that the use of powerful light sources may cause the warm-up of the sample, partial thermal bleaching, and, consequently, additional experimental errors in the darkening kinetic curve measurement (Figure 7, curve 2).

The value of optical density in the stationary part of the characteristic curve (DE), when the rate of color center generation becomes equal to their fading rate, is called equilibrium optical density, D_e. D_e value, or the corresponding value of equilibrium transmittance $\tau_e = 10^{-D_e}$, is often used as the basic parameter characterizing photochromic glasses. It is clear from Figure 7 that the accuracy of D_e measurement depends on the degree of sample warm-up in the measurement chamber.

In some cases a glass is characterized by the time it takes to darken t_d. This parameter is the time it takes for optical density to reach the value of $0.95D_e$. It is clear that t_d can be obtained only after D_e has been determined. It has been pointed out that the accuracy of D_e measurement is rather low. Therefore, it is accepted practice in Russia to use the optical density induced in the glass sample under standard conditions of exposure to nonfiltered radiation of a high-pressure xenon lamp creating an illumination of 60,000 lux for 180 s (3 min) at room temperature:

$$\Delta D_3 = D_{exp} - D_0 \qquad (6)$$

An important characteristic of photochromic glasses that defines their potential practical applications is their integral photosensitivity. There are various ways to determine this characteristic. Frequently, the amount of exposure required to reach a certain value of photoinduced optical density is used for photosensitivity characterization. The value of photoinduced density is called the criterion of photosensitivity. The optical density value of $D = 0.1$ is selected as the criterion of photosensitivity for photochromic materials. So, photosensitivity of photochromic glass is evaluated by the exposure necessary to increase the optical density in the BC linear portion of Figure 7 by the value of 0.1.

Megla[51] has shown that for a photochromic material with a quantum efficiency of 1, when there is neither optical nor thermal relaxation the exposure of 10^{-4} J/cm²

is required to change the optical density by 0.1. The photosensitivity of existing photochromic glasses is in the range of (3 to 25) × 10^{-3} J/cm^2. Thus, the latter value is 1 to 2 orders of magnitude lower than the corresponding one in the limit case considered above. The photosensitivity of other photochromic materials, including organic ones, is of the same level. It should be noted that the photosensitivity of photographic emulsions is about 5 orders of magnitude higher than that of photochromic glasses. This is related to the amplification of color at the chemical development stage in the process of photographic image creation.

Thus far we have been dealing only with photochromic glass characteristics that are integrated by their spectra. No less important are their spectral characteristics. The position of the absorption bands of photosensitive microcrystals in the initial glass spectrum define the range of its spectral photosensitivity. A common and quite natural requirement of the consumers of photochromic glasses is maximum possible transparency in a nonirradiated state. This runs counter to a basic principle of photochemistry — the primary act of every photochemical process is the absorption of a light quantum. Therefore, material is photosensitive only in the spectral range in which it absorbs light.

An important parameter is the spectral sensitivity of a photochromic material, i.e., the dependence of photoinduced color center concentration on quantum energy related to the number of absorbed photons. Exact measurements of that parameter actually were not carried out even for simpler systems (see Chapter 1, Section 1.2). Usually, for the photochromic glasses, the dependence of the saturated photoinduced optical density (D_e) on exciting radiation photon energy is experimentally measured on a sample of a certain thickness. This dependence is called the color center generation spectrum.

The absorption edge of photochromic glass determines the position of the color center generation spectrum because photosensitive crystals absorb exactly in that region (compare Figure 1a, curve 4 and Figure 8, curve 1). Therefore, the color center generation spectrum is a band in the region of the photosensitivity center absorption edge (Figure 8, curve 2). The short wavelength edge of this band reflects the decrease in thickness of the layer containing color centers, that is, it is due to the increase of the glass absorption coefficient. The long wavelength edge is caused by a decrease in the absorption and in the efficiency of photosensitivity center excitation. Therefore, the position of the maximum in the color center formation spectrum does not coincide with that of any maximum in a photochromic glass absorption spectrum. Moreover, its position appears to be a function of sample thickness and drifts to the short wavelength side as thickness decreases (see, for example, the work of Airapetyants et al.[52]). Such behavior of the color center generation spectrum is similar to that of a homogeneous alkali-silicate glass described in Chapter 1, Section 1.2.

The absorption spectrum of an exposed glass doped with **AgCl** microcrystals is shown in Figure 8, curve 3. This absorption represents a wide band in the visible spectral range. This band causes the degree of darkening and the color of exposed photochromic glass. It should be noted that the measurement of the photoinduced absorption in a photochromic glass is a particular problem because of that absorption instability.

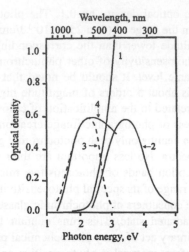

FIGURE 8 Spectra of glass doped with AgCl(Br) microcrystals: (1) absorption spectrum of nonexposed glass; (2) color center generation spectrum; (3) color center absorption spectrum; and (4) spectral dependence of bleaching efficiency. Sample thickness is 5 mm.

In most cases, when measuring photoinduced absorption spectrum, first the kinetic curves of darkening and fading at various probing wavelengths are analyzed and then, on the basis of the data obtained, the spectral dependence of the photoinduced absorption is plotted for each fixed moment of time.[52] Gracheva and Peshkov[53] described a model of a spectrosensitometer which allowed them to measure a stationary photoinduced absorption spectrum of photochromic glasses at a 0.1 ms delay. To achieve this, a special device stopped actinic irradiation for a short interim and made a probing at that moment.

The maximum of the photoinduced absorption spectrum in most cases defines the maximum of the sensitivity to optical stimulation in the visible region. As a rule, such stimulation results in optical bleaching (Figure 8, curve 4) similar to the effect obtained from radiation defects in crystals and glasses (Chapter 1, Section 1.3). However, in some glasses additional coloration induced by visible light is observed (see Chapter 8).

Also, it is important to take into account whether color centers exhibit absorption in the range of the color center generation spectrum. If so, the actinic radiation also works as the bleaching agent. This phenomenon leads naturally to the reduction of the photochromic effect. In this case, color centers attenuate exciting light. It reduces darkening also.

2.3 SPATIAL INHOMOGENEITY OF COLORATION

Unlike common optical glasses, which have constant absorption coefficient over their entire volume, a strong dependence between coloration and the distance from the surface is observed in photochromic glasses, as was mentioned in the previous section. Therefore, for the valid characterization of the colored state of photochromic glass, not the absorption coefficient but the value of photoinduced optical density should be used:

$$\Delta D = \sigma_{cc}^{att} \lg e \int_0^H c(h)dh \qquad (7)$$

where $c(h)$ is the concentration of photoinduced color centers at the distance from the surface of h; H is photochromic glass sample thickness; σ_{cc}^{att} is the cross-section of attenuation (i.e., the sum of absorption and scattering) by a color center at the probing wavelength; and e is the natural logarithm base.

In other words, the Bougher law is not valid for colored photochromic glasses. Therefore, knowing the value of the photoinduced optical density of a photochromic glass sample of H thickness, one cannot derive the optical density value of a sample of different thickness of the same glass. Color center concentration $c(h)$ falls rapidly with distance from the surface. According to Equation (7), there is a certain value of sample thickness (call it H_{lim}) when increased sample thickness will not bring about a significant increase in photoinduced optical density. The higher the value of photochromic material absorption coefficient at the excitation wavelength, the lower the H_{lim}. As a matter of fact, especially under UV irradiation, photochromic glasses darken over a small depth (about 2 to 3 mm for silver halide glasses and a bit more for copper halide glasses because of their photosensitivity in the long wavelength region, Chapter 8). The last feature to be taken into account deals with optical systems containing photochromic glasses and the design of testing units for photochromic glasses.

2.4 PHOTOMETRIC SETUP FOR NONSTATIONARY CHARACTERISTICS MEASUREMENT

Photometric testing units that provide exposure and probing simultaneously by two different emitters are usually applied to measure the parameters of coloration and fading of photochromic glasses. An optical design with a probing beam transmitted through the irradiated surface at 45° with respect to the incident actinic beam (see reference 54, for example) is often used. A similar approach was used in the USSR and the testing setup IFS-1 was developed (Figure 9a). A 200 W high-pressure xenon lamp (DKSSh-200) was used as an emitter of actinic radiation in this unit. The emission spectrum of such lamps is similar to that of the sun. The illuminance on the sample surface can be varied within the range of 150,000 to 1,000 lux by means of net filters.

The probe channel in this unit is an integral photometer. It should be noted that photoinduced absorption is not neutral but exhibits certain spectral selectivity. Therefore it is important to chose the right detector for the integral photometer. Moreover, the measured relaxation parameters depend on probing radiation wavelength because of the difference in fading rate for different color centers.

In addition, such a photometer should meet one more requirement: the probing light should not bleach colored photochromic glasses. However, when the incident beam in a probing channel is directed at a sharp angle to the exposing beam, in order to increase signal/noise ratio, the illuminance made by the probing beam should

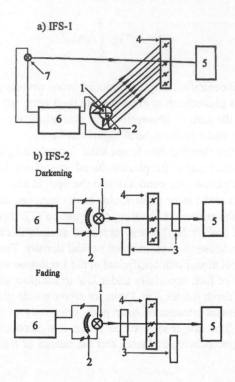

FIGURE 9 Optical designs of the test unit for photochromic material kinetic characteristics:
a) IFS-1 and b) IFS-2. 1) xenon lamp, 2) reflector, 3) movable filters, 4) photochromic glass
sample, 5) powermeter, 6) stabilized power supply, and 7) incandescent lamp.

be as high as 10 lux. Certain distortion of darkening and fading kinetic curves can
be obtained at such illuminance in a lengthy test procedure. Moreover, the design,
with exposing and probing beams directed at the sample at different angles, is not
convenient for thick samples nor for samples with varying thickness (e.g., spectacle
lenses).

The testing unit IFS-2[55] was accepted in Russia as a standard for the inspection
of incoming photochromic glasses produced commercially as sun-protecting
lenses. Both exposing and probing beams in this setup are combined in a single
channel (Figure 9b). The opportunity to observe the darkening and relaxation
processes in the same optical channel has become feasible through the use of a
pair of movable filters (see 3 in Figure 9b). In the exposure process, the filter
placed before the sample is turned off, and the filter placed behind the sample is
plugged in. In the measuring process, the on/off positions of the filters (3) are
altered automatically by means of a special device. The illuminance upon the
sample is reduced to 5 to 10 lux, and the probing is actually being performed.

Testing units IFS-1 and IFS-2 allow one to obtain the kinetic curves of
darkening and fading for standard exposure conditions (Figure 7) and to assess
the standard parameters of photochromic material. The use of monochromators

in the exposing and probing channels of IFS-1 permits us to measure color center generation spectra and photoinduced absorption spectra with a certain time delay.

The methods of unstable absorption description and measurement described in this chapter have served as a technical basis for the investigation and characterization of the optical properties of heterogeneous photochromic glasses.

3 Photosensitive Phase Formation in Heterogeneous Photochromic Glasses

Photochromic glasses doped with silver and copper halides exemplify heterogeneous materials. They represent a two-phase system consisting of a vitreous phase of host glass and of a finely dispersed photosensitive phase. The latter usually exhibits crystalline structure.

As long ago as in the work by Frank and Rabinovich[56] it was noticed that the "cell" effect took place when a photosensitive substance was placed into a rigid host structure. This placement prevents leakage of reaction products. Then photochemical processes would be completely reversible. It is reasonable to believe that inorganic glasses can serve as such rigid hosts. Indeed, they have very high viscosity (10^{23} P) and low gas permeability at room temperature. Therefore, the leakage of reaction products from the photosensitive phase to the host glass is prevented. An additional isolation of photoinduced reaction in a two-phase system is provided by the low mobility of electrons and holes in inorganic glasses.

3.1 THE CONDITIONS FOR HETEROGENEOUS SYSTEM TRANSPARENCY

As was already mentioned, photochromic glasses are designed for light flux modulations. These materials should possess a sufficient transparency in the visible region of the spectrum before exposure. The latter requirement is one of the basic natural ones for photochromic glass applications in optics and opto-electronics. In two-phase systems, light attenuation is caused not only by absorption of each phase but also by scattering, because of possible differences between refractive indexes of the vitreous and crystalline phases. A two-phase system can be transparent if it satisfies two conditions. The first is: both glass and crystalline phases are transparent enough in the working spectral range. The second is: the parameters of microinclusions (size, shape, concentration, and difference in the refractive indexes of the phases) are chosen in a way that prevents strong scattering. Let us consider the conditions of diminishing light scattering in a two-phase system.

TABLE 3
Physical and Optical Parameters of Some Photosensitive Crystals

| | | Temperature (°C) | | | Exciton Parameters | |
Crystal	Density g/cm³	Melting	Boiling	Refractive Index n_e	Peak Position, eV	Bonding Energy, eV
AgCl	5.56	455	1550	2.07	5.12	0.37
AgBr	6.47	404	*	2.25	4.26	0.02
AgI	5.67	552*	*	2.22	2.94, 2.98	0.05
Cu_2Cl_2	3.53	422	1366	1.97	3.28, 3.21	0.19
Cu_2Br_2	4.72	504	1345	2.12	2.97, 3.12	0.11
Cu_2I_2	5.63	605	1290	2.34	3.06, 3.70	0.06
TlCl	7.00	430	720	2.25		
$CdCl_2$	4.05	568	960		6.31, 8.49, 9.02	0.5

* Decomposed.

It is well known that light scattering increases when the size of the particles causing scattering increases. Therefore, to reduce scattering, it is necessary to create microcrystals randomly dispersed in the host glass and to prevent formation of any large aggregates. In addition, it is essential that the difference in refractive indices of the microcrystals and the host glass is minimal.

Dotsenko and Tsekhomsky[57] have evaluated photosensitive microcrystals of maximum size (see Table 3) that produced light scattering of equal magnitudes in vitreous hosts with different refractive indices. The calculations were made using the well-known Rayleigh formula:

$$\sigma_{sc} = \frac{128}{3} \pi^5 r^6 \frac{n_m^4}{\lambda^4} \left[\frac{m^2 - 1}{m^2 + 2} \right]^2 \tag{8}$$

where σ_{sc} is the cross-section of scattering by a particle of radius r, $m = n/n_m$ is the relative refractive index, n and n_m are the refractive indices of the microcrystal and host glass, respectively, and λ is light wavelength in vacuum.

Strictly speaking, Equation (8) is valid for spherical particles with $r \ll \lambda$. Such an approach can also be applied to bigger, nonspherical particles as long as they satisfy the condition of "optical softness" (see, for example, the monograph by Van de Hulst[58]), $\rho|m - 1| \ll 1$, where $\rho = 2\pi n_m r/\lambda$, is the diffraction parameter.

Applying Equation (8), one can assess the maximum size of particles (we designate it as r^*) that can be admitted into a photochromic glass so that the scattering will not exceed a specified value at a certain wavelength. The results of such calculations are presented in Figure 10 for a value of optical density, caused by scattering, of no more than 0.2. Figure 10a illustrates the dependence of r^* on variation of the host matrix refractive index n_m for a constant refractive index of the

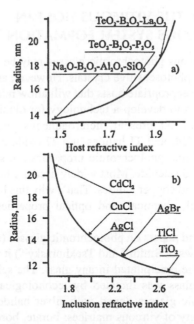

FIGURE 10 Dependence of maximum radius R^* of microcrystals in host glass on refractive index a) of host glass for microcrystal phase refractive index $n = 2.1$ and b) of microcrystals for host glass refractive index $n_m = 1.5$. Maximum radius corresponds to the optical density of 0.2 caused by scattering.

precipitated crystalline phase ($n = 2.1$). Figure 10b shows r^* dependence on the refractive index of the precipitated phase n for the constant refractive index of host glass $n_m = 1.5$. Both cases allow one to see the obvious tendency of radius r^* to increase when the difference between refractive indices of particles and host goes down. For instance, in an optical crown glass with the refractive index of 1.48, the radius of AgCl crystals should not be over 14 nm at the concentration of 10^{14} cm^{-3}. In a glass of the tellurite system with $n_m = 1.9$, for comparison, the scattering value being preserved, the radius of microcrystals can be about 40% more than in the silicate matrix mentioned above.

It is well known that the properties of photosensitive materials essentially depend on the size of microcrystals. For example, Megla[51] reported that glasses doped with silver halide microcrystals did not exhibit photochromic properties at all when their size was less than 5 nm. That means that the creation of large crystals in heterogeneous systems results in photosensitivity growth. Hence, hosts with high refraction are more promising for obtaining photochromic glasses of high sensitivity. Indeed, Volkova et al.[59] obtained highly sensitive tellurite photochromic glasses with low scattering. On the other hand, glasses doped with low-refraction CuCl microcrystals and especially CdCl$_2$, in this sense, possess certain advantages compared to those doped with silver halides.

3.2 THE ROLE OF THE VITREOUS HOST IN HETEROGENEOUS SYSTEM FORMATION

The range of heterogeneous photochromic glasses may be fairly wide as there is a great number of known photosensitive crystals. However, as was already discussed, it is difficult to find such appropriate hosts that will allow microcrystals to precipitate in them. The next task is to develop a technology for obtaining microcrystals with the required parameters. At present, heterogeneous photochromic glasses are obtained with **Ag, Cu, Cd,** and **Tl** halides and **Ti** oxide crystals as a basis of the photosensitive phase. Some photochromic properties are shown by glasses doped with cadmium sulfide and selenide. Most widely used are heterogeneous photochromic glasses with silver and copper halides. That's why this book provides a thorough analysis of the physical, chemical, and optical properties of the latter class of photochromic materials.

In the first patents and papers on photochromic glasses (see patents of Armistead and Stookey[60] and reviews of Smith[48] and Tsekhomsky[50]) it was noted that the silver the halide phase could be precipitated in any glass. The selection of a soda-aluminum-borosilicate host glass was dictated by technological reasons only. Indeed, transparent photochromic glasses doped with silver halides are now successfully obtained in a great variety of vitreous matrices: borate, borosilicate, lithium-aluminum-silicate, germanate, phosphate, tellurite, and others. Glimeroth[61] has demonstrated the possibility of obtaining silver halide photochromic glasses on the basis of just pure boric anhydride. However, the method actually consists in isolation of AgCl microcrystals from the environment by vitreous B_2O_3 and is similar to that of obtaining silver halide emulsions in gelatin. At the same time, there are hosts in which there has still been no success in obtaining photochromic glasses doped with silver or copper halides (e.g., such common vitreous hosts as Na_2O–SiO_2 or Na_2O–CaO–SiO_2[50]).

One can formulate the following requirement for a vitreous host for obtaining heterogeneous photochromic glass. A matrix glass must possess high solubility of the halide compounds in its melt condition at high temperature. That solubility should decrease sharply and discontinuously as temperature decreases. In this case, high concentration of halides in the melt will lead to oversaturation and crystal phase precipitation under heat treatment at temperatures about T_g. The sharper the solubility jump, the more of the introduced photosensitive dopant that enters the crystal phase. At the same time, it would be wrong to believe that the solubility of halide compounds in glass melt is considerably higher than in solid glass simply because of higher temperature. It should be noted that these compounds either are gaseous or have high vapor pressure ($T_{boil\cdot AgCl} = 1550$ °C, $T_{boil\cdot CuCl} = 1368$ °C) at usual melting temperatures. One possible cause of the drop of halides' solubility at cooling may be metastable immiscibility. If a photosensitive component has higher solubility in one of the immiscible phases, its concentration in that phase will grow. Because of that, such a high oversaturation may occur that the photosensitive component would precipitate as a separate phase. In this case, the boundary between vitreous phases may be the location of crystal photosensitive phase nucleation. In addition, the immiscibility structure existing in the glass prevents the photosensitive phase from

aggregating into large conglomerates. This approach (i.e., the hypothesis of immiscibility), which was formulated in the works of Vargin et al.[62] and Tsekhomsky,[63] has been confirmed in many works.[64-66]

Let us consider some vitreous hosts that have allowed us to obtain photochromic glasses. First are borate and borosilicate glasses. Alkali-borate glasses were studied

TABLE 4
Alkali Oxide Content (mol %) in Borate Glasses for Obtaining Photochromism and Phase Separation

Glass	Photochromism	Phase Separation
$Li_2O-B_2O_3$	6–30	2–18
$Na_2O-B_2O_3$	8–32	7–24
$K_2O-B_2O_3$	4–24	2–22
$Rb_2O-B_2O_3$	6–24	2–16
$Cs_2O-B_2O_3$	0–18	2–20

most thoroughly in the work of Tsekhomsky and Papunashvili.[67] Shaw and Uhlmann[68] studied metastable immiscibility in these systems. One can see from Table 4 that the regions of photochromism and metastable immiscibility overlap considerably.

The immiscibility hypothesis justifies the photochromism in glasses of an $Na_2O-B_2O_3-SiO_2$ system (see the review by Tsekhomsky[50]). Figure 11 shows that the photochromism area is somewhat narrower than the immiscibility area in these glasses. It was found[50] that when such glasses are etched in 0.1 N HCl solution at 50 to 100 °C, silver halides are completely removed from glass to solution. The solubility in acids is maximal for the borate phase in borosilicate glasses. Consequently, this result proves preferential inclusion of photosensitive components into the borate phase during the process of phase separation in borosilicate glasses. The correlation between the areas of immiscibility and photochromism was also obtained for $BaO-Al_2O_3-B_2O_3$ system.[50]

In addition, the tendency toward metastable immiscibility is not a sufficient requirement for a vitreous host. In particular, it is known that the soda-silicate system has, according to Andreev et al.,[69] a broad region of metastable immiscibility. However, all attempts to precipitate silver halide photosensitive crystals in these glasses have failed. It may be supposed that metastable immiscibility is not the only cause of the halide solubility discontinuous drop when temperature decreases.

As Araujo and Borrelli[70] considered, the other cause of this jump-like solubility decrease could be the coordination changes of boron and aluminum. Bray[71] has determined experimentally that the relationship between trigonal and tetrahedral coordinated boron varied with temperature and that the variation may reach 15 to 20%. The higher the temperature, the greater the amount of trigonal boron. Supposing it is trigonal boron (boroxol groups) that favors halide solubility in glass, one can conclude that the cause of the solubility drop is in the drastic decrease of trigonal

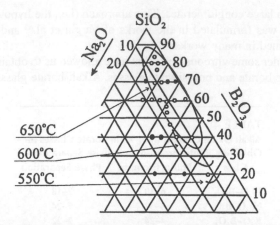

FIGURE 11 Chart of glass composition: open circles = glasses possess photochromism; solid circles = glasses do not possess photochromism; and solid curves = region of metastable immiscibility after heat treatment at different temperatures.

boron concentration when temperature decreases. Araujo and Borrelli[70] supposed that ions of halide can be bonded to boron only by substitution for nonbridging ions of oxygen. Araujo then used a statistical mechanical model[72] and estimated a concentration of nonbridging ions of oxygen as a function of the glass composition and structure.

This approach allowed the use of the difference between the solubility of halide at the temperature of melting and the temperature of thermal treatment (ΔCl) as a measure of the amount of halide that is precipitated during heat treatment and that participates in the creation of the photosensitive phase. It should be noted that Araujo and Borrelli[70] have found a good correlation between the values of (ΔCl) and concentration of the precipitated phase that was determined with the optical method. This correlation was significant for a number of borate, borosilicate, and aluminoborosilicate glasses.

Hence, one can conclude that in borate and borosilicate glasses changes in both immiscibility and boron coordination can cause the oversaturation of halides and result in the crystalline phase precipitation. Both these mechanisms can participate in crystalline phase formation together or independently. For example, the recent work of Araujo[73] shows that photosensitivity caused by copper halide microcrystal precipitation occurred in borosilicate glass exhibiting no phase separation. Meanwhile, the relative contribution of different mechanisms to changes in halide solubility is not completely clear and requires further study.

Values of silver and copper halide solubility in glass melt play an important role in photosensitive phase precipitation. The silver and copper reduction potentials in glass can effect these values. The data reported in Table 5 show that the reduction potential of silver and, consequently, the ability of silver ions to be reduced are maximal in silicate glasses in comparison to borate and phosphate glasses. Therefore, it was not possible to introduce more than 0.5% of silver in silicate glass. When introduced in higher concentrations, ionic silver is reduced to its atomic state and

produces an amber coloration due to the aggregation of neutral silver atoms into colloidal particles. In borate glasses, silver ion is much more stable. At any rate, silver content can reach 1 mass % without exhibiting colloidal coloration. Most resistive to reduction are Ag^+ ions in phosphate glasses, where the silver content can reach 10 mass %.

TABLE 5
Electrochemical Potentials of the Reduction of Silver Ions in Different Glasses

Glass	Potential of Reduction, V
$Na_2O-1.5SiO_2$	1.055
$Na_2O-2B_2O_3$	0.850
$Na_2O-3B_2O_3$	0.650
$Na_2O-4B_2O_3$	0.625
$Na_2O-P_2O_5$	0.325

It is seen from Table 5 that the reduction potential of silver in borate glasses increases when the concentration of alkali oxides rises. In other words, the resistance of silver to reduction falls with the growth of the nonbridging oxygen concentration. On the other hand, as chemical analysis data show, the content of chloride ions in alkali-borate glasses increases as the concentration of alkali oxide, i.e., of nonbridging oxygen, rises (see the works of Tsekhomsky [67] and Morimoto et al.[74]). Also, as was noted by Tsekhomsky,[50] the solubility of halides in glasses is promoted by glass-forming oxides, such as B_2O_3, Al_2O_3, GeO_2, Ga_2O_3, ZnO, CdO, and some others, whose cations form their coordination environment by donor-acceptor interactions.

We believe that **AgHal** and **CuHal** molecules, and possibly even their aggregates, are formed in the glass melt during the melting process. During heat treatment, which will be considered in Section 3.3, these fragments aggregate into a separate phase. In connection with this point, it is important to understand the effect of host glass composition on the tendency for various halide compound creation, especially of **AgCl** and **CuCl**. The values of the free energy (ΔG) of formation of some chlorides and oxides at 1000 K are listed in Table 6. The absolute value of free energy cannot serve as a criterion of the tendency of the glass toward the formation of chloride complexes because the total volume of glass is determined mainly by oxygen ions. However, the ratio of these values for chlorides and oxides and, to some degree, the difference between them, may characterize that tendency. The elements in the table are arranged in decreasing values of $\Delta G_{Cl}/\Delta G_O$ ratio. If this approach is correct, the succession corresponds to the decline of the property of glass to form chloride complexes:

Ag Tl Na Pb Cu(1) Cd

Ba Cu(2) Sn(2) Sb(3) Sn(4) Ca

B Zr Si Al P

TABLE 6
Values of Free Energy ΔG (kCal/mol) for Chloride and
Oxide Formation at 1000 K

Element	$-\Delta G$ chloride	$-\Delta G$ oxide	$-(\Delta G_{Cl} - \Delta G_O)$	$\Delta G_{Cl}/\Delta G_O$
Ag	53.26	18.2	35.06	2.93
Tl	77.5	33.2	44.3	2.34
Na	115.5	59.9	56.6	1.93
Pb	118.4	68.2	50.2	1.74
Cu(1)	54.1	31.2	22.9	1.73
Cd	120.6	74.3	46.3	1.62
Ba	235.5	149.8	85.7	1.57
Cu(2)	76.2	49.7	26.5	1.53
Sn(2)	116.1	81.9	34.2	1.42
Sb(3)	135.8	98.4	37.4	1.38
Ca	215	161.3	53.7	1.33
Sn(4)	192	151.3	40.7	1.27
B	163.8	157.5	6.3	1.04
Zr	279.2	273.5	5.7	1.02
Si	217.8	215.3	2.45	1.01
Al	206.7	206.2	0.5	1.00
P	174.0	201.7	−27.7	0.86

We can see that silver is the first in this series. The tendency toward thallium chloride formation is also quite high. We should also note the somewhat higher propensity for sodium chloride formation than for single valence copper chloride. This makes clear that one of the basic components of glass, namely the alkali ion, essentially effects the glass' ability to form silver and copper chlorides. This approach may help explain the decrease of CuCl formation when the Na_2O content in glass increases (see Figure 12).

The activity of alkali ions is altered significantly if such glass-formers as Al_2O_3, B_2O_3, ZnO, etc., are introduced into glass. This causes variation of the NaCl formation rate and, consequently, also of AgCl and CuCl formation. Figure 13 shows the photoinduced optical density dependence on Al_2O_3 content in copper halide photochromic glass. Complete absence of photochromism is obtained when the Al_2O_3 content is more than 3 mol %. Figure 14 shows the effect of CdO, ZnO, and Tl_2O content in copper halide photochromic glass on photoinduced absorption. Complete lack of photochromic properties was observed at 1% CdO, 1.5% ZnO, and 3.5% Tl_2O. One can see from Table 6 that double-charged ions, including alkali-earth ions, are placed below Cu⁺. Therefore, the decrease of the glass' ability to form silver and copper chlorides is due to the variation of alkali ion activity, similar to the effect of aluminum.

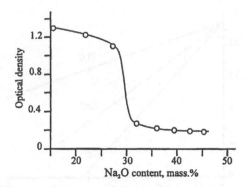

FIGURE 12 Effect of Na_2O on the optical density of photochromic glasses in the maximum of absorption band at $\lambda = 380$ nm (hν = 3.26 eV). Sample thickness is 5 mm.

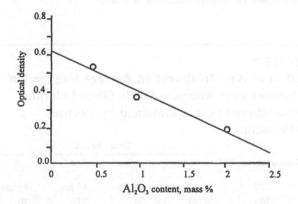

FIGURE 13 Effect of Al_2O_3 on the photoinduced absorption of copper halide photochromic glasses. Sample thickness is 5 mm.

3.3 CRYSTALLINE PHASE PRECIPITATION IN THE PROCESS OF HEAT TREATMENT

Glasses acquire photochromic properties in the process of special thermal treatment in the temperature range of 500 to 700 °C depending on their composition. This region corresponds to the viscosity range of 5×10^{14} to 5×10^9 P. The average concentration of microparticles containing photosensitive crystals decreases while their average size increases if time or the temperature of the glass heat treatment increases. This is illustrated by Tables 7 and 8, which are based on the results obtained by Fanderlik[75,76] by means of statistic treatment of the data obtained independently by the methods of optical diffraction and electron microscopy.

When heat treatment time t is increased in the isothermal regime, the growth of the photosensitive phase size is observed. This dependence is described best in

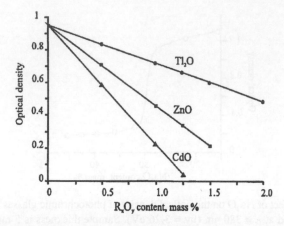

FIGURE 14 Effect of CdO, ZnO, and Tl₂O on the photoinduced absorption of copper halide photochromic glasses. Sample thickness is 5 mm.

TABLE 7
Effect of Heat Treatment on Average Size (nm) of Photosensitive Microcrystals in Silver Chloride Photochromic Glass, Obtained by Electron Microscopy

Temperature, °C	Time, hours			
	1	2	4	8
650	35 nm	40 nm	45 nm	45 nm
700	45	50	55	70
750	50	65	70	85
800	65	75	90	110

From Araujo, R.J., Influence of host glass on precipitation of cuprous halides, submitted to *J. Non-Cryst. Sol.*, in press, 1997.

coordinates $\bar{r} = \bar{r}(t^n)$, where \bar{r} is the mean radius and n ranges between 1/2 and 1/4 (Paskov[77] and Golubkov et al.,[78] see Figure 15). The shape of this dependence is in accordance with the theory of phase separation in oversaturated solid solution on the stage of recondensation, which was developed by Lifshitz and Slyozov,[79] where the following expression describing particle growth was derived:

$$r_0 = \left(\frac{4\sigma_{ov} D_{dif}}{9} \right) t^{1/3} \qquad (9)$$

Here r_0 is the mean radius of particles, D_{dif} is the diffusion coefficient of ions forming a particle, and σ is the coefficient proportional to oversaturated solution concentra-

TABLE 8
Effect of Heat Treatment on Average Concentration of Photosensitive Microcrystals in μm³ in Silver Chloride Photochromic Glass, Obtained by Electron Microscopy

Temperature, °C	Time, hours			
	1	2	4	8
650	2.9	1.8	1.6	1.1
700	1.4	0.8	0.8	0.5
750	1.2	0.6	0.5	0.4
800	0.2	0.1	0.09	0.08

From Araujo, R.J., Influence of host glass on precipitation of cuprous halides, submitted to *J. Non-Cryst. Sol.*, in press, 1997.

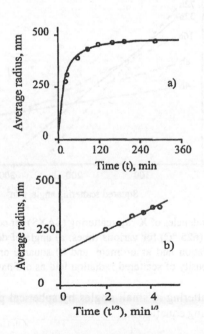

FIGURE 15 Dependence of average radius of **AgCl** crystals in photochromic glasses on exposure time at 480 °C: a) time t as abscissa and b) cubic root of time $t^{1/3}$ as abscissa.

tion. The latter depends on the thermal treatment temperature and can vary during the treatment process.

Vast data on sizes and phase transformations of photosensitive inclusions in photochromic glasses were obtained by Yin[80] and Golubkov et al.[81] by means of

small-angle X- ray scattering (SAXS). Typical angular dependencies of the intensity of scattered radiation for copper halide photochromic glasses treated at 625 °C for different times are presented in Figure 16. One can see that the intensity of scattering increases at small angles if exposure time increases.

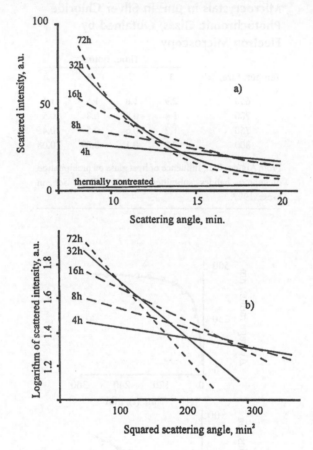

FIGURE 16 Angle dependencies of X-ray scattering (SAXS) for copper halide glass treated at a constant temperature (625 °C) for various times: a) angle of detecting laid as abscissa, intensity of scattered radiation laid as ordinate, and b) squared angle of detecting laid as abscissa, logarithm of intensity of scattered radiation laid as ordinate.

The intensity of scattering at small angles by spherical particles of radius R is expressed in the following equation[78]:

$$I = (\rho_1 - \rho_2)^2 w_1 V v \exp(-s^2 R^{2/5}) \qquad (10)$$

Here ρ_1 and ρ_2 are electron densities of the dispersed phase and host glass, respectively. Their relative volumes are, respectively, w_1 and w_2; V is the volume of the irradiated portion of the sample, v is the volume of a single region of the precipitated

phase, and $s = 4\pi \sin \dfrac{\varphi/2}{\lambda}$ where φ is scattering angle and λ is the X-ray irradiation wavelength used. Since $w_2 = 1 - w_1$ and the volume concentration of the photosensitive phase is usually insignificant, w_2 is nearly 1.

It is clear that the slope of the curves in Figure 16b is defined by the radius of scattering particles, which in turn depends on thermal treatment time. The fact that an exponential dependence is obtained in a wide range of scattering angle values is evidence that size dispersion of scattering particles is comparatively low in copper halide photochromic glasses. The data obtained allow us to determine the average squared difference of electron densities $(\Delta\bar{\rho})^2$ of phases. This term characterizes the volume concentration of the precipitated phase in the case of its constant composition. Actually, $(\Delta\bar{\rho})^2$ can be expressed in the following simple form:

$$(\Delta\bar{\rho})^2 = (\bar{\rho}_1 - \bar{\rho}_2)^2 w_1 w_2 \tag{11}$$

Table 9 lists the values of radii and $(\Delta\bar{\rho})^2$ for copper halide photochromic glasses like FHS-7 (refer to the Russian Catalogue of filter and special optical glasses[82]) as functions of heat treatment conditions. The analysis of R and $(\Delta\bar{\rho})^2$ values presented in Table 9 shows that, with the increase of heat treatment time at temperatures above 550 °C, the size of scattering inclusions increases, while their volume concentration remains almost the same. Consequently, in this temperature range, the growth of the phase enriched with CuCl microcrystals is caused mainly by the recondensation process. It has been shown[81] that the average radius of particles grew proportionally to the time cubic root at the stage of the recondensation process. The confirmation of this conclusion can be seen in Figure 17a. The slope of the straight lines presented in the figure depends on temperature and actually characterizes the rate of the scattering phase growth. The analysis of the temperature dependence of microcrystal growth rate (see Figure 17b) allowed us to determine the activation energy of the process, which was about 30 kcal/mol.

An opinion was proposed by Golubkov and Tsekhomsky[81] that the recondensation process was limited by copper ion diffusion. At the same time, there is reason to believe that the activation energy of photosensitive phase precipitation is approximately of the same value in silver halide glasses. Dependence of the average radius of microcrystals in glasses doped with AgCl on treatment time at 625 °C, presented in Figure 17a (Golubkov et al.[83]), confirms this conclusion. The latter point allows us to suppose that the phase precipitation process is limited mainly by the host glass, i.e., the activation energy value given above corresponds approximately to the energy of activation of viscous flow in glass.

The analysis of experimental data $(\Delta\bar{\rho})^2$ in glasses enables us to estimate the composition of the precipitated phase. The average electron density ρ can be calculated by the formula:

$$\rho = d\frac{Z}{M}N \tag{12}$$

TABLE 9
Radii (R) and Squared Difference Between Electron Densities of the Phase Enriched with CuCl Microcrystals and Basic Glass $(\Delta r)^2$ versus Temperature (T) and Exposure Time (t) of Heat Treatment

T, °C	t, h	R, nm	$(\Delta r)^2 \, 10^{10}$ (e/nm³)²
500	4	1.7	1.8
500	6	1.8	1.7
500	10	1.8	2.8
500	14	1.9	4.0
500	35	2.1	4.4
550	1	1.8	2.2
550	2	2.5	4.0
550	4	2.9	5.5
550	8	3.4	6.3
550	22	4.2	6.0
600	0.5	4.0	3.3
600	1	5.2	4.0
600	2	5.5	4.1
600	4	6.5	4.3
600	7	8.1	4.6
600	13	9.8	5.0
600	21	11.0	5.1
600	26	12.6	5.5
625	1	7.3	4.7
625	2	8.1	4.9
625	4	8.8	4.8
625	8	10.0	4.9
625	16	13.3	4.7
625	24	15.3	4.7
625	32	17.0	4.5
625	48	20.5	4.5
625	72	22.2	4.8
625	96	28.0	4.6
700	1	31.0	2.7

where d is the density of the scattering phase, Z is the number of electrons per atom or molecule, M is the molecular mass, and N is Avogadro's number.

As is seen from Table 9, $(\Delta \overline{\rho})^2$ experimental values vary in the range of (1.7 to 6.3) × 10⁻⁴ (e/A³)². While the asymptotic value of $(\Delta \overline{\rho})^2$, as calculated with the assumption that all copper introduced into such glass is precipitated as copper chloride crystals, appeared equal to 4 × 10⁻⁴ (e/A³)². One can see that the calculated value is a bit lower than experimentally observed maximum ones. One possible explanation of that discrepancy was suggested by Golubkov and Tsekhomsky,[81]

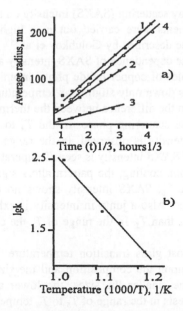

FIGURE 17 Effect of heat treatment on growth rate of photosensitive microcrystals. a) Dependence of microcrystal average radius on exposure time at different temperatures: (1), (4) 625 °C, (2) 600 °C, (3) 550 °C; (1, 2, 3) **CuCl**, (4) **AgCl**. b) Dependence of the growth constant of the photosensitive phase on inverted temperature.

where it was assumed that the scattering inhomogeneities, formed mainly by **CuCl**, also contained some metallic copper (up to 10%). The other explanation can be

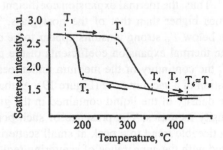

FIGURE 18 Dependence of small-angle X-ray scattering (SAXS) intensity for copper halide glass on temperature.

based on the assumption that the photosensitive phase, when precipitating from the host glass, can be co-deposited together with some other components. Primarily, these can be alkali halides (e.g., **NaCl**), which make the w_l value in Equation (11) rise.

More information on the composition, size, and structural peculiarities of photosensitive inclusions in photochromic glasses was uncovered by the study of the depen-

dence of small-angle X-ray scattering (SAXS) intensity on temperature (Golubkov et al.[81,83-84]). These experiments were carried out in a high-temperature thermostat, according to the technique described by Golubkov et al.[85]

Figure 18 presents the dependence of SAXS intensity at a fixed scattering angle on temperature for samples of copper halide photochromic glasses. In the heating run, SAXS intensity goes down only slightly as temperature rises to T_3. This insignificant decrease is due to the difference between the thermal expansion coefficients of the host glass and the scattering phase. In the T_3 to T_4 temperature range, a significant fall of the intensity is observed. In the range of T_4 to T_6, a slow and almost linear decrease of SAXS intensity is seen. Temperature rise beyond T_6 brings no intensity changes. Upon cooling, the pattern alters significantly. When coming down to the temperature T_6, SAXS intensity shows no changes, while at T_5 an intensity jump is observed. Also a jump in intensity is exhibited at T_2 temperature that is significantly lower than T_3. In the range of T_1 the curves of the heating and cooling runs coincide.

T_6 is close to the host glass transition temperature. The other characteristic temperatures T_i depend upon the composition and the size of the particles of the photosensitive phase. The smaller the sizes, the lower are all the characteristic temperatures. The hysteresis in the range of T_5 to T_6 temperatures cannot be caused by phase transformations and indicates the existence of the other processes at the boundary between the photosensitive phase and host glass.

Golubkov et al.[83] proposed the following explanation for this phenomenon. While the heat treatment of a photochromic glass in the temperature range of 550 to 650 °C, a mixture of liquid immiscible droplets in the plastic host glass is formed. It is known (Lorenz et al.[86]) that the CuCl thermal expansion coefficient at room temperature is $360 \times 10^{-7}\text{deg}^{-1}$, and at 600 °C it is about $(1700 \text{ to } 1900) \times 10^{-7}\text{deg}^{-1}$. While for the host glasses used, the thermal expansion coefficient is in the range of $(60 \text{ to } 300) \times 10^{-7}\text{deg}^{-1}$. Thus, the thermal expansion coefficient of the photosensitive phase is about 10 times higher than that of the host glass. Therefore, when the temperature decreases below T_g, strong tensions appear to be caused by the drastic difference between the thermal expansion coefficients of the phases. This leads us to assume[83] that, at T_5 the continuity of the medium undergoes a break that can be described as the formation of a vacuum pore (Figure 19). At that point tension drops and, consequently, the density of the liquid contained in the glass shell rises somewhat and SAXS intensity increases. The presence of such pores affects the shape of SAXS curves. A noticeable trend to a peak at small scattering angles was found which can be associated with the appearance of scattering regions of lower electron density than the host glass. Rough estimation permits us to assume that such pore size measures about 3 nm and at crystallization temperature of the photosensitive phase, a vacuum pore can expand to some degree.

There are experimental results (Kulinkin et al.[87,88]) describing the effect of hydrostatic pressure on the exciton absorption spectra of microcrystals dispersed in heterogeneous glasses that confirm the hypothesis of glass continuity being broken, or pore creation. It is known that applied pressure shifts the exciton absorption band in the long wavelength direction. The effect of pressure of 23 kbar on the absorption

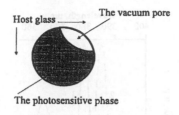

FIGURE 19 Photosensitive inclusion with vacuum pore.

spectrum of **CuI** crystals (T_{melt} = 605 °C) distributed in host glass is shown in Figure 20. One can see a changing absorption pattern and a shift of the exciton absorption band toward the long wavelength region. Similar experiments on glasses doped with **CuCl** and **CuBr** microcrystals show no changes in the exciton absorption spectrum. The latter can be considered evidence of broken continuity in these glasses.

Let us turn our attention to the significant difference in volume variation in photochromic glasses in the process of color center generation in host glass and photosensitive inclusions. Glebov et al.[89] have found that color center generation in common sodium-silicate glasses causes an increase in glass volume. The effect is connected with the relaxation of atoms after electron or hole trapping. This process leads to the stresses appearing in the vicinity of the irradiated volume. It was found that in photochromic glasses, stresses can be obtained if the intrinsic host glass ionization occurs and regular intrinsic glass color centers (described in Section 1.3) are generated. However, after long wavelength exposure when the photosensitive phase is excited and color centers are generated in microcrystals only, no stresses were obtained. The last feature can be considered as evidence in favor of the model when microcrystals do not possess good contact with the host glass and microcrystal volume increase is compensated by vacuum pore shrinking.

A vacuum pore may play an important role in photochemical processes. First, the formation of color centers is promoted under actinic radiation at the "photosensitive phase–vacuum pore" boundary. Second, gas products of the photolysis (halogen molecules) are capable of entering such a pore, thus creating excess pressure that, after irradiation has ceased, will promote the fading process.

Obviously, the temperature ranges T_3 to T_4 and T_1 to T_2 (Figure 18) are connected with photosensitive phase melting and crystallization. Strong hysteresis suggests that photosensitive phase crystallization proceeds from a sharply undercooled state. The trend of microdispersed systems to undercooling causes many defects in the microcrystalline phase and, as a result, enhances photochemical activity. Therefore, it is clear that the photochemical properties of photochromic glasses that have passed through the crystallization stage (T_2 to T_1) are sensitive to a thermal treatment in the range of T_3 to T_4. The annealing of defects occurs at temperatures near T_3, when photosensitive crystals begin melting. It causes a decrease of glass photosensitivity.

It should be noted that relatively fast crystallization of the undercooled liquid may result in precipitation of imperfect and probably polycrystalline aggregates, possibly containing amorphous inclusions. When samples are heated to near the beginning of melting, recrystallization may occur, leading to the growth of separate

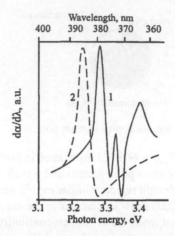

FIGURE 20 Effect of pressure on spectral properties of glasses containing **CuI** microcrystals: (1) 0 kbar, (2) 23 kbar. The absorption coefficient derivative with respect to wavelength ($d\alpha/d\lambda$) laid as ordinate.

crystals and crystallization of the amorphous part of an aggregate. This is accompanied by an experimentally observed increase of SAXS intensity.[83]

Figure 21 shows the dependence of photosensitive crystal melting temperature on the reciprocal average radius of these crystals. This dependence, within the limits of experimental uncertainty, can be described by linear function and the Thompson formula can be applied:

$$T(r) = T_m \left(1 - \frac{2\sigma V}{\Delta h} \frac{1}{r} \right) \tag{13}$$

where T_m is the melting temperature of the bulk sample, σ is the surface tension coefficient, V is the specific volume, Δh is the specific heat of melting, and r is the average radius of a crystal.

The extrapolation of the observed dependence to infinitely large crystals allows us to determine the true melting temperature of a photosensitive phase substance. The latter value obtained on copper halide photochromic glasses with about 0.5% chloride (by synthesis), within experimental error, coincides with the melting temperature of pure **CuCl** crystal. As the chloride content increases in glass composition, as Figure 21 shows, the melting temperature of the bulk phase falls.[83]

Similar data concerning the phase transformations in copper halide glasses can be obtained by the optical method. The absorption coefficient of **CuCl** in the region of the exciton band is about 5 orders of magnitude higher than that of the host glass in the same spectral region.[90] This provides an opportunity to find small volume concentrations of **CuCl** phase in glass and to detect comparatively easily the concentration variations. Nikitin et al.[91] showed that the exciton in **CuCl** crystal possessed high bonding energy and its absorption remained steady without significant quantitative changes up to crystal melting. On the other hand, at crystal melting,

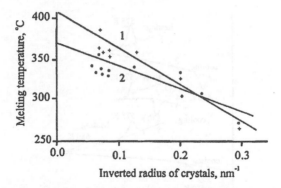

FIGURE 21 Dependence of melting temperature on inverted radius of photosensitive phase in copper halide photochromic glass. Chlorine content by synthesis is (1) 0.5% and (2) 2.0%.

exciton absorption vanishes. Therefore a measurement of exciton absorption represents a very sensitive method for the determination of the melting temperature, crystallization, and other phase transformations in crystals dispersed in a host glass (Figure 22, Podorova et al.[92]).

The methods of SAXS and exciton spectroscopy allow us to make convincing assumptions about phase transformations in heterogeneous photochromic glasses. Nevertheless, alternative explanations of the phenomena discussed above are possible. For example, Gorbatova et al.[93] supposed that the observed drastic changes in exciton absorption seen in Figure 22 were caused not by microcrystal melting and crystallization but by the thermal destruction of excitons.

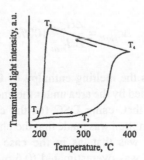

FIGURE 22 Dependence of the transmittance at $\lambda = 380$ nm (hv = 3.26 eV) on temperature for a sample of copper halide glass of 0.1 mm thickness.

Differential scanning calorimetry (DSC), used by Bershtein et al.[94] for the analysis of phase transformations in a photosensitive phase dispersed in glass, allows one to derive more definite conclusions. DSC enables one to find a phase at the earliest stage of its formation (starting with the concentrations of 10^{-3} to 10^{-2} mass %) and to determine the real melting and crystallization temperatures by the location of the extremums corresponding to endothermic and exothermic effects.

Bershtein et al.[94] performed the experiments using a DSC-2 Perkin-Elmer calorimeter. Glasses were heated or cooled in dried nitrogen atmosphere, at rates from

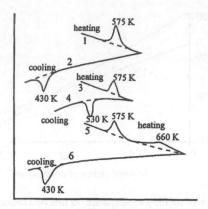

Temperature, K

FIGURE 23 Differential scanning calorimetry (DSC)-curves obtained in different samples of copper halide glass in heating and cooling processes. The sample was treated at 600 °C for seven hours, then: (1–2) cooled at rate of 20 °C/min; (3–6) cooled at rate of 320 °C/min.

2 to 40 K/min in the temperature range of 400 to 700 K. In the compensation channel, as a reference sample, a glass of the same composition that had not previously been exposed to thermal treatment was used, i.e., it was free of the photosensitive phase. The melting and crystallization temperatures of the photosensitive phase in those experiments were determined by the positions of endo- and exothermic peaks (see Figure 23). The concentration of the photosensitive phase c_{phph} in glass can be estimated by the equation:

$$\Delta c_{phph} = \frac{\Delta H_{melt}}{\Delta H_{melt}^0} 100\% \tag{14}$$

where ΔH_{melt}^0 = 103.7 J/g is the melting enthalpy of **CuCl** crystals, and ΔH_{melt} is the melting enthalpy determined by the area under the endothermic peak (Figure 22).

It should be mentioned that, using DSC for the estimation of photosensitive phase concentration, an assumption was made that the photosensitive phase consisted purely of **CuCl**. The result was that, as in the case of the SAXS method, the concentration value obtained was overestimated (0.6 mass %). That provided additional proof that the precipitated phase was of complex composition and contained components other than photosensitive ones, primarily all alkali metal chlorides.

Also, DSC was used to study the annealing and quenching effects on the specific features of the photosensitive phase's structure. The additional advantage of DSC is its ability to measure any glass sample of about 0.2 g weight, while exciton spectroscopy and SAXS methods require polished samples of about 0.1 to 0.2 mm thickness to obtain results with minimized error.

It is known (Araujo and Borrelli[70]) that quenching of a photochromic glass strongly increases its photosensitivity. In order to study the quenching effect, two opposite cases were examined for samples undergoing exposure at 600 °C for seven

hours. The first sample was annealed at the rate of 20 °C/min. The second one was quenched in oil at the rate of 320 °C/min. The results are shown in Figure 23. It should be noted, that the quenched sample, compared to the annealed one, exhibits an extra phase with a higher melting point (endothermic peak at 660 K). If cooling of the sample was started from a temperature below the melting point of that new phase (marked as C in Figure 23), crystallization is observed at T = 530 K. However, if the cooling began from a temperature above that phase's melting point, the crystallization proceeds in the region of T = 430 K. One can assume that T = 430 K corresponds to homogeneous crystallization, while T = 530 K corresponds to heterogeneous crystallization and that a new phase becomes the nucleation center of the process. In the case of annealed samples, the photosensitive phase melting actually is finished at 575 K, while the crystallization proceeds at 430 K according to the homogeneous mechanism.

The revealed effect of annealing and quenching can be explained by redox processes occurring in the photosensitive phase. At quenching, the same redox equilibrium is preserved as at heat treatment. But at slow cooling, the photosensitive phase persists in a liquid state until reaching the crystallization temperature range. Therefore, in this case the redox equilibrium corresponds to the temperature range of the photosensitive phase crystallization. The inclusions being formed at quenching are, in our opinion, the particles of metallic copper resulting from a disproportionation reaction:

$$Cu^+ \Leftrightarrow Cu^{2+} + Cu^0 \tag{15}$$

When the temperature rises, the equilibrium of this reaction is shifted to the right. This conclusion is confirmed by ESR-study of such glasses. In the samples of quenched glasses, the intensity of the ESR signal from double-charged copper is somewhat higher than that in annealed glasses.[92]

4 Spectral Properties of Photochromic Glasses

Experimental study, theoretical description, and mathematical simulation of spectral characteristics play important roles in the creation of materials with variable light transmittance that possess a number of required properties. As was mentioned in the previous sections, darkening of photochromic glasses is a visually observed result of the photoinduced generation of color centers. Therefore, the problems of photochromic glass spectra analysis, the nature of color centers, and the mechanisms of coloration and fading are closely connected. Usually, the first stage of such study is systematic measurement of the absorption spectra in the original glass. The next step is the measurement of photoinduced absorption spectra (as was pointed out in Chapter 2, what is actually under consideration is photoinduced attenuation) and their comparative analysis for different conditions of irradiation. On the basis of that examination, hypotheses are proposed on the mechanisms of color center generation, and on their physical nature, structure, spatial distribution, and evolution with time (the latter problems are discussed in the next section). Next, physical models of color centers are created. These models are used as a basis for mathematical (computer) simulation of the spectral curves. The comparison of the results of computer and natural experiments allows us to understand more exactly the nature and structure of color centers and to predict the behavior of the materials under various operational conditions. In addition, there may be ways of creating new materials with the required properties and of evaluating their characteristics.

Figure 24 shows the absorption spectra of nonirradiated silver halide photochromic glasses, and Figure 25 shows copper halide absorption spectra. It is seen that, in both cases, the edges of absorption spectra of photochromic glasses are shifted toward the long wavelength compared to those of host glasses. This is connected with the absorption by the precipitated phase of silver or copper halides. Measurement of thin samples at low temperature shows narrow bands in absorption spectra (see curves 4, 5 in Figure 24b and curves 5, 6 in Figure 25d). This structure is connected with physical properties of excitons in precipitated microcrystals.

4.1 SPECTRA OF SILVER HALIDE GLASSES

Let us consider in more detail the spectral properties of silver halide glasses. The absorption edge of glasses doped with silver bromide is shifted to the long wavelength region compared to that of silver chloride glasses (Figure 24a). These data agree with the positions of the long wavelength absorption edges for silver halide

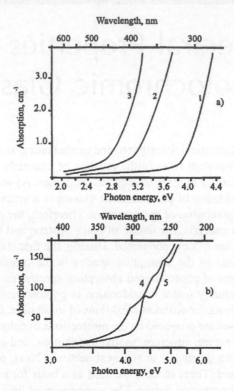

FIGURE 24 Absorption spectra of nonexposed glasses: (1) host glass, (2) doped with silver chloride, (3–5) doped with silver bromide. (1–4) room temperature, (5) temperature is 77 K.

crystals[1] and for photographic emulsions.[94] The absorption spectrum of nonirradiated photochromic glass and the color center generation spectrum may be appreciably affected by different dopants and heat treatment conditions. The latter is due to the strong effect of the time-vs.-temperature schedule of heat treatment on features of the silver halide phase in glass (see Chapter 3).

4.1.1 ABSORPTION SPECTRA OF NONEXPOSED GLASSES

Let us consider the variation of the position of a photochromic glass absorption long wavelength edge depending on heat treatment conditions. Figure 26 shows absorption spectra of 0.5-cm thick samples of photochromic glass doped with **AgCl(Br)** that have been treated under different conditions. For the comparison, the absorption spectrum of the glass in its initial state (before heat treatment) is shown. One can see that increasing the heat treatment temperature causes a shift of the spectra in the long wavelength direction without significant change in their slope. A similar shift of spectra is observed with increasing intervals at constant temperature heat treatment (see Chapter 3).

To discuss the results it is necessary to consider in more detail the structure of photosensitivity regions of heterogeneous photochromic glasses. Tsekhomsky et

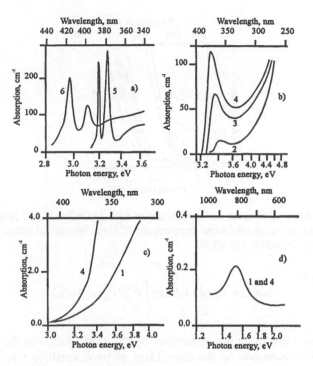

FIGURE 25 Absorption of nonexposed copper doped glasses: a) 4.2 K; b), c), and d) room temperature; a), b) thin samples; c), d) thick samples; (1–5) copper chloride; (6) copper bromide; (1) nontreated; (2–6) treated for 2 hours at T °C: (2) 550, (3) 600, (4) 650, (5, 6) 700.

al.[63,67] pointed out that one of the conditions of creating photochromic properties in those glasses is the ability of phase separation to occur during the process of secondary heat treatment. That enabled Galakhova et al.[96] to assume that the photosensitive component is placed on surface layers in the droplet phase and, when crystallizing, builds a shell around a spherical droplet.

To calculate spectral characteristics of photochromic glasses Dotsenko et al.[97] used a model of a photosensitive microparticle with a surface layer as a spherical shell of silver halide. The mathematical apparatus of the Mie theory, modified for a double-layer spherical particle (see Van de Hulst[98]), was applied to calculate the spectral characteristics of such a center. Optical constants of silver halides and of host glass for the calculations can be found in the relevant reference sources (e.g., James[95] and Demkina[46]). These estimations did not take into account the presence of other dopants (e.g., copper ions) and of possible microdefects in the crystals.

The observed absorption spectrum of a nonirradiated photochromic glass is averaged over the ensemble of photosensitive microcrystals of different size dispersed in a glass host. In various papers $c^*(r)$ distribution was modeled by different functions (Gauss distribution,[97] Gamma-distribution,[99] Lifshitz-Slyozov distribution[78,100]). However, when calculating the absorption spectra of nonirradiated photochromic glasses, one can always use the expression:

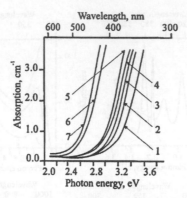

FIGURE 26 Absorption spectra of glasses doped with **AgCl(Br)** before heat treatment 1)
and treated under different conditions (temperature, °C/time, hours): (2) 500/6, (3) 550/1, (4)
550/2, (5) 550/3, (6) 600/6, (7) 650/6.

$$D(\lambda) = D_m(\lambda) + H \lg e \int_0^\omega \sigma_{mc}^{att}(r,\lambda) c^*(r) dr \qquad (16)$$

where the first term describes absorption by the host glass and the second one
describes light attenuation by the assemblage of photosensitive microcrystals. In
Equation (16), H is sample thickness and $\sigma_{mc}^{att}(r,\lambda)$ is the cross-section of light
attenuation (attenuation means absorption plus scattering) by a microcrystal of radius
r. Dotsenko et al.[98] calculated the integral in (16) by the Simpson method in the
wavelength range of 300 to 600 nm at every 10 nm. The cross-sections $\sigma_{mc}^{att}(r,\lambda)$
had been previously evaluated at each measurement wavelength for r in the limits
of 0 to 100 nm, at every 2 nm.

The results of the calculations show a shift of the long wavelength edges of
photochromic glass absorption spectra compared to that of the host glass. This shift
is caused by precipitation of the silver halide microcrystal phase in the process of
secondary heat treatment. At the same parameters of photosensitivity center distri-
bution, the absorption edge of silver bromide doped glass is shifted to the long
wavelength side with respect to that of silver chloride glass in accordance with the
experiment (see Figure 24).

The conditions of secondary heat treatment determine the size distribution of
photosensitive microcrystals. Hence, the parameters of that distribution are functions
of heat treatment temperature T and time t. For example, with increasing T or t, the
average radius increases and the average concentration decreases correspondingly.
Therefore, it is important to see the effect of the parameters of the microcrystal
distribution function on the absorption spectrum. The results of the calculations
showed that both the increase in the average radius of photosensitive microcrystal
distribution at constant dispersion and the dispersion at the constant average radius

FIGURE 27 Calculated attenuation spectra of nonirradiated photochromic glass doped with AgCl microcrystals. Computer simulation of shell model of absorbing centers considering double Gaussian distribution in inner and outer radii. Dispersion of radius is 3 nm, radius is, nm: (1) 0, (2) 3, (3) 5, (4) 10, (5) 15, (6) 20, (7) 25, (8) 30, and (9) 50.

shift the absorption edge toward the long wavelengths (Figure 27). The slope of the curves does not vary in either case. Similar behavior of the absorption spectra is observed experimentally at rising temperature or time of heat treatment of glass (see Figure 26). The calculations of the spectra were carried out for constant volume fraction of the crystalline phase:

$$V = \frac{4}{3} \pi \int_0^\omega r^3 c(r) dr \qquad (17)$$

This condition imposes certain restrictions on the parameters of distribution. Physically, that corresponds to the consideration of the recondensation stage,[76] when redistribution only of the crystalline phase takes place.

It should be noted that the absorption edge of a photochromic glass before heat treatment (curve 1 in Figure 25) is shifted to the long wavelength end with respect to that of the host glass, i.e., of glass which is similar but free from photosensitive additives (curve 1 in Figure 26). According to results given by Barachevsky et al.,[101] the shift is caused by the absorption of copper introduced into the host glass.

4.1.2 Spectra of Photoinduced Absorption

The photoinduced absorption spectra of irradiated photochromic glasses doped with either silver bromide or silver chloride present broad bands that cover almost all visible spectra, with the maximum in the range of 500 to 600 nm (2.5 to 2.1 eV, Figure 28, see Barachevsky et al.[101]). The induced absorption in glasses doped with

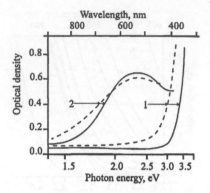

FIGURE 28 Absorption spectra in silver halide photochromic glass. (1) Nonexposed glass, (2) exposed glass. Solid lines = doped with silver chloride, dashed lines = doped with silver bromide. Samples thickness is 5 mm.

Br extends to a longer wavelength than that in pure **Cl** glass (see Airapetyants et al.[52]).

In the process of coloration, the photoinduced optical density grows evenly over the whole spectrum and the absorption band maximum shifts a bit in the long wavelength direction. At fading in darkness, the reverse "drift" of the photoinduced absorption spectrum is observed (Figure 29). Consequently, fading of photochromic glasses may be followed by visually observed changes in their color. For example, Glimeroth and Mader[64] pointed out that at relaxation of one glass (namely, number 2), its color changed from blue to pink. The same drift of photoinduced spectra is typical for the fading process of silver halide single crystals.[4]

To clarify the nature of color center generation the analysis of the effect of temperature both on the photoinduced absorption spectrum of colored glass and on the process of coloration was carried out (Figure 30).[52] It was found that the photoinduced absorption spectrum depends on the temperature of exposure but does not depend on the temperature after cessation of exposure (in the absence of fading). Temperature of exposure affects the value of photoinduced absorption also. For silver chloride photochromic glasses, the maximal coloration is achieved at temperatures of −10 to −30 °C, while for silver bromide glasses — at room temperature. When the temperature is raised, the efficiency of thermal fading increases. At temperatures above 80 °C, most photochromic glasses do not respond to actinic irradiation at all.

The comparison of silver halide photochromic glasses, silver halide single crystals, and photographic emulsions allows one to conclude that it is the silver halide microcrystalline phase that is responsible for photochromic processes in glasses. Summarizing the major results of that analysis, we point out the following items:

a) the position of the maximum and the shape of the absorption bands of irradiated photochromic glasses and of silver halide single crystals are identical[52]

b) the low-temperature luminescence spectra of both materials are identical[103]

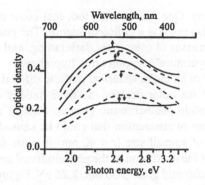

FIGURE 29 Varying photoinduced absorption spectra of silver chloride glass in processes of coloration (solid lines) and fading (dashed lines). Samples thickness is 5 mm.

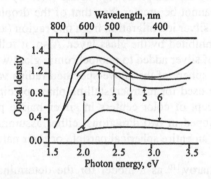

FIGURE 30 Photoinduced absorption spectra of photochromic glass doped with **AgCl** exposed at different temperature, °C: (1) –110, (2) 52, (3) –10, (4) –6, (5) +4, (6) +27. Sample thickness is 5 mm.

 c) when changing from chloride to bromide, the absorption spectrum edge of nonirradiated photochromic glasses shifts to long waves,[52] such as occurs in pure silver halides and photographic emulsions[4]

 d) optical bleaching under the visible light exposure is observed in photochromic glasses that is similar to the well-known Herschel effect for silver halide crystals (see Moser et al.[104])

 e) as in silver halides,[105] small amounts of copper enhance the sensitivity of silver halide photochromic glasses[102,103]

We should also note that the presence of the silver halide microcrystalline phase in photochromic glasses was determined by X-ray diffraction structure analysis by Bach and Glimeroth.[106] Differential scanning calorimetry (DSC) analysis carried out by Bershtein et al.[94] also provides evidence that a microcrystal phase exists in the glass.

It is known that the color centers that appear in silver halides under light illumination and produce the broad absorption band in the visible region are colloidal

particles of metallic silver. One can assume, too, that color centers in silver halide photochromic glasses also possess a colloidal nature. The photoinduced absorption spectrum drift in the processes of coloration, dark fading, and optical bleaching, and its independence of temperature[52] supports this hypothesis.

However, the model of an entire spherical particle offered by Hilsch and Pohl[107] and by Savostyanova[108] for color centers in silver halides cannot be transferred immediately to silver halide photochromic glasses. First, it appears that the main maximum in the spectrum of attenuation that could be caused by an entire metallic silver spherical particle of a small size ($r < 40$ nm) in glass does not coincide with the spectral placement of the maximum of the photoinduced absorption experimental band of irradiated photochromic glass (550 nm, 2.25 eV, Figure 28). The assumption of a significant number of larger metallic silver particles in irradiated glass does not agree with the experiment. The problem is that the average radius of photosensitive particles, according to Smith,[48] lies in the interval of $2.5 < r < 15$ nm (the data obtained by other authors are compiled, e.g., in the work by Filippov et al.[109]). The size of a color center cannot be greater than that of the droplets filled with photosensitive phase because silver ion migration from one region (an immiscible droplet) to another is strongly inhibited by the glass layer. Also, it follows from our evaluations that the amount of silver added to photochromic glass would not be sufficient to completely fill every sphere of the above-specified radius values (even assuming that all silver atoms are used for microcrystalline phase precipitation only).

Therefore, the concept of color centers in silver halide photochromic glasses may generally be developed in two directions: either assuming the centers have a structure different from an entire spherical particle or their nature differs essentially from the colloidal one.

Dotsenko and Zakharov,[110] as a model for the determination of color center spectral characteristics in photochromic glass, suggested a shell model, i.e., a vitreous nucleus (either silver halide or a certain combination of alkali and silver halides) that is covered by a spherical shell of metallic silver. As a specific feature of practical importance, such a model provides the opportunity for precise calculations of the cross-section of light absorption and scattering by a single color center with the following determination of the photoinduced spectrum, $\Delta D(\lambda)$, of a photochromic glass by means of averaging over the ensemble of color centers of different sizes:

$$\Delta D(\lambda) = H \lg e \int_0^\omega \sigma_{cc}^{att}(r, \lambda) c(r) dr \tag{18}$$

The work[110] seems to be the first example of an application of the Mie theory to the description of optical properties of glasses containing microscopic inclusions of a different nature. Also, the idea of using the Mie theory and its generalized modifications (e.g., for the cases of particles of sophisticated shapes or of semiconductor microcrystalline phase, etc.) were successfully developed in numerous works on photochromic, polychromatic, heterogeneous magneto-optical, and impregnated porous glasses.

The Mie theory applied to double-layer particles was used for the calculation of the cross-sections. Optical constants of silver were taken from the work by Johnson and Christy[111] and then modified by consideration of the known size effect, which is connected with the restriction of electron free run length (Kawabata and Kubo[112]). The result of the calculations (see Figure 31) provided a correct estimate of the position of the main maximum (550 to 600 nm, 2.25 to 2.1 eV) and the halfwidth (0.6 to 0.9 eV) of the absorption bands.

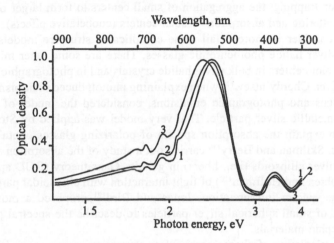

FIGURE 31 Calculated photoinduced attenuation spectra of 5-mm-thick photochromic glass doped with AgCl microcrystals. Computer simulation of shell model of color centers considering double Gaussian distribution in inner and outer radii. Radius is 20 nm; the dispersion of radius is, nm: (1) 2, (2) 5, (3) 10.

Together with the main peak, a secondary maximum was predicted in the calculated photoinduced absorption spectra in the region of 360 to 380 nm (3.45 to 3.25 eV, Figure 31). This maximum was also found experimentally by Moriya[113] and Bennert.[114] In order to clear up the question of whether both maxima are independent with respect to each other, in the work of Bennert and Hempel[114] the glass was irradiated by light of various wavelengths. It appeared that even the longest-wavelength actinic radiation induced both absorption peaks. At optical bleaching, the destruction of only one of the peaks without bleaching the other also proved impossible. The results of these experiments allow one to attribute those two maxima to color centers of the same nature and are in agreement with the results of the above-mentioned calculations.

Another attempt to model photoinduced absorption spectra is the expansion by Abramov et al [115] of the concepts of quasimetal centers that were developed earlier for ionic crystals (particularly for silver halides, by Adamyan and Glauberman[116]) to the color centers of silver halide photochromic glasses. Considering briefly the model of quasimetal centers we should note that in the relevant works the problem of interaction between quasimetal centers and the real structure of nonirradiated photochromic glass was not discussed. All calculations[116] presented are usable either

for a single quasimetal center or for the assemblage of centers isolated from each other. One can assume that in a bulk silver halide single crystal quasimetal centers are really separated from each other. However, for the case of photochromic glass it should be clarified why just a sole quasimetal center of small size is formed in a silver halide particle of typical size of 10 to 20 nm. If each photosensitive microcrystal generates several quasimetal centers, it is necessary to take into account the interaction between them, the effects on both quasimetal centers (competition for photoelectron trapping, the aggregation of small centers to form larger ones, etc.), and light scattering and absorption by such centers (cooperative effects).

Let us consider in more detail some complicated structure models of color centers in silver halide photochromic glasses. There are some other microscopic models of color centers in bulk silver halide crystals and in photographic materials based on silver. Cherdyintsev,[117] when explaining photoinduced dichroism in silver halide crystals and photographic emulsions, considered the model of an entire ellipsoidal metallic silver particle. That very model was applied by Stookey and Araujo[118] to explain the absorption spectra of polarizing glasses containing colloidal silver. Skilman and Berry[119] carried out a study of the absorption spectra of elongated silver ellipsoids (i.e., fibers) in gelatin. Gans theory (RGD approximation, see Bohren and Hoffman[120]) of light interaction with ellipsoidal particles was used for the spectra interpretation. Jones and Bird[121] proposed a model of an aggregation of small spherical silver particles to describe the spectral properties of photographic materials.

For the calculation of photochromic glass absorption spectra, a model of ellipsoidal metallic silver particles[122-124] was proposed. In particular, Anikin et al.[122] applied the model to the qualitative consideration of photoinduced dichroism. Moriya,[123] according to Gans theory, calculated the spectra of attenuation by such particles in order to interpret the experimental spectra of photoinduced absorption presented in Byurganovskaya et al.[13]

Nolan et al.[125] offered a model of a fragment of a colloidal silver shell on the surface of a silver halide particle. In view of the complex shape of the simulated particle, the algorithm computation of the model was not trivial (Seward[126]). The results obtained were in good agreement with the experimental positions of two maxima. One can fit the values of absorption band halfwidth with the experimental ones by taking into account colloidal segment distributions over thickness and radius (or body angle).

In the case of natural (nonpolarized) radiation, it is assumed that the orientation of color centers of anisotropic shape is random, so the attenuation coefficient can be calculated as[125]:

$$\alpha = \frac{1}{3}\alpha_{\parallel} + \frac{2}{3}\alpha_{\perp} \qquad (19)$$

where α_{\parallel} is the attenuation coefficient when the electric vector is directed normally toward the sphere and α_{\perp} is the attenuation coefficient when the electric vector is tangential.

Let us now attend to a more complicated model that actually considers photochromic glasses as a dual heterogeneous medium. Here is implied the model of an incomplete metallic shell offered by Dotsenko et al.[127] In the simplest case, this model can be imagined as an assemblage of small spherical metallic particles placed in the subsurface region of a particle of the photosensitive phase in photochromic glass. One of the limiting cases of this model of a color center as a noncontinuous shell is the model of noninteracting small metallic particles, i.e., the metallic shell model considered above.

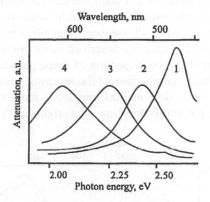

FIGURE 32 Calculated photoinduced attenuation spectra of photochromic glass in the frame of model of discontinuous shell color centers for different volume fraction of silver in the shell, θ: (1) 0.01, (2) 0.2, (3) 0.4, and (4) 0.6.

When talking about a dual heterogeneous medium we mean two levels of heterogeneity. The first is the host glass with inclusions of the crystalline phase. The second is the host crystal with inclusions of metallic silver. Then, a silver halide microcrystal containing small silver particles can be considered an optically homogeneous medium with effective complex dielectric permeability ε_{ef}. Depending on the metal volume fraction, different theoretical approaches can be used for its determination. For instance, in reference 127, the widely known Maxwell-Garnett formula was applied:

$$\frac{\varepsilon_{ef} - \varepsilon_m}{\varepsilon_{ef} + 2\varepsilon_m} = \Theta \frac{\varepsilon - \varepsilon_m}{\varepsilon + 2\varepsilon_m} \qquad (20)$$

where ε is the complex dielectric permeability of the metal and ε_m is the dielectric permeability of the relevant halide. Of course, in the calculations the spectral dispersion of all optical constants was involved, and dimensional corrections for ε of the metal were introduced. Then the cross-sections of light absorption and scattering by microinclusions of various sizes were counted as they were earlier. Then, using Equation (19), a photoinduced absorption spectrum of photochromic glass was simulated. The model allows us to describe photoinduced spectra of photochromic glasses (Figure 32) and the trends of their variations depending on the conditions of

heat treatment. The concepts considered together with the relevant computer software can be easily generalized for exposure and bleaching by polarized light. For that, it is enough to consider small ellipsoids instead of small silver particles in the computation of the effective optical constants. So, we can state that, despite a certain difference in the approaches, the models developed by different scientific schools show certain similarity.

One can see that a number of models allow us to explain the appearance of two peaks in photoinduced absorption spectra in terms of the concepts of colloidal color centers. Moreover, they enable us to obtain the correct position of the main (i.e., long wavelength) maximum, which is impossible when the model of an entire spherical particle is applied. After all, the experimentally observed halfwidth of the main absorption band can be plausibly described in the frames of a number of the models by taking into account the dispersion of shape parameters of color centers. However, for the quantitative comparison of the results of computer simulation with those of actual experiments, additional information is required on the specific features of photolytic silver particle distribution in an original silver halide microcrystal.

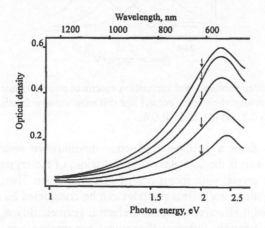

FIGURE 33 Effect of optical bleaching at 632.8 nm (1.96 eV) on the photoinduced absorption spectrum of photochromic glass. Arrows show the wavelength of bleaching radiation. Sample thickness is 5 mm.

4.1.3 EFFECT OF OPTICAL BLEACHING ON PHOTOINDUCED ABSORPTION SPECTRA

Important information can be obtained from the study of optical bleaching to select the right model for color centers in silver halide photochromic glasses. However, experimental results differ. The cause of the difference in the experimental results is not clear, but it should be noted that the data described below were obtained on photochromic glasses of various brands and possibly under essentially different conditions of photoinduced coloration and bleaching.

It was noted in reference 52 that when photochromic glass doped with silver bromide was bleached by monochromatic radiation ($\lambda = 632.8$ nm, 1.96 eV), as well as faded in darkness, the absorption gradually decreases over the whole spectral range and the maximum of the photoinduced absorption band moves toward short wavelengths (Figure 33). Thus, there is no significant bleaching in the spectral region near the exciting radiation wavelength that is typical for the photoinduced color center bleaching in silver halide crystals.[4]

Other authors[124,126,128] found a phenomenon they called color adaptation (or "photoburning"). This phenomenon is explained by the fact that the fraction of particles whose absorption maximum is situated near the wavelength of bleaching light is destroyed more rapidly than the others. It causes a spectral dip to appear near that wavelength.

It is known that exposure of previously irradiated photographic emulsion to red light causes destruction of the latent image (Herschel effect). This phenomenon was explained (Hamilton[105]) by electron photoemission from the center of the latent image into the conduction band of the silver halide crystal. To interpret the phenomenon of optical bleaching, Borrelli et al.[128] proposed a mechanism that developed Mott's concepts to explain the Herschel effect in photographic emulsions.[94] According to the presumption of Borrelli et al.,[128] it is the first stage, when the collective excitation of silver electron plasma takes place, that is specific for the similar mechanism for colloidal silver particles in photochromic glass. Then the excitation is transferred to the state of a single electron with the energy high enough for its excitation to the conduction band of the original silver halide particle.

The above-mentioned model proposed by the Corning research group[125,126,128,129] to interpret colloidal silver color centers of anisotropic shape allows us to study polarization phenomena in the bleaching process. As was already mentioned, in the case of nonpolarized coloration, anisotropic colloidal silver color centers exhibit a random orientation. Further, it was proposed that, under exposure to polarized long wavelength radiation, mainly those centers are destroyed whose orientation coincides with the direction of the polarization of the bleaching beam. This hypothesis was confirmed in a set of experiments carried out by the same researchers on the kinetics of dichroism under various combinations of actinic UV and probing visible polarized radiation.

We should dwell on one more interesting effect that was first described by Borrelli et al.[128] and that could be named "the effect of the memory of former photoinduced anisotropy." The experiment implied that previously a photochromic glass was exposed to polarized light that caused dichroism. After that, dichroic coloration was destroyed thermally up to complete restoration of the initial (nonirradiated) state. Finally, under nonpolarized UV irradiation, the glass exhibited that its dichroism was restored. In other words, the visually colorless photochromic glass remembered its optical prehistory.

We will come back to the peculiarities of the long wavelength effect in Chapter 7 when comparing photochemical processes in bulk and in waveguide surface layers of photochromic glass.

4.2 SPECTRA OF COPPER HALIDE GLASSES

In recent decades, rapid and diversified development has proceeded in the field of investigation and creation of silver-free photographic materials.[130,131] This is motivated primarily by the scarcity and high price of silver. However, it has turned out that silver halide materials are not always the best ones for new applications. One can see these trends in holography, polygraph engineering, microfilming, and a number of other applications of photosensitive materials.

In the late 1970s an interest emerged in the development of silver-free photochromic glasses. Attempts were undertaken to use various activators, but only copper halides as the photosensitive component produced results of practical importance. At present, a good deal of investigation has been done on that type of glass. A number of glass compositions has been developed for ocular lens manufacturing. Research has been started into the technology of flat photochromic glass production for use in vehicles and buildings.

4.2.1 ABSORPTION SPECTRA AND ELECTRONIC STRUCTURE OF NONIRRADIATED GLASSES

Ekimov et al.[90] were the first to show that **CuCl** microcrystals, which have typical exciton absorption, were responsible for the specific features of copper halide photochromic glasses. Two exciton bands appearing in the absorption spectrum of nonirradiated photochromic glasses is convincing evidence of microcrystal phase precipitation in the host glass. A high level of bulk **CuCl** crystal exciton absorption (5×10^4 cm^{-1}) allows us to detect very small amounts of the phase precipitated in the host glass. On the other hand, a comparatively low volume of **CuCl** phase distributed over a rigid inorganic vitreous host opens new opportunities for the thorough study of the nature of exciton absorption and its responses to various factors. The formation of the microcrystalline phase in a dielectric host with wide band gap, besides absorption, also causes light scattering that is due to a dielectric permeability mismatch at the boundary between the microcrystal and glass phases.

It has been pointed out that thermal treatment of copper halide glasses causes the crystalline phase precipitation and two sharp absorption lines to appear at the long wavelength edge of the absorption spectrum (Figure 25d). Comparison of the parameters of these bands (placement of maxima, ratio of absorption coefficient, etc.) with parameters of the absorption bands in relevant crystals **CuBr** and **CuCl** confirms the exciton nature of this absorption. The exciton type of absorption spectra of copper halide microcrystals in photochromic glasses persists as temperature rises to room temperature. At that point, a broadening of exciton absorption bands is observed that is caused by electron–phonon interaction, and by the bands shifting to the long wavelength end of the spectrum. As was shown by Vasilev et al.[133] and Valov et al.,[134] at temperatures above 150 °C, the Z_3-band disappears from the exciton absorption spectra of **CuCl**-containing glasses.

It has been shown by Ekimov et al.[132] that the parameters of exciton absorption of copper halide microcrystals depend essentially on their size. The observed shift of the exciton bands in the short wavelength direction at decreasing microcrystal

size attains the values of 0.06 eV for **CuCl** and 0.02 eV for **CuBr**. It has been shown that the changes in the exciton spectrum become essential in the microcrystal size range less than 10 nm, i.e., when the radius of microcrystals becomes comparable with that of excitons (see the data obtained by Goldman et al.[135]).

The work by Ekimov et al.[132] shows that the short wavelength shift of exciton absorption bands of copper halide microcrystals depends linearly on the reciprocal average squared radius of microcrystals in a wide range of their size variation (Figure 34). The results obtained reveal the presence of quantum size effect of semiconductor microcrystals dispersed in photochromic glasses. It has been found that when microcrystal radius reaches more than 1.5 to 2 nm, the shift of the exciton bands is caused by quantum size effect of the movement of an exciton as a whole. In the region of ultra-small microcrystals ($r_{ex} < r < 3r_{ex}$, where $r_{ex} \approx 0.7$ nm for **CuCl** and $r_{ex} \approx 1.5$ nm for **CuBr**, see Levonchuk et al.[136]), the short wavelength shift of the exciton bands is far more than the value that could be expected at quantum size effect of an exciton as a whole. The observed effect was explained by Efros et al.[137] in terms of a donor-like exciton model that supposes a localization of a heavy hole caused by its Coulomb interaction with the distribution of electron density distorted by microcrystal walls.

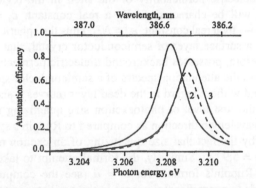

FIGURE 34 Spectra of the attenuation efficiency factor for **CuCl** microcrystals in accordance with the approach developed in reference 136 (1, 2) and Ruppin theory (3): (1) microcrystal radius $b = 6.6$ nm; (2) microcrystal radius $b = a + d = 6.6$ nm, dead layer thickness $d = 0.7$ nm; (3) microcrystal radius $a = 5.9$ nm.

Here we would like to discuss a number of works devoted to the effect of the dead layer on the absorption spectrum of an exciton under quantum size effect in a semiconductor sphere. Hopfield and Thomas[138] were the first to show that the consideration of the dead layer for Vanier-Mott excitons of large radius at the boundary of a half-infinite single crystal allows one to describe principally new non-classic features in the reflection spectra. In particular, near the reflectance minimum, a sharp though not high peak was observed experimentally. Pekhovsky and Dotsenko[139] have developed a theory to study the effect of the dead layer on the absorption spectrum of an exciton of small Bohr radius a_{ex} (the Frenkel exciton) under quantum size effect in a semiconductor sphere. As a macroscopic parameter of a semiconductor sphere, we use the dielectric permeability of an infinite crystal

$\varepsilon_{bulk}(\omega,k)$ that can be described for semiconductor crystals of cubic lattice in the vicinity of an isolated simple exciton band, considering the spatial dispersion, by the Lorentzian contour (see Pekhovsky et al.[139]):

$$\varepsilon(\omega,k) = \varepsilon_\omega \left(1 - \frac{\Delta E_{LT}}{E_T - \hbar\omega + Uk^2 - i\Gamma} \right) \qquad (21)$$

where: ΔE_{LT} is the longitudinal-transverse splitting, E_T is the bottom energy of the exciton sub-band, $U = \hbar^2/2M_{ex}^*$ (M_{ex}^* is the effective mass of the exciton), Γ is the resonance halfwidth, and ε_ω is the short wavelength contribution to the dielectric permeability. The values of the parameters involved in Equation (21) for a 1s-exciton of bulk CuCl single crystal can be taken from the work by Masumoto et al.[140]: $\varepsilon_\omega = 5$, $M_{ex}^* = 2.1m_0$, $\Delta E_{LT} = 0.0055$ eV, and $E_T = 3.2025$ eV.

Using Equation (21) imposes the bottom limit on the radius of a semiconductor sphere $a \gg a_{ex}$ (where a_{ex} is the Bohr radius of an exciton). So the only case under consideration is when quantum size effect of 1s-exciton as a whole takes place in the sphere. The dielectric permeability of the shell in the region of the exciton resonance energy will be characterized by a real constant, $\varepsilon_d = N_d^2$, and that of transparent matrix — by a real constant, $\varepsilon_m = N_m^2$. Thus the spherical shell represents a dead layer, i.e., a surface layer of semiconductor crystal, that is inaccessible to excitons and, therefore, possesses background dielectric permeability, $\varepsilon_\omega = \varepsilon_d$.

Figure 34 shows the attenuation spectra of a semiconductor sphere of the radius $b = 6.6$ nm with and without regard to the dead layer (curves 2 and 1, respectively). One can see that the first level of photoexciton size quantizing undergoes a large shift to the short wavelength direction as compared to Ruppin's spectrum (curve 1). This is explained by the fact that size quantizing of an exciton now proceeds in a sphere of radius $a = 5.9$ nm. Similarly, the formal attempt to take into account the dead layer using Ruppin's formula for $b = a$ (see the computer simulation in reference 139) leads to a significant decrease in the oscillator strength of the optical transition to the first exciton level of the exciton size quantizing (curve 3).

To estimate the dead layer thickness in CuCl microcrystal for Z_3-exciton, one can proceed from the work by Ekimov et al.,[132] where, on the basis of a 6-band Hamiltonian, the theory of quantum size effect was developed for Schroedinger $Z_{1,2}$ and Z_3 excitons in a spherical CuCl microcrystal and, in particular, a nonparabolic type of Z_3-exciton sub-band having undergone a spin-orbital split-off was taken into account. Applying the theoretical results of the work[132] to the consideration of the exciton dead layer, we will express the shift of Z_3 band maximum in the form:

$$\Delta E_{Z_3} = 0.67 \frac{\gamma_1 \hbar^2 \pi^2}{2m_0(\delta^* - d_{Z_3})^2} - \frac{0.46}{\Delta^*}\left(\frac{\gamma \hbar^2 \pi^2}{m_0(\delta^* - d_{Z_3})^2} \right)^2 2\left(1 - \frac{6}{\pi^2} \right) \qquad (22)$$

and the shift of Z_2 band maximum in the form:

$$\Delta E_{Z_{1,2}} = 0.67\hbar^2 \frac{\gamma_1 - 2\gamma}{2m_0(\delta^* - d_{Z_{1,2}})^2} (\Phi_1)^2 \tag{23}$$

In Equations (22) and (23), γ_1 and $\gamma_1 = m_0/M_{ex}^*$ are Luttinger constants, $\Delta = 70$ meV is the value of spin-orbital splitting, δ^* is microcrystal average radius, Φ_1 is the first root of the transcendental equation:

$$j_2(\phi)j_0(\phi\eta^{1/2}) + j_0(\phi)j_2(\phi\eta^{1/2}) = 0 \tag{24}$$

where $j_l(x)$ is Bessel spherical function, $\beta = \gamma_1 - 2\gamma/\gamma_1 + 2\gamma$, and $d_{z_{1,2}}$ are the thickness of the dead layers for $Z_{1,2}$ and Z_3 excitons, respectively.

It is clear that information about the electronic structure of the photosensitive phase plays an important role in understanding photoinduced processes in heterogeneous photochromic glasses. Mathematical models of the molecular cluster and quasi-molecular extended elementary cell (QEEC), in an approximation of complete neglect of differential overlapping (CNDO), are widely used for calculations of the electronic structure of perfect crystals of silver and copper halides.

Ermoshkin et al.[141,142] applied this approach to estimate the electronic structure of the photosensitive phase in photochromic glass which was assumed to be a silver halide crystal doped with monovalent copper. Their results show that a single cuprous ion in the silver chloride or silver bromide crystal creates the local energy levels with symmetry e_g and t_{2g} which are placed in the crystal bandgap. This means that cuprous ion can be ionized by optical excitation with photon energy less than the value of the crystal bandgap. These data convincingly confirmed the assumptions that were stated in a number of publications[143-147] that cuprous ions can be considered hole traps in the photosensitive phase of the silver halide.

The energies of the additive levels e_g and t_{2g} were calculated for silver bromide as 0.19 and 0.71 eV and for silver chloride as 0.23 and 0.78, respectively. It should be noted that the wave functions of the additive levels contain both d-atomic orbitals of copper and p-atomic orbitals of neighbor halide ions. Moreover, Ermoshkin et al.[141, 142] evaluated the effect of the interaction between cuprous ions in the silver bromide crystal in the framework of the mathematical model of periodic defects. It was found that for the ratio of the number of cuprous ions to the number of silver ones of Cu/Ag = 1/7 this interaction leads to the creation of the additive bands with width of 0.4 eV. For Cu/Ag = 1/3 the additive bands overlap with the intrinsic bands of the AgBr crystal. These estimations are in accordance with the data of the copper content effect on the rate of photochromic processes (See Chapter 6, Section 6.2.4).

4.2.2 NONLINEAR ABSORPTION

Apparently the first experiments on nonlinear absorption of CuCl crystals with quantum size effect were carried out in 1988 by Itoh et al.[148] and Woggon et al.[149] Exploiting a single-beam measurement design, where actinic radiation worked at the same time as the probing one, did not allow the authors to examine in detail the

configuration of the absorption spectrum of an excited sample. However, those experiments determined that the excitation at the exciton band maximum resulted in considerable decrease in the absorption at pumping frequency and strong displacement of the absorption peak. In the subsequent works by Masumoto et al.[150] and Gilliot et al.[151] the shifting of the exciton band for intense monochromatic pumping was studied in detail using independent radiation sources for sample excitation and probing.

Figure 35 shows the absorption spectra variation when glasses doped by microcrystals with different diameters are examined at the same pumping power (from Gilliot et al.[151]). In all these cases the short wavelength shift of the exciton band under optical pumping is connected with the interaction of a finite number of excitons in the system. The experimental results agree well with theoretical concepts described thoroughly by Bellegie and Banyai.[152] For $d = 12$ nm, the average number of excitons in one microcrystal is between 2 and 10 depending on pumping power, whereas for $d < 5$ nm no more than two excitons are generated. This is the main reason for the different sensitivities of absorption spectra on high power optical illumination. It is interesting that there was observed a correlation of the transmittance dependence, $t(d)$, for **CuCl** microcrystals in **NaCl** host crystal vs. light intensity, $I^*(d)$, at which nonlinear effects become observable in **CuCl** microcrystals dispersed in glass (Figure 33). This is evidence that excitons' lifetime is defined by radiation processes in the vitreous host.

When systems with inhomogeneous broadening are exposed to high intensity monochromatic actinic radiation, dips may appear in the absorption spectrum at excitation frequency. For such dips to be observable, the following condition should hold:

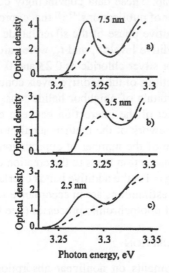

FIGURE 35 Absorption spectra at 80 K of glasses doped with **CuCl** microcrystals of different size. Solid lines = original samples. Dashed lines = samples under exposure to 100 MW/cm² excitation at the maximum of the Z_3 band.

$$\Gamma_{las} \ll \Gamma_0 \ll \Gamma_{inhom} \qquad (25)$$

where Γ_{las} is the width of the exciting radiation line, Γ_0 is the homogeneous width of the exciton band in a crystal, and Γ_{inhom} is the value of inhomogeneous broadening of exciton absorption in glass. One can suppose that in reference 150 for relatively large samples spectral dips were not obtained because the right side of Inequality (25) was not satisfied. Zimin et al.[153] used relatively broad-band pumping radiation ($\Gamma_{las} > 1$ meV), and the left side of Inequality (25) possibly was not satisfied.

Selective photoburning of narrow spectral dips in **CuCl** crystals was observed by Wamura et al.[154] and by Kippelen et al.[155] at nano- and picosecond pumping using narrow-band exciting radiation ($\Gamma_{las} < 0.1$ meV). It turned out that crystals with quantum size effect had an extremely small homogeneous width of the exciton absorption band. Γ_0 did not exceed 1 meV for $d = 2.5$ nm and decreased with size growing according to d^{-2} function. The dependence of $\Gamma_0(d^{-2})$ was interpreted by Wamura et al.[154] as a result of the exciton being scattered by a microcrystal surface. It should be noted that in these experiments[154] there was no broadening of the dip in the absorption spectrum even as intensity increased by more than an order of magnitude. This allows one to state that the bleaching under monochromatic excitation in **CuCl** microcrystals distributed in dielectric host glass is not simple absorption saturation in an ensemble of two-level systems. Deviations from this model may be caused by: different contributions from exciton–exciton interactions at various pumping; size and intensity dependencies of the lifetime and the time of phase relaxation of excitons; photoionization of microcrystals by generation of defects or, on the other hand, by annealing of defects at optical excitation.

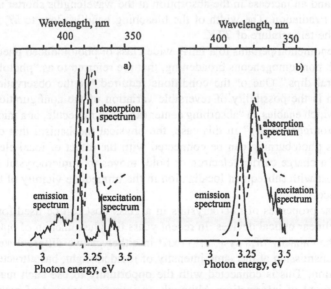

FIGURE 36 Optical spectra at 77 K of glass doped with **CuCl** microcrystals with average radius of 15 nm (a) and 2.5 nm (b).

The comparison of the data on photoluminescence excitation spectra and on nonlinear absorption in the exciton band of **CuCl** microcrystals grown in host glass (Figure 36) and in **NaCl** host crystal[148] enables one to find an interesting peculiarity connected with the phase separation boundary between host and microcrystal. Borosilicate glass containing the **CuCl**-phase shows no bleaching in the exciton band if the energy of exciting radiation quantum $h\nu_{exc}$ corresponds to that of interband absorption. The spectrum of Z_3 luminescence excited in glass is also characterized by a drop at $h\nu_{exc} \rightarrow E_g^0$. At the same time, **CuCl** microcrystals in **NaCl** host crystal are effectively bleached at interband pumping[150] and do not perform any specific features in exciton luminescence spectra at $h\nu_{exc} \rightarrow E_g^0$ (Itoh et al.[148]). The difference in the properties of microcrystals of the same compound placed in different hosts can apparently be explained by the height of the potential barrier, that is different for electrons and for holes, and also by the structure of the host–microcrystal phase separation boundary (Gaponenko et al.[156]). Thus, **CuCl** microcrystals in **NaCl**, unlike those in glass, are shaped like parallel pipes built into an **NaCl** lattice (Itoh et al.[157]), whereas in a vitreous host, as was already mentioned, microcrystals are more isolated owing to vacuum pores.

Naoe et al.[158] found that upon long exposure of copper halide glasses to monochromatic irradiation at the wavelength of exciton absorption the absorption spectrum shows changes that remain stable for a long while. At liquid nitrogen and lower temperatures the changes in the absorption spectrum remain for tens of minutes and vanish as the temperature rises or under illumination by light of a wide spectrum. A typical pattern of a differential absorption spectrum is given in Figure 37. The main specific feature of a differential spectrum is a bleaching at the irradiating light wavelength and an increase in the absorption at the wavelengths shorter and longer than that of irradiation. The width of the bleaching band is close to kT, i.e., about 10 meV at the temperature of 77 K.

This phenomenon pertains to a fairly wide class of photoinduced phenomena in systems with nonhomogeneous broadening, that are referred to as "photoburning of stable spectral dips." One of the conditions required for the observation of that phenomenon is the possibility of reversible variation of the configuration state of the system which enables an "absorbing center (an ion, a molecule, or a microcrystal) and an environment (host)." In this case, the physical mechanism that carries out spectral falls photoburning can be connected with the effect of local electric field generated if a charge carrier (electron or hole) moves to a microcrystal surface or enters the host with subsequent localization in the immediate vicinity of the microcrystal surface.

Nonlinear properties of microcrystals in a glass host can be used for different types of nonlinear optical devices. In recent years the phenomenon of optical bistability, i.e., the capacity of a system to exist in either of two different stable states of optical transmission at the same intensity of incident light, has attracted considerable attention. This is connected with the opportunity to use such materials for optical treatment of information. Although an immense amount of materials and devices has been analyzed and a wide range of nonlinear mechanisms causing optical bistability have been studied both theoretically and experimentally (see, for instance,

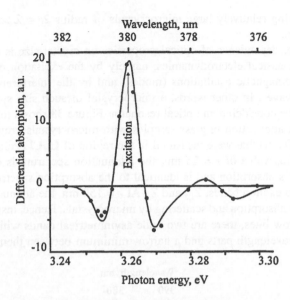

FIGURE 37 Difference in absorption between original sample of glass doped with **CuCl** microcrystals and sample exposed to UV radiation at 380 nm (3.263 eV). Arrow shows the position of exciting radiation. $T = 77$ K.

the monograph by Gibbs[159]), the diminishing of switching times (picoseconds and shorter) and lowering of the switching threshold intensity remains the key problem.

One widely studied bistable device is the Fabry-Perrot interferometer, which contains nonlinear absorbing material. The first experimental demonstration of the phenomenon used a resonator containing sodium vapor. In reference 160, photo-chromic salicylidene aniline was investigated, and this allowed us to obtain image amplification exploiting the nonlinear response of the system. Kirkby et al.[161] used organic photochromic films of the fulgide type, 7.5 mm in thickness, for that purpose.

The results discussed above of the investigation of color center generation mechanisms and of the determination of heterogeneous photochromic glass darkening rates have shown that nonlinear coloration of those materials cannot decrease the switching time. This is connected first of all to the ionic stage taking place at the formation of a color center. Together with that, as Dotsenko et al.[162] pointed out, photochromic glasses representing heterogeneous systems with semiconductor microcrystals can be regarded as a special type of optical resonator. The idea that internal optical bistability is possible in the microcrystals was proposed by Leung.[163] Once a technology of growing microcrystals of specified sizes in vitreous hosts has been developed, that idea will have practical importance.

As was already mentioned, optical spectra of glasses with copper halide crystals of sizes about the order of value of the de Broglie wavelength of quasi particle, λ_e, describing electron excitation in a semiconductor, were investigated by Ekimov et al.[132] and by Efros et al.[137] It was shown that the peculiarities of the optical properties of such systems are due to the quantum size effect. Dotsenko et al.[162] studied such

glasses containing relatively large microcrystals of radius $2r \cong \lambda \gg \lambda_e$; here λ is light wavelength.

In this case, dependence of optical properties on crystal size is determined by the effects of classical electrodynamics, namely by the excitation of microcrystal intrinsic electromagnetic oscillations (modes) and by the interference of incident and scattered waves. In other words, a microcrystal of such size surrounded by a glass host can be considered an optical resonator. Figure 38 shows low-temperature spectra of light attenuation in glass samples with microcrystals grown to different sizes (50 to 300 nm) that were measured in the region of **CuCl** exciton absorption. At average radius value of $r = 25$ nm, the attenuation spectrum is determined by the microcrystals absorption and is identical to the absorption spectrum of a single crystal with two exciton bands, $Z_{1,2}$ and Z_3. At $r = 150$ nm, the attenuation spectrum consists both of absorption and scattering by microcrystals. Hence, instead of exciton absorption narrow lines, there are two wide asymmetrical bands with side maxima in their short wavelength parts and a narrow minimum between them.

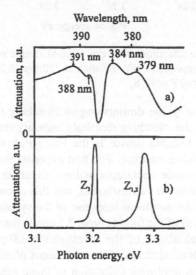

FIGURE 38 Measured attenuation spectra of glasses doped with **CuCl** microcrystals of different average radius a) 150 nm, and b) 25 nm at T = 4.2 K.

In the work of Dotsenko et al.,[164] the treatment of the spectra was carried out on the basis of the Mie theory. The dielectric permeability of **CuCl** in the range of exciton transition frequencies was described by the Lorentz formula. In the calculations, the decay constants were considered as fitting parameters and spatial dispersion was not taken into account. The results of the calculations for radius of 150 nm are presented in Figure 39. One can see that the calculation simulates well enough the basic features of the extinction spectrum, and the shape of the spectrum is defined basically by scattering (see also Section 4.2.3).

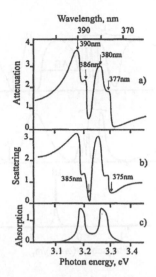

FIGURE 39 Calculated spectra of the efficiency factors of light absorption, scattering, and attenuation by a glass doped with **CuCl** microcrystals of 150 nm radius.

To clarify the physical causes of the peculiarities in the spectra under study, the structure of partial waves of an electric and magnetic nature was analyzed. Figure 40 illustrates an example of partial factor of electric type scattering efficiency $q_l(\omega)$ at three different values of diffraction parameter $\rho = n_m\omega_l r/c$, where ω_l is the frequency of Z_3 exciton transition. It is seen that, at $\rho \ll 1$, a single narrow line is observed in the spectrum that is due to the excitation of surface mode 1S (in accordance with mode classification offered by Fuchs[165]). As the diffraction parameter grows, this line broadens and shifts its frequency. Also, at $\rho > 1$, maxima appear in the $q_l(\omega)$ spectrum that are due to the excitation of low-frequency modes (1L). As the microcrystal radius grows, their number, intensities, and widths increase and their frequencies decrease.

The difference in the shape of the resonance scattering peak from a Lorentzian one, as well as smoother changing in $q_l(\omega)$ (e.g., AB segment in Figure 40) are due to interference effects. At ω_c frequency, where refractive indices of crystal and matrix phases coincide, the value of q_l becomes zero (see Figure 40). At a finite value of the decay constant of exciton transition, the scattering at ω_c frequency is non-zero though there is a minimum (the Christiansen effect). In Figure 36 these minimums are reached at $\lambda = 375$ and 385 nm (3.3 and 3.22 eV). The analysis of partial waves shows that the physical cause of the observed peculiarities in the attenuation spectra in glasses containing copper halide microcrystals of sizes about wavelength is resonance excitation of their intrinsic electromagnetic modes, the interference of incident and front scattered waves, and the Christiansen effect.

Since a semiconductor microcrystal existing in a glass host possesses resonance properties, there is a certain similarity between that microcrystal and a semiconductor single crystal placed in a Fabry-Perrot resonator. At light intense enough to cause

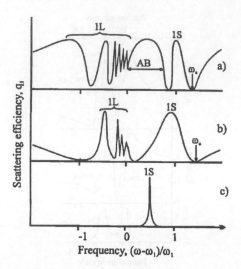

FIGURE 40 Efficiency of scattering of electric type wave versus normalized frequency $\omega - \omega_1)/\omega_1$. Diffraction parameter, ρ_1 is: a) $\rho_1 = 5$, b) $\rho_1 = 3$, c) $\rho_1 = 0.2$.

nonlinear effects in a microcrystal, feedback should be generated similar to that in the Fabry-Perrot resonator, which may lead to such phenomena as differential amplifying or optical bistability. The possibility of bistability appearance near the optical resonance frequency of a Rayleigh-sized spherical particle $(r \ll \lambda)$ was shown by Jungk.[166] In this case, only the 1S mode is excited.

Dotsenko et al.[164] investigated the same problem for a small ellipsoidal particle and found the opportunity for a certain lowering of the switching threshold. As was shown by Jungk,[166] at $2r \cong \lambda$ there is a number of modes whose frequencies depend on microcrystal size. The presence of several optical resonance and interference effects can lead to the appearance of optical bistability and multistability in a wide frequency range. In addition, the high excitation of surface modes is followed by the electromagnetic field being localized at a particle surface layer, which may result in nonlinear effects at not very high intensities of incident light.

Justus et al.[167] carried out the investigation of nonlinear refractive index n_2 in the region of Z_3 exciton resonance on borosilicate glasses doped with **CuCl** microcrystals. To evaluate n_2 value, Kramers-Kronig transformations were used. There was obtained the dependence of n_2 on microcrystal size. Thus, for instance, for a crystal of 3.4 nm in diameter, $n_2 = 3 \times 10^{-7}$ cm^2/W, that is about an order of magnitude as high as that for 2.2 nm crystal. In that work it was also pointed out that this value for glass doped with microcrystals was substantially higher than for bulk **CuCl** ($n_2 = 7.5 \times 10^{-9}$ cm^2/W), despite the fact that the volume fraction of the microcrystalline phase was less than 0.5%.

Let us now describe the works by Hakamura,[168] where an interesting suggestion was made that biexciton resonance is a possible nonlinear mechanism of optical bistability in copper chloride. In fact, biexciton resonance is a result of an effective two-photon absorption process in that exciton molecules are formed due to the

intermediate resonance exciton level. Hakamura also noted the opportunity to obtain short (picosecond) switching times in **CuCl**, notwithstanding the difficulties connected with the necessity of operating at short wavelength and at low temperatures. Glasses containing copper halide microcrystals are promising objects from this point of view.

4.2.3 EFFECT OF SCATTERING ON PHOTOINDUCED ATTENUATION SPECTRA

As was already mentioned above, with microcrystals of small radius, $r < 30$ nm, experimentally observed attenuation spectra of copper halide photochromic glasses are due mainly to light absorption in microcrystals. As microcrystal size increases, when the radius becomes comparable with the radiation wavelength, the scattering contribution becomes significant. The glass becomes hazy because of the scattering of visible light. However, the effects of light scattering are obtained most strongly in the near UV region, near the exciton absorption bands. This is caused by the significant variation of the dielectric permeability of microcrystals in this spectral region.

Turning to a theoretical description of the problem, we should note that for the first time the problem of diffraction of light on an exciton microcrystal was solved by Ruppin et al.[169] Dotsenko et al.[170] examined in detail the case in which quantum size effects could be ignored and the dielectric permeability of a semiconductor substance could be considered local. It was shown (see Figure 41) that, as particle

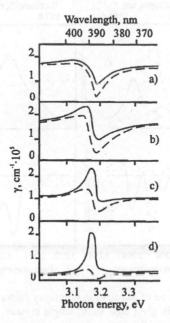

FIGURE 41 Calculated spectra of coefficients of attenuation (solid lines) and scattering (dashed lines) of **CuCl** microcrystals in glass host. Radius of microcrystals r, nm: (1) 50, (2) 100, (3) 150, and (4) 200.

radius grows, the contribution from scattering increases. At $r = 200$ nm the shape of the attenuation spectrum is mainly caused by the scattering. Indeed, there appears a deep dip against a strong extinction background, i.e., one can note an inversion of the spectrum in the region of exciton resonance. The obtained results are in good agreement with numerous experimental works.[132,137,162]

The angular distribution of scattered light as a function of the conditions of heat treatment of copper halide photochromic glasses was studied experimentally and theoretically by Dotsenko et al.[171-173] With certain assumptions, the technique proposed by these authors allows one to get information on the size of microparticles though only for those heat treatment regimes at which microcrystal average radius is not too small.

Pekhovsky[174] has developed the model for the solution to the problem of scattering by a semiconductor sphere with spatial dispersion taking into consideration and having applied the model of the Green function. This theoretical approach enables one to calculate in compact form (quite appropriate for computer program development, though rather cumbersome because of the complexity of the problem) both attenuation spectra and Faraday rotation and magnetic circular dichroism spectra. Finishing the elaboration and applications of those mathematical methods allowed Pekhovsky et al.[100] to study the specific features of Faraday rotation spectra for an ensemble of semiconductor **CuCl** microcrystals placed in a glass host and subjected to a weak magnetic field.

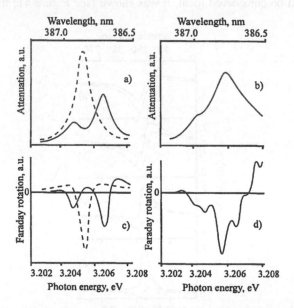

FIGURE 42 Calculated spectra of attenuation efficiency factor (a, b) and Faraday rotation (c, d) of **CuCl** microcrystals in glass host. (a, c) single crystals of 14 nm, (b, d) ensembles described by the Lifshits-Slyozov distribution function with average radius of 14 nm. Dashed lines = no mismatching between dielectric constants.

Figure 42 shows the results of this calculation, presenting for comparison the data obtained for spectra of optical attenuation and Faraday rotation. Here (a) and (c) of Figure 42 correspond to a single microcrystal of 14 nm radius and (b) and (d), to a microcrystal ensemble with the Lifshitz–Slyozov distribution function,[79] at an average radius of 14 nm.

It is seen from Figure 42 that both optical attenuation and Faraday rotation spectra possess a structure caused by the quantum size effect that can be obtained in non-averaged spectra. The positions of Faraday rotation peaks (Figure 42c) are ruled by the same regularity as the positions of quantum size affected levels in the optical attenuation spectrum (Figure 42a). Analyzing Figure 40b and d, one can conclude that including dispersion of sizes of a heterogeneous medium into the calculation results in blurring of the quantum size effect structure of the spectra. This is especially true in the Faraday rotation spectrum (Figure 42d) in that, unlike in the single crystal case (Figure 42c, solid line), one can distinctly identify a broadened and shifted to the long wavelength end rotation peak of the second level of quantum size effect. The other peculiarities of the spectrum in Figure 40d appear because the Faraday rotation spectrum for single particle in the region of exciton energy exhibit a peculiarity of the opposite sign — negative peak and positive wings.

5 Kinetics of Coloration, Fading, and Bleaching

The study of the kinetics of photochromic glass coloration, fading, and bleaching is an important problem to be solved in connection with their use under various conditions of stationary and pulse irradiation. Numerous kinetic experiments performed on different types of photochromic glasses exhibited vast and sometimes difficult to interpret information on the peculiarities of their behavior during exposure. This is due to quite a number of causes.

First, as has been mentioned in earlier chapters, the term *heterogeneous photochromic glass* covers a wide class of various composite materials. Ignoring the principal difference between silver halide and copper halide photochromic glasses, different glass brands, even within each of those two larger groups, possess essential distinctions in their compositions and second heat treatment schedules. Second, in both kinetic study and actual use the glasses are subject to different exposure conditions (light sources of different emission spectra, polarization, intensity, exposure times, or pulse shape). In particular, a number of interesting effects are obtained when the effects of two different types of light sources are combined.

Notwithstanding the diversity of experimental material, general analysis of the kinetic phenomena and an attempt at systematization are possible. This is why a significant number of papers are devoted to the problems of kinetic simulation. The creation of adequate models and their computer simulation performance open up opportunities for not only quantitative description of kinetic peculiarities of photochromic glasses but also prediction of their ultimate characteristics. The latter is important because of a still growing need for the practical development of photochromic materials with various specified rates of direct and reverse processes.

5.1 MECHANISMS OF PHOTOINDUCED COLORATION

As was already mentioned, according to the Mott and Gurney theory (see references 1 and 95) the coloration of silver halide crystals is a two-stage process including electron and ionic stages. The processes connected with the generation of photoelectrons, their migration through the crystal, and localization at defects pertain to the electron stage. The ionic stage of the process that drives the rate of color center (i.e., colloidal particles Ag_n) formation consists in the movement of interstitial silver ions toward a localized electron. Typical time for the latter process at room temperature is about 10^{-5} s, while at liquid nitrogen temperature it takes hours.[4] Even the

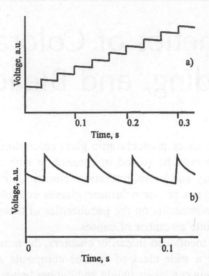

FIGURE 43 Kinetics at room temperature of the intensity of probe beam transmitted by silver halide photochromic glass under exposure to the radiation of a pulsed nitrogen laser at 337 nm with the repetition rate of 30 Hz when coloration is started (a) or equilibrium is attained (b).

first works dedicated to photochromic glasses[64,123,175] pointed out that the irradiation of photochromic glasses by comparatively long (10^{-4} to 10^{-5} s) light pulses is followed by coloration without delay.

Abramov et al.[115] studied the kinetics of photochromic glass coloration under nitrogen laser excitation ($\lambda = 337$ nm, pulse width –2 ns). In that work, a measure of the inertia of the process was determined as an interim when glass shows coloration after the cessation of excitation. It was found that there was no inertia of coloration over 250 ns in the temperature range of 77 to 300 K.

Figure 43 presents oscilloscope traces that illustrate the process of silver halide photochromic glass coloration under laser pulses with the repetition rate of 30 Hz at room temperature. As a result of such a treatment, a stepped darkening of a photochromic glass sample is observed. Each step of darkening corresponds to the effect produced by one laser pulse. In the time between the exposures of two laser pulses, the absorption is partially faded. This fading is not significant in the primary period of laser irradiation (Figure 43a) and grows as the glass darkens (Figure 43b). At the first 3 to 7 pulses of excitation, a coloration step has grown 1.5 to 2.5 times. Further on, its value remained stable.

Measurements carried out at low temperatures showed that the amplitude of unit step changed little in the range of 300 to 77 K, while the inertia of coloration, as was already mentioned, was absent at low temperatures. The coloration of photochromic glass at 300 K remains for a long time. Therefore the results of several exposures are added. At 77 K, after the instant coloration under exposure to a laser pulse, the sample restores its transparency rapidly (in less than 10 ms). Hence, the effect of a series of light pulses imparts only small coloration of the glass.[176]

These experiments allowed Tsekhomsky[177] to offer a fluctuation model of color center generation in silver halide photochromic glasses. The statements that are well known in the photochemistry of silver halide crystals were used to develop this model. It is known[178] that photosensitivity centers in silver halide crystals are silver atoms or their aggregates. The latter, according to Latyshev and Molotsky,[179] are adsorbed at the surface of **AgHal** crystals, then form quasi-molecules like Ag_2^+. At sufficient total concentration of atomic silver, because of its relatively high mobility, small (10 to 15 nm) fluctuation domains are created with locally higher concentration of Ag_2^+ quasi-molecules. These domains, bearing comparatively high positive charge, work as deep traps for electrons. Filling these traps, or clusters, with electrons leads to the formation of the color centers observed under pulse irradiation. The process of filling those domains, consisting of nonbonded Ag_2^+ quasi-molecules, with electrons apparently has a purely electron character. However, once electron stabilization takes place, a certain change in the distances between Ag_2^+ molecules must occur that makes such a center more stable. This drifting together of Ag_2^+ molecules shows an activation nature and is only possible at relatively high temperatures.

The fluctuation hypothesis proposed by Tsekhomsky has acquired additional confirmation in a series of works by Naboikin et al.[180-182] and by Ogurtsova et al.[183] These works were devoted to the study of silver halide photochromic glasses of the FHS-4 type under exposure to pulse radiation (of 50 ns pulse width) of second ($\lambda = 530$ nm) and third ($\lambda = 353$ nm) harmonics of Nd:glass laser at temperatures of 220 to 600 K. These investigations showed that photoinduced absorption occurs without delay in 10 ns. The most important result of that research was the detection of the absorption spectrum induced by pulse irradiation (Figure 44). This absorption has a wide band with the maximum in the range of 450 to 570 nm (2.75 to 2.15 eV) and is very like that appearing under stationary irradiation (curve 1 in Figure 44). The latter enabled Ogurtsova et al.[183] to conclude that color centers of the Ag_n type are mainly responsible for the absorption induced in 100 ns. Temperature dependencies of both the photoinduced absorption spectrum (Figure 44) and the value of photoinduced absorption at 632 nm (1.96 eV, Figure 45) present additional proof of the correctness of the model described above.

The dependence of the coefficient of photoinduced absorption on the temperature of exposure is presented in Figure 45. This curve allows us to determine the energy of the color center generation process. This energy appears as 0.077 eV, i.e., it is in agreement with analogous values obtained by Abramov et al.[176] and by Marquard et al.[184] However, we should note that Marquard et al.[184] interpreted the absorption appearing in photochromic glasses under pulse irradiation as the absorption by photoinduced double-charged copper.

5.2 MECHANISMS OF THERMAL FADING

As was mentioned in Chapter 3, the rate of thermal relaxation depends essentially on the composition of the glass host, on the concentration of dopants, and on the schedule of heat treatment. The value of the relaxation rate of actual photochromic glasses may vary widely. Thus the relaxation criterion K_{rel} (see Chapter 2) can change

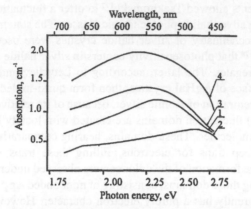

FIGURE 44 Photoinduced absorption spectra of photochromic glass under stationary (1) or pulsed (2–4) excitation (pulse width 50 ns, wavelength 353 nm, irradiance 10^7 W/cm^2) at temperature, °C: (1, 2) 20, (3) 70, and (4) 130.

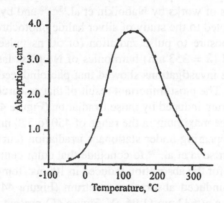

FIGURE 45 Dependence of photoinduced absorption coefficient of photochromic glass subjected to pulsed radiation (pulse width 50 ns, wavelength 353 nm, irradiance 10^7 W/cm^2) on temperature of exposure.

its value from 0 to 1. It was already mentioned in the foregoing sections that the relaxation process possesses an activation nature, therefore the relaxation rate rises with temperature.

In the beginning, the theoretical study of the process of thermal relaxation was confined to attempts to approximate experimental relaxation curves by some monotonously decreasing function or by solving a simple differential equation. The development of that view of the relaxation process was summarized by Araujo.[185] Here are the results of that summary. It should be noted that the references listed by Araujo (see references 2–6 of reference 185) are actually oral presentations or private communications with his colleagues, therefore we do not list them among the references quoted in this book but just summarize them in accordance with Araujo's work.[185]

According to Araujo, King was the first to establish that thermal fading differed from optical bleaching. The latter is described by an equation of first-order reaction. Plummer showed that thermal fading could not be described well enough by an equation including only one term of the first order. Eppler established that an equation containing two terms of the second order was most appropriate for a simulation of thermal fading. Then, King proved that data obtained by Eppler could be described by an equation with the only term of the n-th order. Edwards supposed thermal fading to be connected with the diffusion process.

Hence, the fading and bleaching for photochromic glasses cannot be described by relaxation reactions of the first and second orders as for single crystals (see Chapter 1). This forced researchers to develop a number of different approaches for describing the relaxation process. Some examples of the mathematical description of fading will be considered below.

As is known, most photochromic glasses, after UV irradiation has ceased, are not bleached completely to their initial stage in real measurement times (about tens of minutes). The initially high rate of thermal relaxation decreases considerably. Therefore, Fanderlik[186] suggested introducing the term *residual photoinduced optical density* D^*. Then one can plot a relaxation curve, not in the usual lgD versus t coordinates, but in $lg(D - D^*)$ *versus* t coordinates, where t is relaxation time and D is photoinduced optical density. Plotted in the new coordinates, relaxation dependence appears as a straight line, i.e., the decomposition of rapidly relaxing centers proceeds according to first-order reaction:

$$D - D^* = (D_{ex} - D^*)\exp(-k_f t) \tag{26}$$

where D_{ex} is photoinduced optical density at the moment of radiation cessation, i.e., at $t = 0$. In other words, exponential decay is typical only for centers of short life time and the relaxation curve as a whole cannot be described by a single exponential function. However, a conclusion made on that basis by Voloshin et al.[187] that the law of fading is hyperbolic is not quite right because exponential and hyperbolic functions do not cover the entire range of functions that can describe the relaxation process.

A number of works[175,186,187] suggested that there are two types of color centers in photochromic glasses that are characterized by strikingly different constants of thermal relaxation. Therefore, the possibility of describing the color center fading process by two superimposed exponential functions was considered. The description of the relaxation process in terms of such a simple two-exponential model was used by Dotsenko et al.[142,188] to study the effect of dopants added to photochromic glasses on the relaxation. This model showed that both copper ions, which exhibit a complex redox equilibrium, and double-charged Zn^{2+}, Pb^{2+}, or Cd^{2+} cations affect relaxation properties. Those divalent dopants that effectively create cation vacancies in microcrystals were used by Sukhanov et al.[189] to develop photochromic glasses which did not fade and were therefore useful for recording holographic information.

Despite the fact that the two-exponential model approximates experimental curves for certain time intervals, one should not be satisfied by such a rough description. The point is that the constants of the relaxation process, determined by

such an approach, depend upon a selected time interval. Thus, the two-exponential description does not give a correct description of the relaxation process at growing observation time (i.e., at $t \Rightarrow \infty$). To eliminate a rising discrepancy, one may suppose the presence of a third type of color center and describe the process by superposition of three exponential functions, etc. The fallaciousness of such a method of approximation with respect to the study of the relaxation process is obvious. As was rightly noticed by Adirovich,[190] applying such an approach achieving "agreement" with an experiment only proves the possibility of the expansion of empirical regularities into a series of functions but can say nothing about whether individual items in the sums are real nor about the nature of the process.

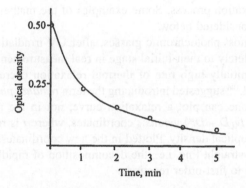

FIGURE 46 Fading of photoinduced absorption in photochromic glass FHS-4 at room temperature. Circles = experimental data, solid line = calculation in accordance with the Becquerel Formula (28). Sample thickness is 1 mm.

It is interesting that color center relaxation can be described with the same accuracy without using a large number of functions. It was mentioned in Chapter 1, Section 1.3 that the relaxation of intrinsic color centers in silicate glasses is described with high accuracy by fractional hyperbolic function.[16] This description is well known as the Becquerel formula:

$$c = \frac{c_0}{(1 + t/t_c)^{\omega - 1}} \qquad (27)$$

The study of the bleaching kinetics of a number of photochromic glasses and of planar waveguides revealed that the kinetics is described well by Equation (27) with only two parameters. As an example, Figure 46 shows the kinetics of isothermal fading of FHS-4 glass. The solid line represents the calculation by Equation (27) with the parameters $\omega = 2.8$ and $t_c = 2$ min. The physical meaning of these parameters is not clear of course. Meanwhile, such kinetics of photochromic glass relaxation can be discussed in terms of the Adirovich theory of recombination in dielectric single crystals[190] that was developed for the single-type centers without dispersion of parameters.

In spite of the successful description of the relaxation process by different functions or their combinations, a rigorous physical description is still desirable. It should be noted that relaxation processes of different types in disordered systems can be described with a continuous spectrum of relaxation times. One powerful approach is to take into account possible dispersion of the parameters of the centers that participate in the processes of fading and bleaching. This approach is not specific for the process of photochromic glasses thermal relaxation. Kohlrausch[191] seems to have been the first to apply it when studying the processes of elastic stress relaxation. Later on, Kohlrausch's approach was widely used to describe the kinetics of glasses' structural relaxation,[192] the kinetics of glasses' postirradiation relaxation,[193] luminescence kinetics,[190] etc. Therefore, the description of relaxation in such systems with the use of any finite number of exponentials is evidently approximate. From a physical point of view, one should first define (or simulate) the parameters of relaxation rate distribution and then describe the relaxation process with the consideration of that distribution.

The confirmation of this approach can be found in the results of Abramov et al.[176] where it was shown that color centers induced by pulse radiation at different temperatures possess different resistance to optical bleaching. Centers photoinduced at room temperature are more stable than those induced at liquid nitrogen temperature. In other words, dispersion of the relaxation rates of different centers can be shown experimentally.

The model that describes this dispersion was established by Araujo[185] and developed later by a Corning research group. Initially, this model supposed that, under UV irradiation, the photolysis of silver halide microcrystals distributed in photochromic glass initiates the generation of electron-hole pairs that are responsible for the absorption of visible light. During thermal relaxation, the diffusion of electrons (and/or holes) takes place, and when they have approached each other at a less than critical distance, their pair annihilates. So the basis of the relaxation process, according to this model, is a diffusion mechanism.

Subsequently Araujo et al.[146] modified the diffusion equation to include explicitly the known details of silver halide physics. In this model, the electrons reside in a silver colloid particle located on the surface of the silver halide crystal. The cupric ion Cu^{2+} is treated as a trapped hole which diffuses in the silver halide crystal. In the model presented, fading occurs as the result of an electron tunneling from the silver colloid to a nearby cupric ion in a silver halide crystal. The positive charge on the colloid, which remains as a result of the electron tunneling process, is dissipated by a silver ion reentering the silver halide crystal from the silver colloid. Repetition of this process eventually restores the system to its initial undarkened state.

Since tunneling is probable only at short distances, diffusion of trapped holes is required to maintain a supply of cupric ions close enough to the silver colloid to allow tunneling to continue. Only those electrons in the colloid which have energy equal to that of the cupric ion state in the silver halide band gap can tunnel. It is clear that both electron energy distribution in the silver colloid and cupric ion distribution near the silver halide crystal surface depends on temperature. Therefore the tunneling rate, as well as the diffusion coefficient, depends on temperature.

The mathematical formulation of the diffusion model is expressed as[146]:

$$\frac{d\phi}{dt} = D\frac{d^2\phi}{dz^2} + k_b I_b(\alpha_0 - \alpha)H(z_1) - R(z,t) \qquad (28)$$

where ϕ is the concentration of cupric ions Cu^{2+}, α is the absorption coefficient, α_0 is the maximum absorption possible, I is the intensity of the UV irradiation, k_b is a constant, and $H(z_1)$ is the Heaviside function. The recombination rate $R(z,t)$ is given by:

$$R(z,t) = \frac{k_f \phi(z,t)\left[\int_0^r \phi dz\right]\exp(-\eta z)}{1 + \exp\dfrac{E - E_f}{kT}} \qquad (29)$$

where r is the size of the silver halide crystal, E_f is the Fermi level, and η is a constant which determines the tunneling probability.

With the use of reasonable values for the parameters, solutions of the diffusion equation are in good agreement with the observed fading rate. More important is the fact that, because both tunneling and the diffusion coefficient depend on temperature, solutions of the diffusion equation predict surprising dependencies of the steady-state absorption and of the fading rate on temperature and on the intensity of the UV irradiation employed to darken the glass. It should be noted that the diffusion model explains[194] the difference in the relaxation rates of the centers generated at different temperatures that was mentioned above.[176] These predictions were subsequently verified by experiment. The reader is referred to Araujo and Borrelli[70] for a discussion of this phenomena.

5.3 SIMULATION OF KINETIC PROCESSES

The immense volume of experimental data should be taken into consideration when developing a simulation approach to describe the kinetics of photoinduced processes in glasses. In other words, the kinetics study should be based on a unified approach that would include a combined description of the coloration and relaxation processes, a concrete physical model of an individual color center, and a description of the spatial-time evolution of such centers.

Let us briefly formulate the set of regularities found more than twenty years ago by the specialists at Corning Inc. (USA) and at the Vavilov State Optical Institute (at that time USSR, Russia) independently, though published by the Corning researchers' group first:[49,185,195]

- Initial rate of thermal fading of glasses irradiated by light of constant intensity increases as exposure time lengthens.
- Initial rate of thermal fading of glasses colored up to the same absorption value by exposure to radiation of different intensity is higher after irradiation by more intense light flow.

- Glass exposed to short wavelength radiation exhibits higher initial rate of thermal fading than one exposed to light of a longer wavelength, when colored up to the same absorption value.
- For repeated exposure of an incompletely relaxed glass sample, the observed initial darkening rate is higher than the rate at the moment, corresponding to the same optical density in the first cycle of coloration.

5.3.1 General Statement of the Simulation Problem

The problem of the simulation of spectral and kinetic properties of composite material can be generally presented as follows. Suppose, $f(\xi)$ is a function of photoinduced color center distribution by a certain set of parameters $\xi = (\xi_1, \xi_2, ..., \xi_3)$. For now, we will not specify the number and exact physical nature of these parameters.

We should note that, if we are to proceed from general definitions, the photochromic process is one of a nonlinear optical phenomena. Indeed, under irradiation, the complex dielectric permeability of irradiated material changes which, in its turn, causes changes in the process of actinic radiation propagation. However, modern physics usually understands nonlinear optical processes as those in which the real part of a complex refractive index changes. In this book, we will keep to the latter principle, though never forgetting the well-known correlation between the changes in the imaginary and the real parts of a complex refractive index.

In previous sections, we have used the term *photoinduced absorption spectrum*, having assumed by default that the probe radiation would not incite photoinduced effects. Presumably, its spectrum, as much as possible, is chosen to avoid overlapping the maxima of photoinduced absorption bands, and its intensity is considerably (as much as several orders of magnitude) lower than that of actinic radiation. So, as with any probe, this radiation is required to be essentially *noninterfering* with respect to the processes taking place in the object under investigation.

Having considered these introductory remarks, we can express the photoinduced absorption spectrum of a material as:

$$\Delta D(\lambda) = \lg e \int_\Omega \sigma_{cc}^{att}(\lambda, \xi) f(\xi) d\xi \tag{30}$$

where $\sigma_{cc}^{att}(\lambda, \xi)$ is the attenuation cross-section of probing radiation at wavelength λ by a color center with a set of parameters ξ, and Ω is the region of these parameter variations.

In other words, the experimentally detected photoinduced absorption spectrum of heterogeneous material is an integral characteristic obtained as a result of averaging the cross-section of an individual center over the sum of such centers with distribution function $f(\xi)$. We should note that, in Chapter 4 examples of the calculation of spectra were considered, where geometrical parameters of various structural models were used as such ξ parameters.

Since the photoinduced state of a photochromic material is continually changing with time, when speaking about the spectra we should be aware that we are actually

dealing with the function of $\Delta D(\lambda, t)$. Thus, the general statement of the problem of the simulation of heterogeneous photochromic material coloration and relaxation consists in the following. Based on the concepts of microinclusion structure and the processes of individual color center formation and destruction, an equation or, most often, a system of equations should be worked out describing the time evolution of distribution function $f(\xi)$. Mathematically, it can be put as:

$$\Delta D(\lambda, t) = \lg e \int_\Omega \sigma_{cc}^{att}(\lambda, \xi) f(\xi, t) d\xi \qquad (31)$$

To calculate the integral in Equation (31) one first needs to calculate the cross-sections for all possible sets of parameters (λ, ξ values). The extent of the task's complexity is defined both by the complexity of the structural model of color centers (see Chapter 4) and by the complexity of a kinetic scheme or model applied to the description of $f(\xi, t)$ behavior. Clearly, the construction of the kinetic model should be based on the physical model of the color center formation process. On the other hand, one can say that the comparison of the results obtained from computation of kinetic curves with those from experiments can verify whether model simulations reflect the structure of color centers adequately and give information on mechanisms of their formation and destruction.

5.3.2 KINETICS OF COLORATION

Now let us proceed to the consideration of the mathematical interpretation of the kinetics of coloration. In the simplest exponential form, the dependence of photo-induced optical density ΔD on time t can be generally expressed as:

$$\Delta D = \Delta D_e \{1 - \exp(-k_f t)\} \qquad (32)$$

The designations here are those accepted in Chapter 2. However, the application of this formula to the kinetic curves of different types of photochromic glasses by a number of independent investigators[185,186,196] revealed that Equation (31) described the experiment too approximately. Therefore, in the work of Dotsenko et al.[196] it was suggested that a parameter ρ should be introduced for the evaluation of time dependence of degree of darkening that is, in a sense, an analog of the Schwarzschild parameter in photography (see James[95]):

$$\Delta D = \Delta D_e \{1 - \exp(-k_f t^\rho)\} \qquad (33)$$

It turned out that a fairly good quantitative agreement between calculation and experiment might be achieved here. It was also shown that the parameter k_f was a function of irradiation conditions and of sample thickness, whereas the parameter ρ does not depend on those values and, consequently, characterizes the type of photochromic glass, in a sense. However, the problem of rendering physical sense to the latter unitless parameter has not yet got its solution. It should be noted that

even in photography engineering the Schwarzschild parameter should be regarded as a sort of well-fitting adjustment parameter.

Of course, such an approximate description of the kinetics could have satisfied neither the developers of photochromic glasses nor the investigators. We have already mentioned that the processes of photochromic material darkening and relaxation should be considered together. That is, a kinetic equation (or a system of equations) describing the darkening process should turn into an equation of relaxation upon the formal substitution of zero for the intensity of actinic radiation.

In the works by Filippov, Zakharov, and Dotsenko,[109,197] and by Dotsenko and Zakharov,[198,127] a quite general approach to the description of kinetic processes in photochromic material was formulated. The essence of this approach is that a system of equations will be worked out, the first describing the time evolution of the $f(\xi,t)$ function and the second describing the change of actinic irradiation intensity with the depth of photochromic material sample under investigation. The experimentally observed kinetic curve, i.e., the dependence of photoinduced optical density vs. time is defined by an integral expression like that in Equation (31).

We have already mentioned in Chapter 2 that it is necessary to consider the distribution of color centers over sample thickness. Deviations from the Bougher law were most thoroughly studied in the works of Fanderlik[186] and Ashcheulov and Sukhanov.[199] In sufficiently thick samples of irradiated photochromic glasses, one can easily see the darkening gradient visually.

On the other hand, the analysis presented in the previous section gives every reason to assume that microcrystal size plays an important role in the formation of the spectral and kinetic properties of a photochromic glass. As has been discussed, the kind and the parameters of microcrystal radius distribution function, $n^*(r)$, can be estimated based on the experiments independent of the kinetic measurements. Therefore, in the development of a kinetic scheme, the function $n^*(r)$ can be regarded as information known *a priori*.

Dotsenko et al.[198] suggested that the term *color center* in photochromic glass should be ascribed to a microcrystal in which, under actinic radiation, photochemical changes proceed and result in a variation of light transmission of the composite material. Because the typical time it takes for photoinduced formation of metallic silver in a single photosensitive microcrystal is much less than that of the darkening of a photochromic glass as a whole, one can regard the transformation of a photosensitivity center as an instantaneous process. In other words, it is suggested that actually existing intermediate states of a microinclusion should not be taken into account. We should note here that these suppositions conform with the ergodicity hypothesis about legitimate substitution of the average value over the ensemble for the average value over time. Dotsenko et al.,[198] for instance, deal with size distribution of color centers.

Let us designate by $n(r,h,t)$ the concentration of color centers of the radius within $(r, r + dr)$ interval, at the depth of h (i.e., in a thin layer of $(h, h + \Delta h)$, at the moment of time t; $I_a(\lambda,h,t)$ is the intensity of actinic radiation and, λ is its wavelength. Then, the equation describing color centers changing in the exposure process can be written as follows:

$$\frac{\partial c(r,h,t)}{\partial t} = k_a(r)\sigma_{mc}^{abs}(\lambda,r)I_a(\lambda,t,h)[c*(r) - c(r,h,t)] - k_f(r)c(r,h,t)$$

$$- k_b(r)\sigma_{cc}^{abs}(\lambda,r)I_b(\lambda,t,h)c(r,h,t)$$

(34)

$$\frac{\partial I_a(\lambda,h,r)}{\partial h} =$$

$$-\left\{ \alpha(\lambda) + \int_0^\infty \sigma_{mc}^{att}(\lambda,r)[c*(r) - c(r,h,t)]dr \right.$$

(35)

$$\left. + \int_0^\infty \sigma_{cc}^{att}(\lambda,r)c(r,h,t)dr \right\} I_a(\lambda,h,t)$$

where $k_a(r)$, $k_f(r)$, $k_b(r)$ are the parameters characterizing the probabilities of the formation and thermal and optical decomposition of a color center, respectively; $\sigma_{mc}^{abs}(\lambda,r), \sigma_{cc}^{abs}(\lambda,r)$ are the cross-sections of radiation absorption by a photosensitive microcrystal (glass photosensitivity center) and by a photoinduced color center of the radius r, respectively; $\sigma_{mc}^{att}(\lambda,r), \sigma_{cc}^{att}(\lambda,r)$ are the analogous attenuation cross-sections; and $\alpha(\lambda)$ is the absorption coefficient of the glass host.

Equation (34) describes the changing of color center concentration in the process of irradiation. The first and third terms of its right-hand side correspond to color center formation and decomposition under the exposure to actinic radiation, and the second one describes their thermal decomposition. Equation (34) should be solved in combination with Equation (35) of actinic radiation transfer through sample thickness. To solve the system of Equations (32) through (33), initial and boundary conditions must be specified. The initial condition has the form of:

$$c(r,h,0) = c(r,h)$$

(36)

provided the initial state corresponds to nonirradiated glass, i.e., $n_0(r,h) = 0$. In the case of repeated irradiation of incompletely relaxed glass, the initial distribution of color centers is different from zero. The boundary condition is written as:

$$I(\lambda_a,0,t) = I_0$$

(37)

where I_0 is the intensity of actinic radiation incident to the glass surface. At the activation by a source of stationary radiation, $I_0 = const$, whereas at using a pulse source, I_0 is a function of time.

For the observation of photochromic glass coloration and relaxation, a probing beam of low intensity is used. The wavelength of the probing light is usually selected equal to 550 nm (2.25 eV), which corresponds to the peak of the absorption band of irradiated silver halide photochromic glass. Since the probing light passes, in

principle, the same way as the actinic radiation, an equation like Equation (35) can be written for the description of its intensity change, $I(\lambda,h,t)$:

$$\frac{\partial I(\lambda_3,h,r)}{\partial h} =$$

$$\left\{\alpha(\lambda_3) + \int_0^\infty \sigma_{mc}^{att}(\lambda_3,r)[c*(r) - c(r,h,t)]dr \right. \tag{38}$$

$$\left. + \int_0^\infty \sigma_{cc}^{att}(\lambda_3,r)c(r,h,t)dr \right\} I(\lambda_3,h,t)$$

where by α and σ the above-specified values are designated though calculated for the wavelength of the probing light λ_3. The corresponding boundary condition has the form of:

$$I(\lambda_3,0,t) = I_3^0 = const \tag{39}$$

The values of radiation absorption and extinction cross-sections included in the system of Equations (34) through (35) had been previously calculated using the Mie theory modified for a two-layer spherical particle (it is described in more detail in Chapter 4). The calculation done in the work of Dotsenko et al.[198] has shown that:

$$\sigma_{mc}^{att} \ll \sigma_{cc}^{att} \tag{40}$$

and this inequality (40) holds more strictly for photochromic glasses doped with both silver chloride and silver bromide throughout the whole range of particle sizes under examination. Therefore, neglecting $\sigma_{mc}^{att}(\lambda_3,r)[c(r,h,t)]$ compared to $\sigma_{cc}^{att}(\lambda_3,r)[c(r,h,t)]$ on the right-hand side of expression (38) and then integrating (38), we have:

$$I(\lambda_3,0,t) =$$

$$I_3^0 \exp\left\{-\left(\left[\alpha(\lambda_3) + \int_0^\infty \sigma_{mc}^{att}(\lambda_3,r)c*(r)dr\right]h \right.\right. \tag{41}$$

$$\left.\left. + \int_0^\infty \sigma_{cc}^{att}(\lambda_3,r)\int_0^\infty c(r,h,t)dhdr\right)\right\}$$

For transmittance $\tau(t)$ and for optical density $D(t)$, we can write the following expressions:

$$\tau(t) = \frac{I(\lambda_3, H, t)}{I_3^0} = \tau_0 \exp\left\{-\int_0^\infty \sigma_{cc}^{att}(\lambda_3, r) \int_0^H c(r, h, t) dh dr\right\} \qquad (42)$$

$$D(t) = -\lg \tau(t) = D_0 + \lg e \int_0^\infty \sigma_{cc}^{att}(\lambda_3, r) \int_0^H c(r, h, t) dh dr \qquad (43)$$

where the designations are:

$$\tau_0 = \exp\left\{-\left[\alpha(\lambda_3) + \int_0^\infty \sigma_{mc}^{att}(\lambda_3, r) c^*(r) dr\right] H\right\} \qquad D_0 = -\lg \tau_0 \qquad (44)$$

are the transmittance and the optical density of nonirradiated glass, respectively, and H is sample thickness.

Equations (42) and (43) allow us, with the solution to (34) and (35), i.e., $c(r,h,t)$ function, to calculate the basic integral optical characteristics of photochromic glasses — the transmittance and the optical density — and to see their variation both under the irradiation of the glass and at its relaxation after irradiation.

Now we will consider the kinetics of photochromic processes for stationary exposure to monochromatic light. The system of Equations (34) through (35) has a complex structure and, in general, allows only a numerical solution. Filippov et al.[197] have studied a case of no size distribution of color centers. According to that work, we will call the totality of $c(h,t))$ values at a fixed t the profile of color center concentration at the moment t. Under prolonged irradiation ($t \Rightarrow \infty$) the darkening of a photochromic glass saturates, $d\tau/dt = 0$, which corresponds to dynamic equilibrium between the concentrations of color centers being formed and of those decomposing, $\partial c/\partial t = 0$. In equilibrium, we have, from Equation (35):

$$I(h) = \frac{k_f c_\infty(h)}{k_a \sigma_{mc}^{abs} C^* - (k_a \sigma_{mc}^{abs} - k_b \sigma_{cc}^{abs}) c_\infty(h)} \qquad (45)$$

where C^* is the concentration of photosensitive microcrystals (not considering their size distribution) and c_∞ is the equilibrium profile (the parameter λ_a is omitted everywhere). Differentiating this expression in h and substituting dI/dh from Equation (34), we have an ordinary differential equation:

$$\frac{dc_\infty}{dh} = \frac{c_\infty}{C^*}\left[C^* - \left(1 + \frac{k_b \sigma_{cc}^{abs}}{k_a \sigma_{mc}^{abs}}\right) c_\infty\right][\alpha + \sigma_{mc}^{abs} C^* + (\sigma_{cc}^{att} - \sigma_{mc}^{att}) c_\infty] \qquad (46)$$

the integration of which will enable us to determine the equilibrium profile as a nonexplicit function, $F[c_\infty(h), h] = 0$:

$$\exp\left\{h(\alpha+\sigma_{mc}^{att}C^*)\left[(\sigma_{cc}^{att}-\sigma_{mc}^{att})C^*+(\alpha+\sigma_{mc}^{att}C^*)\left(1+\frac{k_b\sigma_{cc}^{abs}}{k_a\sigma_{mc}^{abs}}\right)\right]\right\}=$$

$$\left(\frac{c_{in}}{c_\infty}\right)^{(\sigma_{cc}^{att}-\sigma_{mc}^{att})C^*+(\alpha+\sigma_{mc}^{att}C^*)\left(1+\frac{k_b\sigma_{cc}^{abs}}{k_a\sigma_{mc}^{abs}}\right)}\times\left[\frac{C^*-\left(1+\dfrac{k_b\sigma_{cc}^{abs}}{k_a\sigma_{mc}^{abs}}\right)c_\infty}{C^*-\left(1+\dfrac{k_b\sigma_{cc}^{abs}}{k_a\sigma_{mc}^{abs}}\right)c_{in}}\right]^{(\gamma+\sigma_{cc}^{ext}C^*)\left(1+\frac{k_b\sigma_{cc}^{abs}}{k_a\sigma_{mc}^{abs}}\right)} \qquad (47)$$

$$\times\left[\frac{\alpha+\sigma_{mc}^{att}C^*+(\sigma_{cc}^{att}-\sigma_{mc}^{att})c_\infty}{\alpha+\sigma_{mc}^{att}C^*+(\sigma_{cc}^{att}-\sigma_{mc}^{att})c_{in}}\right]^{(\sigma_{cc}^{att}-\sigma_{mc}^{att})C^*}$$

$$c_{in}=c_\infty(0)=C^*\frac{k_a\sigma_{mc}^{abs}I_0}{k_f+(k_a\sigma_{mc}^{abs}+k_b\sigma_{cc}^{abs})I_0} \qquad (48)$$

where color center concentration at the boundary is in the process of irradiation relaxation, the distribution of color centers is continuously undergoing changes, which allows us to talk about the "motion" of the concentration profile in time (Figure 47). Nonequilibrium profiles were determined by numerical solution with the use of the box method and the equilibrium profile was according to Equations (47) and (48).

We will designate as $\delta_i = h_i - h_{i-1}$ ($i = 1,2,...$) a step in sample thickness and as $\Delta_j = t_j - t_{j-1}$ ($j = 1,2,...$) a step in time, $c(h_i,t_j) = c_{ij}$. In the calculations, considering the specific character of the problem (i.e., gradual decreasing of the rate of $c(h,t)$, changing as h and t rise), a variable step is chosen along the axes h and t. The procedure for solving the system of Equations (34) and (35), when there is no size distribution of color centers, is drawn schematically in Figure 48. The profile along the left vertical is known, according to initial condition (35). Now we integrate (35)

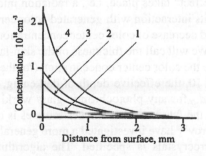

FIGURE 47 Calculated dependence of color center concentration profile on time of excitation, s: (1) 10, (2) 20, (3) 25, and (4) ∞.

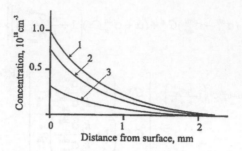

FIGURE 48 Calculated dependence of color center concentration profile on time of fading, s: (1) 3, (2) 15, and (3) 22.

in h from 0 to δ_1 neglecting in that thin layer the dependence of the expression in brackets on the intensity of activation, and substitute the result into Equation (34), thus obtaining profile c_{i1}. Repeating this procedure, we have profile c_{i2}, and so on. For the determination of c_{ij} element, we can write the following difference formula:

$$\frac{\dfrac{c_{ij}-c_{ij-1}}{\Delta_j}+k_a c_{ij}}{k_a\sigma_{mc}^{abs}C^*I_0-(k_a\sigma_{mc}^{abs}-k_b\sigma_{cc}^{abs})I_0 c_{ij}}=$$
$$\exp\left\{-(\alpha+\sigma_{mc}^{att}C^*)h_i+(\sigma_{mc}^{att}-\sigma_{cc}^{att})\sum_{l=0}^{i-1}c_{ij}\delta_l\right\} \tag{49}$$

It is clear from Equation (49) that, in order to determine c_{ij}, one should know the foregoing element c_{ij-1} of the same row and all the elements above in the same column: c_{0j}; c_{1j}; ...; c_{i-1j}, i.e., it is necessary to know center concentration both in the previous moment of time at the same depth and in the next moment in all layers located above.

As was pointed out in Chapter 2, at the irradiation of photochromic glass, a particular sort of "skin-effect" takes place, i.e., a radiation intensity decrease in the surface layer caused by its interaction with generated color centers. The latter, in its turn, leads to a more rapid decrease of color center concentration with depth (distance from the glass surface). We will call the thickness of the skin-layer the distance from the sample surface where the color center concentration (for the saturated coloration) decreases by a factor of 10, the effective depth of darkening, designating it as d_{eff}. With the knowledge of d_{eff} for any photochromic glass working in a certain range of activation intensities, the fabrication of thicker samples is of no use.

Dotsenko and Zakharov[198] have investigated a more general case, where a certain size distribution of microcrystals is specified. The algorithm of the solution of Equations (34) and (35) is similar to that described above though more complex, as the problem becomes three-dimensional. Having determined κ_i values for a given glass under given irradiation conditions and assuming them to be constants, we can

predict the behavior of that glass under other irradiation conditions (at different intensity, time, and wavelength). The calculation and experiment were carried out for actinic radiation of λ_a = 330 nm (3.75 eV). The following values of distribution parameters $c*(r)$ were used in the calculation: average radius r_0 = 10 nm, size dispersion s = 6 nm, and volume concentration $C*$ = 10^{14} cm^{-3}. Figure 49 presents kinetic curves of the considered glass calculated for different intensities of actinic radiation on the basis of the above-estimated constants and corresponding experimental curves.

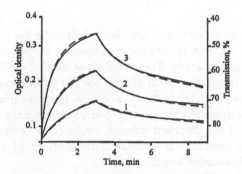

FIGURE 49 Calculated (solid lines) and experimental (dashed lines) coloration and relaxation kinetics of photochromic glass (sample thickness is 5 mm) for different intensities of actinic radiation, a.u.: (1) 100, (2) 38, and (3) 300.

Using mathematical simulation enables one to explain experimentally observed effects of the dependence of a photochromic glass initial relaxation rate on irradiation conditions (i.e., the "optical prehistory" of the sample). First, let us consider the dependence of the initial relaxation rate of glass darkened to the same extent under light of different intensities on actinic radiation intensity. Presuming the fulfillment of the conditions allowing to differentiate in the parameter under integral, we can write the expression of the photoinduced optical density $\Delta D = D - D_0$ describing the relaxation process:

$$\Delta D(t) = \lg e \int_0^\infty \sigma_{cc}^{att}(\lambda_3, r) \int_0^H c_0(r, h) \exp[-k_f(r)t] dh dr \qquad (50)$$

and then calculate the time derivative at $t = 0$:

$$\frac{d\Delta D(t)}{dt}\bigg|_{t=0} = \lg e \int_0^\infty \int_0^H c_0(r, h) dh \sigma_{cc}^{att}(\lambda_3, r) k_f dr \qquad (51)$$

where $c_0(r, h)$ is the distribution of color centers in r at the depth h at the moment of irradiation ceasing.

Different conditions of the irradiation of glass bringing it to a specified darkened state produce different distributions of $c_0(r,h)$ that, due to the dependence of color center decay probability on its size, results in different initial relaxation rate values. The latter circumstance is essential, because, in case there was no dependence k_2 vs. r according to Equation (51), we would have:

$$\frac{d\Delta D(t)}{dt}\Big|_{t=0} = -k_f \lg e \int\limits_0^\infty \int\limits_0^H c_0(r,h)dh\sigma_{cc}^{att}(\lambda_3,r)dr = k_f \Delta D(0) \qquad (52)$$

i.e., the initial relaxation rate would have been defined by the photoinduced absorption degree at the moment of irradiation cessation, irrespective of color center distribution in the glass sample. The calculations carried out have shown (Figure 50a) that the initial relaxation rate of glasses colored to the same degree under light of different intensities is higher in the case of more intensive irradiating light, which corresponds to experimental observations. Such a dependence is explained by the fact that, in terms of the proposed scheme, larger color centers decompose more slowly. Figure 50b presents the calculated distributions of color centers at the moment when the irradiation was stopped:

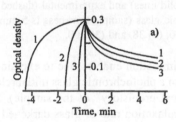

FIGURE 50 Calculated dependence of properties of photochromic glass on the intensity of exciting radiation, a.u.: (1) 300, (2) 500, and (3) 1000. a) Dependence of the photoinduced optical density (sample thickness is 5 mm) on time of exposure and relaxation. b) Size distributions of color centers at the moment of exposure cessation.

$$z(r) = \frac{1}{H} \int_0^H c_0(r,h)dh \tag{53}$$

corresponding to the three activation intensity values considered. One can see that, at long irradiation by light of comparatively low intensity, the proportion of big color centers being formed is greater. This defines the relative slowing down of the relaxation process.

Another peculiarity of the kinetics is the growth of the initial relaxation rate as irradiation time increases. In contrast with the above, this dependence can be explained in the framework of a simplified kinetic scheme with color centers of the same size and defined by exponential type of color center decay. Figure 51 illustrates the results of the relevant calculation showing that, as irradiation time grows, the initial relaxation rate increases, reaching a certain constant value that agrees with the experimentally observed tendency and is explained (see Equation (52)) by the growth of $\Delta D(0)$. We should note here (Figure 51b) that during the darkening process, the peak of $z(r)$ distribution is displaced toward greater r values, while in the course of the relaxation process, a reverse displacement of the peak takes place. This circumstance explains the experimental results obtained from photoinduced absorption spectrum measurements done as the photochromic cycle proceeds. These results show that in the process of glass irradiation, along with the growth of photoinduced absorption throughout the whole spectrum, there occurs some shifting of the main peak toward longer waves, and at the relaxation, a reverse shift of the spectrum is observed. Indeed, the bigger a color center is, the longer will be the wavelength in the spectral region where the peak of light extinction by such a particle is located.

The method of mathematical simulation allows one to assess the limiting characteristics of photochromic material. We would like to remind the reader that the maximal photoinduced optical density that can be obtained in real photochromic glasses ranges from 1 to 2. This appears insufficient for the solution of a great number of practical tasks. At the same time, formal theoretical evaluations carried out by Dotsenko and Zakharov[200] have shown that if all photosensitive centers in a photochromic glass sample of 5-mm thickness turned into color centers, the optical density could reach an unbelievably high value of about 100. This hypothetical case could happen at infinitely long irradiation of a nonrelaxing photochromic glass. Of course, this value does not correspond to any physical reality but only demonstrates the estimation of the highest photoinduced optical density. Through such an estimation, it also becomes clear that the degree of darkening is limited not by the silver introduced into the glass but by other factors. One of the causes that confines such increasing of photoinduced darkening is the very nonuniform distribution of color centers in the bulk of the sample versus the distance from the irradiated surface.

Taking these considerations into account, it is clear that if exposure to exciting light and use in an optical device can be carried out in different directions, it becomes possible to enhance strongly the efficiency of photochromic glasses. For instance, if a fiber was made of photochromic glass and was irradiated on its side surface,

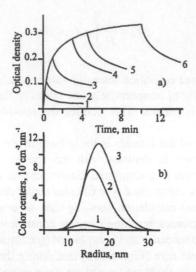

FIGURE 51 Calculated dependence of properties of photochromic glasses on exposure time for intensity of 300 a.u. a) Dependence of the photoinduced optical density (sample thickness is 5 mm) on time of exposure and relaxation. b) Size distribution of color centers for different coloration time, s: (1) 2, (2) 90, and (3) 1500.

obviously the effect of coloration would grow depending on the length of the irradiated segment (see Chapter 7).

The mutual substitution law is widely used in photography. According to this law, the photochemical effect of light is defined by the energy $E_0 = I_0 t_0$ and does not depend separately on the intensity I_0 and the time t. Using mathematical simulation, one can study whether this law works in photochromic glasses. Dotsenko et al.[201] have shown that the deviation from the mutual substitution law observed experimentally in photochromic glasses is caused first of all by the process of color center thermal destruction (i.e., fading).

In practice, photochromic glasses are used under conditions of light intensity that varies with time. In order to solve a number of practical problems, it is important to know how glasses will be colored when illuminated by light pulses. It is essential to be able, using mathematical simulation, to perform calculations of the basic spectral and kinetic parameters of photochromic glasses exploited under the illumination with light pulses. In this case, boundary condition (36) has the form of $I(0,t) = I(t)$ and represents time configuration of a pulse incident onto the glass.

The configuration of $I(0,t)$ function was specified in the work by Dobrovolskaya et al.[202] in two ways — as a smooth function:

$$I_0(t) = A \sin \omega t, \qquad 0 \leq t \leq \pi/\omega = t_0 \qquad (54)$$

(Figure 52a) and as a model pulse (Figure 53a). The parameters A, ω, t_0, and I_M changed so that the value of pulse energy density should have been preserved.

Numerical solution of the system of Equations (34) and (35) has shown that some bleaching can be observed in the process of exposing glass to radiation. This phenomenon was mentioned in some experimental studies and attributed to the glass warming up. It turned out that the bleaching of glass could be explained in some cases by a decrease in the intensity in the rear of the actinic radiation pulse. Besides that, it can be seen that the bleaching appears not at the moment of t_M, when the intensity begins to fall, but a bit later. Such a delay in the response under pulse irradiation is also observed experimentally.

It should be noted that the effect of bleaching is observed when the value of photoinduced optical density $\Delta D(t_M)$ at the pulse maximum $I_0(t_M)$ is close to the level of saturation ΔD_M. In this case the rates of coloration and bleaching are close to the pulse maximum and, consequently, a small drop in intensity leads to the dominant effect of bleaching. The nearer $\Delta D(t_M)$ is to ΔD_M, the more distinctly is the effect of bleaching under pulse exposure.

FIGURE 52 Effect of the temporal shape of exciting radiation (a) on kinetics of photochromic glass coloration (b). Dashed lines = step pulse, solid lines = sinus pulse. Sample thickness is 5 mm.

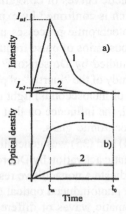

FIGURE 53 Effect of "triangular" exciting pulses (a) on kinetics of photochromic glass coloration (b). Maximum intensity of pulses at time t_m is I_m, a.u.: (1) 100, (2) 5. Sample thickness is 5 mm.

These results yield some information on the deviation from the law of mutual substitution in the case of glass interaction with radiation of time-variable intensity. It appeared that, at the same incident energy:

$$E_0 \int_0^{t_0} I(t)dt \tag{55}$$

and the same irradiation time t_0, the result of light effect on a photochromic glass is determined by the shape of $I_0(t)$ dependence. There is one more interesting peculiarity of the interaction of photochromic glasses with radiation of variable intensity. One can see a point of inflection in the initial part of the coloration curve when exciting light intensity rises (solid curve in Figure 52b and curve 2 in Figure 53b). This behavior of the photoinduced optical density is explained by the fact that at the first moments of time $(t = +0)$, as it follows from Equation (34),

$$\frac{d^2 \Delta D(t)}{dt^2} \equiv \Delta D'' = A \frac{dI}{dt} > 0 \tag{56}$$

because

$$\Delta D(t) \approx \int_0^d \int_0^\infty \sigma_{cc}^{att}(r)c(r,h,t)drdh$$

and then, due to relational processes, $\Delta D''$ becomes negative. By force of the $\Delta D''$ continuity, at $0 \le t \le t_0$ there is a point t^* where $\Delta D''(t^*) = 0$, i.e., the point of inflection. In the case of stationary irradiation $(I_0 = const)$, at any infinitesimal value of $t > 0$, $\Delta D'' < 0$, so all the kinetic curves of coloration obtained under stationary irradiation must be convex, which is confirmed by experimental results.

The specific features of photochromic processes under the effect of a periodic sequence of light pulses for various ratios of pulse frequency to rate of photochromic glass thermal relaxation were studied by Dotsenko.[203] The work by Dotsenko and Morozov[204] was devoted to the study of the "inertia" of photochromic glass coloration after the exposure to short (tens of nanoseconds) light pulses. It was found, through their developed two-stage model, the influence on that phenomena of the totality of parameters that describe a photochromic glass.

The system of Equations (34) and (35) was generalized to a frequently occurring practical case of nonmonochromatic activation by Dobrovolskaya et al.[202] The results of the calculation (Figure 54) indicate a nonadditive response of a glass to the effect of radiation. In other words, the photoinduced optical density of a glass exposed to a superposition of N monochromatic waves of different wavelengths (ΔD_Σ) is not equal to the sum of the photoinduced optical densities produced by each of those light waves separately $(\Delta D_1 + ... + \Delta D_N)$.

FIGURE 54 Modeling of photochromic glass coloration by different sources of monochromatic exciting radiation at λ_1 and λ_2. Sample thickness is 5 mm. a) Dependence of photoinduced optical density on the time of exposure to radiation with different intensities, I_λ a.u.: (1) $100I_1$, (2) $20I_2$, (3) $1I_1$, (4) $100I_1 + 20I_2$, and (5) $1I_1 + 20I_2$. b) Size distribution of color centers after exposure to λ_1 and λ_2 radiation for 600 s up to the same photoinduced optical density.

The above mathematical model was used by Dobrovolskaya et al.[202] for the analysis of the dependence of the photoinduced absorption spectrum of photochromic glass on the emitting spectra of actinic radiation sources. Let us calculate the color center size distributions for two separate cases of exposure to radiation at different wavelengths λ_1 and λ_2 assuming the photoinduced optical density is the same in both cases. Comparing these two distributions, one can see (Figure 54) how they differ: the peak locations do not coincide and neither do their magnitudes and the half-widths of the distributions. This fact can explain the dependence of the photoinduced absorption spectrum on the wavelength of actinic light at monochromatic irradiation, since

$$\Delta D(\lambda) = \lg e \int_0^\infty z(r)\sigma_{cc}^{att}(\lambda, r)dr \qquad (57)$$

where

$$z(r) = \int_0^H c(r, h, t_0)dh$$

Mathematical simulation with the use of the developed kinetic model enables us to describe the dependence of photochromic properties on temperature T. For that purpose, it is necessary to create the model $k_i(T)$ functions that are substituted into the kinetic calculation procedure. The numerical experiments studied the tendencies of the $\Delta D(T)$ function peak position to change with variations in the rest of the parameters of the kinetic model.

6 Technology of Photochromic Glasses

6.1 MELTING AND HEAT TREATMENT

Numerous patents and papers devoted to heterogeneous photochromic glasses point out that, from a technological viewpoint, these glasses are inorganic ones that can be treated using various techniques of melting, pressing from liquid glass melt, rolling, casting into a slab, and so on. In those publications, it is noted that platinum, fused silica, shamotte, etc., can be used as refractory materials in a melting unit. At the same time, photochromic glasses exhibit some specific peculiarities that impose certain restrictions on their technology.

First of all, photochromic glasses are heterogeneous systems consisting of a vitreous matrix and photosensitive microcrystals with sizes ranging within 5 to 25 nm. The objective of technology is to obtain such a two-phase system with homogeneously distributed photosensitive microcrystals.

A two-phase system may be obtained in glass melt with a significant content of photochromic components added to the batch. However, in this case, it is difficult to obtain both uniform distribution of microcrystals over the glass and the required size distribution. Another method of photochromic glassware fabrication that is widely practiced is as follows: a concentration of photochromic components is chosen so that in the melting process at high temperature no oversaturation of the melt with photosensitive compounds is achieved, and the glass is worked out and annealed. Glassware resulting from such processing does not exhibit photochromic properties. Photochromic glasses of this sort are usually called "original" in Russian-language publications. The photosensitive phase is precipitated as a result of additional heat treatment that is carried out in the range near glass transition temperature T_g. For borosilicate glasses, this region corresponds to 500 to 700 °C, depending on the glass composition. The corresponding viscosity range is 10^{10} to 10^{13} Poise.

The simplest schedule of photochromic glassware fabrication, except machining, consists of four stages: melting, rough annealing, additional heat treatment (roasting), and final annealing (Figure 55, curve 1). Rough annealing is usually carried out at temperatures 50 to 100 °C below true annealing temperature in order to inhibit uncontrolled precipitation of the photosensitive phase. More correctly, such annealing is a relatively slow cooling to room temperature, with partial relaxation of stresses, that does not lead the casting to break. It is economically beneficial to eliminate rough annealing and perform the roasting of the casting immediately after it has been worked out (e.g., pressed from a liquid glass melt). Another method can be called "top-to-bottom" heat treatment (Figure 55, curve 2), i.e., from the

FIGURE 55 Temperature vs. time diagram of the heat treatment schedule for photochromic phase precipitation in glasses. (1) bottom-to-top and (2) top-to-bottom.

temperature of pressing,[198] unlike "bottom-to-top" heat treatment when a product is heated from room temperature to roasting temperature. (Figure 55, curve 1).

The choice of an optimal heat treatment schedule is of particular importance because of the mass production of photochromic glasses in continuous-type tank furnaces. The problem is that even for fabrication of spectacle lens castings it is difficult to apply "bottom-to-top" heat treatment. In the manufacturing of, for instance, flat photochromic glass, this type of heat treatment schedule practically cannot be used at all.

Basically, both schedules are aimed at initiating the nucleation of the photochromic phase and sustaining its growth to a certain optimal size. As was experimentally shown by Golubkov et al.,[78] this growth, having as its initial stage the depletion of the oversaturated solution in photochromic components, then enters the stage of recondensation. According to Lifshits and Slyozov,[79] a system (a solid solution with an insignificant oversaturation containing precipitated particles) during the recondensation stage, passes on to universal behavior independent of the initial conditions and does so asymptotically in terms of time t (i.e., at sufficiently long heat treatment duration).

The difference in the results produced by the first and second types of heat treatment schedules (Figure 55) is an indication that asymptotic behavior is not reached in these cases. Therefore for the proper insight into this difference, it is necessary to confine our discussion to the stages of nucleation and particle growth from oversaturated solution and the early period of the recondensation stage when the system is still far from asymptotic and the difference in the initial conditions has a decisive influence on the results of heat treatment. Under the first schedule (Figure 55, curve 1), the glass is cooled from the temperature of melting process T_3 down to room temperature T_1, and then, after reheating, it is annealed at T_2 temperature. When being cooled (Figure 55 region a–b on curve 1), the glass crosses the temperature regions of the growth (Figure 56, curve 2) and of the nucleation (Figure 56, curve 1) of photochromic phase particles.

Usually, these two regions overlap only slightly and, if the cooling rate is not too low, it is legitimate to neglect the growth of photochromic phase particles. At that, the greater portion of the centers of nucleation appears in the vicinity of nucleation rate peak temperature T_m, where growth rate is insignificant. So, at point

FIGURE 56 Dependence of rate of nucleation (1) and rate of crystal growth (2) of photochromic phase on temperature.

b (Figure 55), photochromic phase nuclei are distributed in the sample at random, their concentration is c_{nuc} and the size of most of them somewhat exceeds the critical size typical for the maximum nucleation temperature T_m. The value of c_{nuc} can easily be found only if temperature variations do not bring about, owing to the effects of nonstability, a noticeable change in the nucleation rate compared to the stationary-state value of $J(T,\Delta_{ov})$ (Δ_{ov} is the oversaturation of the glass by the component of precipitated photochromic phase):

$$c_{nuc} = \int_{t_a}^{t_b} J(t,\Delta_{ov})dt = \int_{T_1}^{T_3} \frac{1}{C_T} J(T,\Delta_{ov})dT = \frac{1}{C_{ov}} \int_{T_1}^{T_3} J(T,\Delta_{ov})dT \qquad (58)$$

where the cooling rate, $C = dT/dt$, in the last equality is assumed to be constant. The depletion of the glass in the photochromic components during nucleation may often be neglected, assuming that in this case the oversaturation $\Delta(T)$ is solely determined by temperature dependence of the solubility. The value of $J(T,\Delta(T))$ differs substantially from zero in a relatively narrow temperature range within the interval T_1, T_3, i.e., the value of the integral remains unchanged with the T_1, T_3, interval varying within reasonable limits. Consequently, under the constraints imposed, the number of photochromic particle nuclei in cooled glass is inversely proportional to the cooling rate.

After it has been held at room temperature, the glass is heated to the treatment temperature T_2 (Figure 55, curve 1, segment c–d). In the process, the effects of the nonstability of nucleation may play a more important role than in the process of cooling at the same rate C. That is due to the increasing of critical radius with temperature and is essential in a decrease in the number of new particles nucleating at heating compared to c_{nuc}. As these matters have not yet been resolved in theory, we will not dwell upon them. We will assume only that nuclei concentration at point d (Figure 55, curve 1) is of the order of c_{nuc}. Thus, at point d we have a system of nuclei with their average concentration of $\approx c_{nuc}$, randomly distributed (Poisson distribution) in the medium with oversaturation $\Delta(T_2)$, whereas the

amount of photochromic component dissolved in the glass is close to the initial one. At time t_d, the stage of particle growth in the oversaturated solution commences. In this case, the nucleation of new particles during this stage may be neglected because of the low nucleation rate at T_2 and the presence of a great c_{nuc} value.

As the glass is being progressively depleted of its photochromic component, the oversaturation decreases which causes the increase of the critical radius r_c. When the r_c value becomes comparable with particle average radius r, the growth from the oversaturated solution turns to the recondensation stage. By the time the growth from the oversaturated solution is complete, the concentration of particles has come close to the initial c_{nuc} value, and the distribution function of their volumes in case the growth was controled by volume diffusion may be described approximately by gamma-distribution used by Shepilov and Bochkarev.[99] During the recondensation stage, with increasing time t, there is a decrease in the number of particles, $c(t)$, and an increase in particle average radius $r(t)$. As was noted earlier, of special interest is the commencement of the recondensation stage, when the system has not yet come to universal asymptotic behavior. The kinetics of the initial recondensation stages can be calculated by numeric modeling performed by Shepilov.[206] Shepilov and Dotsenko[207] performed a comparison of the most essential differences between the first and the second types of heat treatment schedules.

Now we turn to the second type of heat treatment schedule (Figure 55, curve 2) in which after melting the glass is allowed to cool to heat treatment temperature T_2, held at that temperature, and then cooled to room temperature. In this treatment process, the particles of the photosensitive phase must both nucleate and grow. In other words, T_2 must fall into the temperature range where the nucleation and growth curves overlap (Figure 56). The changes that occur in this temperature region may be described as follows. Just as it appears, every nucleus grows rapidly from the oversaturated solution, thus depleting the neighboring region of the glass of the photochromic component. Simultaneously with the growth of already nucleated particles, there proceeds the nucleation of new particles in the regions where the oversaturation remains. Here, in contrast to the first heat treatment schedule, the nucleation and particle growth stages merge into one stage of phase separation. In the case of the growth controlled by volume diffusion, it can be described mathematically to some approximation in terms of diffusion simulation (reference the work by Shepilov and Bochkarev[99]). The completion of the initial stage and the beginning of the recondensation stage are due to a fall in oversaturation throughout the glass bulk that terminates the nucleation and promotes a critical radius increasing up to values comparable with the particle average radius.

To characterize the state of the system at the moment when the first stage is completed, it is necessary to know the concentration c_2 of the newly formed particles. The concentration of particles c_2 decreases as the nucleation rate decreases. An increase in the particle growth rate speeds up the depletion of the glass in the photochromic component and likewise draws c_2 down. As a consequence, increasing heat treatment temperature T_2 produces lower particle concentration and, if we neglect the temperature dependence of the solubility, provides the tendency of increasing particle average size with rising T_2 at the end of the first stage of phase

separation. The increase of solubility with rising T_2 will bring about just the opposite — a decrease in particle average size. Taking into account an extremely abrupt fall in the nucleation rate as oversaturation decreases, it is reasonable to assume that the former tendency will prove stronger, i.e., a rise in heat treatment temperature under the second type of schedule will cause an increase in particle average size toward the end of the first stage of phase separation along with the reduction of the total amount of the precipitated phase.

Summarizing, we can say that the processes of nucleation and particle growth from oversaturated solid solution follow essentially different pathways under the heat treatment of the first and second schedules applied to photochromic glasses. That is responsible for different states of the treated sample by the time recondensation begins. Leaving aside the differences in the size distribution functions of the particles, which defines quantitative details in the behavior of particles together, let us dwell on the difference in the concentrations of particles c_1 and c_2, which is more noticeable. The ratio of these concentrations depends on a number of parameters (the rates of nucleation and particle growth, the rates of cooling and heating) and may, in principle, vary within broad limits. While it does not affect c_2 over a wide range of values, the cooling (heating) rate C appears to be a decisive factor for c_1 in the first type of schedule. In the case of high C values, not considered here, nucleation does not take place in the course of cooling and heating (Figure 55, curve 1 a–d), i.e., $c_1 \Rightarrow c_2$ at $C \Rightarrow \infty$.

At finite high values of C, the additional nucleation at the stages of cooling–heating, will lead to $c_1 > c_2$. Finally, as C is reduced further, a situation arises when the nucleation in the process of cooling–heating becomes so great that the additional particles produced in the course of annealing may be ignored. In this circumstances $c_1 \gg c_2$. Of course, the criterion of the "quickness" of the cooling process is connected with the values of nucleation and growth rates.

The two types of heat treatment schedules will differ essentially in satisfying the latter inequality. Then, the recondensation will commence at high concentration c_1 of fine particles,

$$r \approx [\Delta(T_2)/c_1]^{1/3} \tag{59}$$

in samples treated according to the first schedule and at low concentration c_2 of coarse particles,

$$r \approx [\Delta(T_2)/c_2]^{1/2} \tag{60}$$

in the case of the second type of heat treatment schedule. Particle size in the samples of the first type of heat treatment can be increased to the value of r in the course of recondensation. However, because particles are growing more rapidly in the oversaturated solution ($r \approx t^{1/2}$) than they are in the process of recondensation ($r \approx t^{1/3}$), total heat treatment time required for particle average size to have reached r_2 value will be longer for first type of schedule than for the second type.

Therefore heat treatment schedules of the second type appear to be more economical because they produce the required particle average size more quickly. Moreover, were it not for the complication of temperature dependence on the solubility, it would be possible, by varying T_2, to achieve easily a ratio of nucleation and growth rates that would produce a specified average particle size in heat treatment of the second type immediately after the growth of particles in an oversaturated solution has been completed (i.e., well before the onset of recondensation, which is a slow process).

FIGURE 57 Schematic diagram of a belt furnace for top-to-bottom heat treatment of photochromic castings.

It is easy to understand why the growth of particles in oversaturated solution is more economical than recondensation. Indeed, when particles are growing in oversaturated solution, the precipitating phase diffuses from glass bulk to a particle only once, whereas in the case of recondensation the same result is achieved by multiple transfers of the substance from finest particles to progressively coarser ones along a dog-leg trajectory — a far longer way to travel. Furthermore, at the growth from an oversaturated solution, the diffusion is induced by greater concentration gradients than at recondensation, which also helps make the first type of heat treatment more efficient compared to its second-type counterpart.

Possibly, top-to-bottom heat treatment cannot be applied to all photochromic glasses, although this method has been carried out for copper halide photochromic glasses manufactured in the Soviet Union as FHS-7 and FHS-8.

Top-to-bottom heat treatment allows one to speed up the process of phase precipitation many times: when following this method, the roasting of FHS-7 type glasses takes 15 to 20 minutes. That provides an opportunity to use belt kilns and to apply the individual pattern of the processing of photochromic glassware (Figure 57). The design of a belt kiln supposes only one casting of photochromic glass placed on the moving belt. In this case, the complete identity of photochromic properties from casting to casting (the reproducibility) is achieved and the need to deal with the complicated task of maintaining a gradient-free temperature field in the kiln is avoided. One should also remember that the method of top-to-bottom heat treatment implies the application of relatively high temperatures, which may result in distortions of the geometry of the final casting shape. To eliminate the latter possibility, the belt of a kiln should be equipped with special sockets preserving the shape of the casting from distortions.

If the original (nontreated) glass is subjected to polythermal analysis (see the work of Mukhin et al.[208]) throughout a wide temperature range, the result may be as depicted in Figure 58. In the temperature region below T_g no changes are observed (Figure 58, region 1). Beyond T_g is located the region of photochromic glass roasting (Figure 58, region 2); its limits vary depending on the time schedule of the heat treatment. For instance, at short heat treatment times, the limits are shifted toward high temperature regions, while at longer times they are shifted toward low temperature regions.

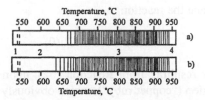

FIGURE 58 The view of original glass FHS-3 after heat treatment in gradient furnace (polythermal study) for different times, h: (a) 6, (b) 24. (1) transparent original glass, (2) transparent glass with photosensitive microcrystals, (3) total crystallization, and (4) transparent glass without photosensitive microcrystals.

The upper boundary of the second region separates transparent glasses from opalescent ones. As temperature rises further, the photosensitive phase becomes soluble in the host glass — i.e., the temperature of the immiscibility dome has been achieved. The heat treatment of the glass in temperature region #4 makes photochromic properties disappear. We have shown that temperature-induced transformations in photochromic glasses are wholly reversible. In other words, the roasting of an original glass sample and of one of the glasses treated in the fourth temperature region, under one and the same schedule, brings about identical photochromic properties. The latter provides the opportunity to carry out repeated pressing of castings rejected as defective.

The analysis of the data obtained by the polythermal method allows one to conclude that photochromic glasses are a thermosensitive material. This feature of the glasses imposes certain limitations on the application of different processing techniques. Only those workout methods should be used that, having been applied to a product, would keep it in regions 2 and 3 (Figure 58) for a limited period. The details pointed out above naturally complicate the fabrication of large castings from photochromic glasses (e.g., flat glass for window panes), of products with sophisticated shapes (car windshields), etc. The most favorable article to be fabricated from photochromic glasses is a casting for a spectacle lens or a filter of 70 to 120 g made by pressing the liquid glass melt.

Another distinguishing feature of photochromic glasses is that their properties are determined by the precipitated crystalline phase. As a result, there is noticed a sensitivity to impurities unusual for glass technology, small fluctuations in redox and temperature melting conditions. As a rule, the process of melting silver halide glasses should be carried out under neutral or slightly oxidizing conditions. On the

other hand, the synthesis of copper halide glasses is carried out under reducing conditions. The latter is explained by the fact that only $CuCl$ microcrystals perform photochemical activity, whereas the absorption by double-charged copper dissolved in the glass reduces the transparency of a nonirradiated glass.

When choosing the reducing agent, one should take into account that, along with the reaction

$$Cu(II) + red = Cu(I) \tag{61}$$

there also may take place the reaction

$$Cu(II) + red = Cu(0) \tag{62}$$

Elementary copper resulting from Reaction (62), upon coagulation, produces strong colloidal coloration ("copper ruby"), which obviously also reduces the initial transparency of the photochromic glass. Therefore, the synthesis of copper halide photochromic glasses should be carried out under intermediate redox conditions. Fluctuations in these conditions will bring about a variation in the equilibrium between different valence forms of copper that will consecutively affect the photochemical properties of the glass. The optimal conditions for photochromic glass melting assume a melting performed in a closed space under oxygen partial pressure maintained at a certain constant level. Only this method will provide strict reproducibility of the properties from melting to melting.

When the usual methods of synthesis are used, approximately similar results can be gained provided there is the addition to the glass of some excess amounts of another variable valence oxide (R), e.g., SnO_2, As_2O_3, Sb_2O_3 etc. Then, at the melting process, the following reaction will proceed:

$$2Cu_2O + O_2 \Leftrightarrow 4CuO \tag{63}$$

$$2RO + O_2 \Leftrightarrow 2RO_2 \tag{64}$$

including the interaction between polyvalent ions and copper ions:

$$2\ CuO + RO \Leftrightarrow Cu_2O + RO_2 \tag{65}$$

In an open system, an equilibrium between the ions is established, independent of whether other polyvalent ions are present or not. However, under real conditions of limited oxygen intake through the glass melt surface, the combination of those three processes may produce a stationary state that is characterized by the Cu^{2+}/Cu^+ ratio being maintained at the same level throughout the whole melting process on the condition that the temperature was constant. The value of Cu^{2+}/Cu^+ ratio will be determined by the polyvalent ion used, its concentration in the glass, the synthesis temperature, and the specific features of the melting vessel (its shape, capacity, etc.).

Figure 59 illustrates how the Cu^{2+}/Cu^{+} ratio varies in a soda-borate glass with the content of polyvalent element oxide. The strongest reducing agents, under these conditions, are stannous ions, while arsenic oxides force the $Cu^{2+} \Leftrightarrow Cu^{+}$ equilibrium to the left. As is seen from Figure 59, when a high concentration of the variable valence element oxide is added to the glass, a saturation effect is observed. A glass containing such amounts of variable valence element oxide can be regarded as a buffer system.

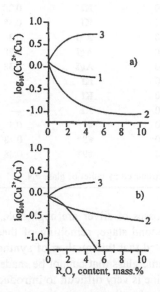

FIGURE 59 Effect of content of SnO_2 (1), Sb_2O_5 (2), and As_2O_5 (3) on the Cu^{2+}/Cu^{+} ratio in glasses melted at 1200 °C (a) and 1400 °C (b).

One more peculiarity of heterogeneous photochromic glasses is an extremely high volatility of the photochromic components being added (see Table 3). Chlorides and bromides of alkali metals are volatile, silver chloride boils at 1550 °C without decomposition, and Cu_2Cl_2 boils at 1366 °C. The silver, copper, and halide volatility was the subject of studies that included using radioisotopes (see, e.g., Pavlovsky et al.[209]). Experiments on the problem have shown that, during the melting process, about 30% of silver and 70% of halides are lost. At that, 60% of those losses take place at the stage of batch loading. Increasing melting time or temperature make those losses grow. In the development of heterogeneous photochromic glass manufacturing technology, one should be guided by two principal considerations: melting should be conducted with minimal duration and the lowest possible temperature. In this sense, the most beneficial method is glass synthesis using batches prepared by deposition from solutions. This method allows one to diminish silver and halide losses by 15 to 20%, even without changing the temperature of melting.

Another way to decrease silver and halides losses is a two-stage method of synthesis. At the first stage, two glasses of the same basic composition are synthesized, each containing either silver or halides. Under these conditions, (temperatures

TABLE 10
Effect of Glass Components on Iodine Losses in Melting Process

#	Glass	Melting Temperature, °C	Component Introduced	Content by Synthesis Ag	Content by Synthesis I	Total Losses of I by Analysis %
1	Silicate	1500	KI	0.3	0.3	100
2	Germanate	1150	KI	0.28	0.3	94
3	Borate	900	KI	0.38	0.3	95
4	Silicate	1500	AgI	0.3	0.3	100
5	Germanate	1150	AgI	0.28	0.3	83
6	Borate	900	AgI	0.38	0.3	98
7	Silicate	1500	KI	—	0.3	50
8	Germanate	1150	KI	—	0.3	30
9	Borate	900	KI	—	0.3	20
10	Silicate	1500	#7*	0.3	0.3	30
11	Germanate	1150	#8*	0.28	0.3	40
12	Borate	900	#9*	0.38	0.3	30

* Iodine in these glasses was introduced by cullet of glass #N.

of 1400 to 1500 °C), the losses of silver are negligible, and the losses of halides decrease as well. At the second stage, remelting of these two glasses together is carried out. It should be noted that this method of synthesis allows one to produce a heterogeneous photochromic glass that cannot be made by traditional methods of synthesis. For example, iodine is very difficult to introduce into glass. In a common synthesis technique, the use of radioactive isotopes determines about 100% losses (see Table 10). As an indicator, I^{131} was used (I^{131} is a β, γ emitter with a half-life of eight days). At that, iodine losses can be detected at the stage of batch making by the release of iodine according to the reaction

$$Ag^+ + I^- = Ag^0 + I^0 \tag{66}$$

Using the two-stage method allowed iodine sensitization to be successfully achieved. Belous et al.,[210] using low-temperature luminescence analysis, have detected iodine entering the lattice of **AgHal** microcrystals distributed in glass.

It is somewhat easier to introduce bromine into glass, but the losses also occur in this case, being 30 to 90% (see Table 11). The extent of losses depends strongly on glass composition, the temperature of melting, and the imposed redox conditions. To obtain the data listed in Table 11, a radioactive isotope of **Br**[82] was used as an indicator, a β, γ-emitter with a half-life of 36 days. The isotope, as it was in the case of silver and iodine loss examination, was introduced into the batch prepared for glassmaking. Analyzing the results given in Table 11, it can be seen that, as it is for silver, the major portion of bromine losses take place in the batch loading process and at the first stage of melting. We can also notice that oxidizing melting conditions increase bromine losses. Chlorine included in the batch shows a very strong effect

TABLE 11
Effect of Sodium-Containing Components and Chlorine Content on Bromine Losses in the Melting Process

Melting Condition	Content of Halide by Synthesis		Bromine Loss, %	
	Cl	Br	After 30 min.	Total
A	—	0.52	55	58
A	0.28	0.52	73	74
A	0.40	0.52	85	87
A	0.53	0.52	90	90
B	—	0.52	47	66

Note: Basic glass composition (mass %): SiO_2 — 64, B_2O_3 — 21.5, Na_2O — 9.0, Al_2O_3 — 5.5, Ag — 0.34. Melting condition: Na_2O was introduced with Na_2CO_3 — A or with $NaNO_3$ — B.

on bromine losses during the melting. Obviously, chlorine forces bromine out of the glass.

The high volatility of the photosensitive component imposes certain restrictions on the usage of return cullet. Indeed, compared to the cullet, the batch contains much greater halide content and about 30% more silver and copper.

Also, it should be noted that it does not really matter what particular batch component is used for adding a halide to the glass. Figure 60 illustrates that the more chlorine that remains in the glass, the less silver remains there. In addition, silver losses evidently grow in the series $KCl \rightarrow NaCl \rightarrow LiCl$. Artamonova and Solinov[211] have shown that using bivalent metal chlorides as batch components leads to an additional increase of silver losses in the series

$$MgCl_2 \rightarrow CaCl_2 \rightarrow SrCl_2 \rightarrow BaCl_2 \rightarrow ZnCl_2 \rightarrow CdCl_2 \qquad (67)$$

Especially significant silver losses are observed when chlorine is introduced to the batch by zinc and cadmium chlorides.

A thorough examination of the dependence of silver ion content on the content of chloride ions remaining in the glass shows that the product of these two values is constant in certain concentration limits and, similar to the case of aqueous solutions, can be called the solubility product. In alkali-borate glasses this value, depending on the batch component used for adding chloride, is $(0.2 \text{ to } 2.0) \times 10^{-13}$ mol^2/l^2 (see Artamonova and Solinov[211]).

The primary conclusion is that the more halide that remains in the glass, the higher the probability of **AgHal** molecule formation right in the melt and the higher

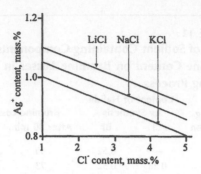

FIGURE 60 Dependence of silver content in glass on chlorine content (by analysis) when different alkaline chlorides were used as batch components.

the probability of silver losses due to volatility. In addition, as is seen from Figure 60, the probability of a substitution reaction like

$$KCl + AgNO_3 \Rightarrow AgCl + KNO_3 \tag{68}$$

proceeding in the glass melt apparently decreases in the series $LiCl \rightarrow NaCl \rightarrow KCl$. There are certain reasons to believe that further growth of the probability of such a reaction of substitution would be observed at the interaction of $AgNO_3$ with $ZnCl_2$, $CdCl_2$, and $BaCl_2$.

In conclusion, we should note two more methods available of manufacturing heterogeneous photochromic glasses. They are the method of ion exchange (see the works by Garfinkel[212] and Vikhrov and Karapetyan[213]) and the method employing porous glass (see Tsekhomskaya et al.[214]).

It should be noted that, initially, both methods seemed promising because they provided the opportunity to obtain photochromic glasses with an increased concentration of photosensitive component, and they should have diminished the unrecoverable losses of silver, and so on. However, the two methods did not permit the development of a variety of photochromic glasses with the different properties provided by the traditional method of synthesis.

6.2 EFFECT OF COMPOSITION ON PROPERTIES

As has been mentioned, the properties of heterogeneous photochromic glasses depend essentially on the concentration, the size, and additive composition of the photosensitive phase distributed in the glass host. It is the chemical composition of the glass host that mainly influences these characteristics formed in the processes of melting and heat treatment. In this section, major attention is paid to silver halide photochromic glasses, in which those problems are most thoroughly solved and can be reliably interpreted. First of all, we should turn to glass components that directly affect the silver halide phase: silver, halides, and additives included in photosensitive microcrystals (sulfur, copper, cadmium, lead, zinc, and some other elements).

6.2.1 Silver Chloride

At present, studies pay intense attention to photochromic glasses doped with silver chloride. This is explained by the fact that the chloride, in the set of silver halides, is thermally most stable. AgCl boils without decomposition at 1550 °C, whereas AgBr decomposes at 700 °C and AgI at 552 °C.

One of the first works on photochromic glasses carried out by Stookey[215] presented data reporting that the total content of silver in such glasses is in the range of 0.2 to 0.7 mass % in transparent and 0.8 to 1.5 mass % in opalescent glasses, while the chlorine content varies within limits sufficient for stoichiometric reaction with 0.2 to 0.4 mass % silver. We should note that chemical analysis data do not allow definite conclusions concerning the AgCl-phase volume content in glass because a certain portion of silver and halides will always remain in the vitreous host.

Neither can AgCl-phase volume content be used for obtaining data on those optical techniques (see Chapter 3) that only determine that the microcrystal phase has precipitated from the inorganic glass host. Even in the case of copper halide photochromic glasses, where exciton absorption typical for copper halide crystals[90] serves as a good tool to determine the copper halide phase present in glass, quantitative evaluations of the phase volume content are difficult (see Kuchinsky[216]).

There are no methods at present that give comprehensive information on the composition of silver halide crystals precipitated in photochromic glass. Some results were obtained with the use of the X-ray analyzer in the works by Glimeroth et al.[64,106] Balta et al.[217] studied silver halide phase precipitated in glass through X-ray fluorescence. The results obtained allowed the authors to conclude that the photochromic glass X-ray fluorescence spectrum significantly differs from that obtained in pure AgCl crystals. The authors[217] suggested that this difference is explained by the presence of some amounts of metallic silver, borates, and oxygen and alkali ions in the photosensitive phase.

As an example we will consider in detail the properties of photochromic glasses of a $K_2O-B_2O_3$ system doped with AgCl microcrystals (see Table 12). The major conclusion that the data given in Table 12 permit is that photochromic properties of glasses depend both on glass host composition and on the ratio of silver and chlorine introduced into the glass. One can note that the decrease of the Ag/Cl ratio is followed by the growth of the relaxation rate (K_{rel}), while darkening degree, which is itself a function of the fading rate (see Chapter 5), is characterized by a more complicated dependence. It should be noted that such a conclusion is correct only if the host composition, melting conditions, and either Ag or Cl remained constant.

For the examination of the influence of glass composition on photochromic properties it is helpful to use the chemical analysis data of the glasses for silver and halide (chloride) content. However, in this case too, as was already mentioned, there is no strictly uniform interpretation of the results.

Consider the properties of three samples of soda-aluminum-borosilicate glasses of the same composition by synthesis (FHS-1) melted in 100-liter silica crucibles under identical schedules. These glasses were doped with silver (see Table 13). The relative similarity of the chemical analysis data suggests that the glasses should possess similar properties. However, the results obtained after a heat treatment

TABLE 12
Photoinduced Absorption (ΔD_3) and Criterion of Relaxation (K_r) of K_2O–B_2O_3 Glasses Doped with AgCl Microcrystals

Glass Number	Glass Composition, mol %		Photochromic Components (above 100%)		Photochromic Properties	
	K_2O	B_2O_3	Ag	Cl	ΔD_3	K_r, %
1	4	96	1	2	0.06	40
2	6	94	1	2	0.17	33
3	8	92	1	2	0.19	33
4	10	88	1	2	0.48	27
5	12	86	1	2	0.28	50
61	14	86	1	0.25	0.33	17
62	14	86	1	0.5	0.44	28
63	14	86	1	2	0.12	97
64	14	86	1	3	0.10	100
65	14	86	1	4	—	—
7	16	84	1	4	0.14	91
81	18	82	1	0.25	—	—
82	18	82	1	0.5	0.1	33
83	18	82	1	1	0.36	41
84	18	82	1	2	0.5	83
85	18	82	1	4	—	—
86	18	82	2	4	0.47	41

TABLE 13
Chemical Analysis of Photochromic Glass (FHS-1) Obtained from Three Consequent Melts under the Same Conditions

Melting Number	Ag	Cl	Ag/Cl
1	0.17	0.36	0.47
2	0.23	0.50	0.44
3	0.17	0.44	0.38

standard for such glasses (620 °C, 2 hours) appeared to have strong differences: the photochromic properties of glass 1 (Table 13) were usual for such glasses; an intense opalescence manifested itself in the samples of glass 2; complete absence of photochromic features was observed for the samples of glass 3. Any kind of heat treatment applied to glass 3, even at temperatures far beyond T_g, did not bring about silver chloride microcrystal precipitation. This could be legitimately concluded from

the absence of any displacement of the absorption edge of the glass after the heat treatment had been carried out (see Chapter 4).

In connection with that, we should note that besides the requirement of a considerable oversaturation of the glass in its photosensitive component, a necessary condition for phase precipitation is the presence of nucleation centers. Such centers usually are silver atoms or their aggregates, alkaline metal fluorides, etc. At comparatively high total concentration of silver, the following process may take place:

$$Ag^+ + red \Rightarrow Ag^0 \qquad (69)$$

Singly charged copper can work as a reducing agent in such a reaction that, as we will show, is used for sensitization. Table 14 illustrates these considerations. One can see that, at sufficiently high silver content, it is silver that serves as a nucleation center of phase precipitation, while at low silver content, the role of nucleation center is taken on by fluorides.

TABLE 14
Effect of Silver and Fluorine
Content (mass %) on
Photoinduced Coloration
of Glass

Ag	F	ΔD_3
0.3	0.035	1.15
0.25	0.035	0.86
0.13	0.035	0.04
0.10	0.035	0
0.10	1.4	0
0.10	2.7	0.16
0.10	4.5	0.47

Returning to the glasses whose analyses are given in Table 13, we can suppose that the most probable explanation for the absence of sensitivity of glass 3 with respect to heat treatment is associated with the absence of the nucleation centers of phase precipitation in that glass while being thermally treated. It is known that ionizing radiation is used for the creation of nucleation centers in photosensitive and polychromatic glasses containing silver, gold, etc. (see the works by Stookey et al.[218] and by Trotter[219]). It is worth noting that γ-irradiation of glass 3 (Table 13) and subsequent heat treatment resulted in photochromic properties performed by this glass, i.e., caused the precipitation of a photosensitive phase in this glass.

Let us examine in more detail the effect of preliminary γ-irradiation on the properties of heterogeneous photochromic glasses. These glasses, by their response to such an exposure, can be divided into three groups:

1. γ-irradiation does not affect the properties (sample FHS-1/1, Table 15).
2. γ-irradiation affects the properties (sample FHS-1/2, Table 15).
3. γ-irradiation triggers the precipitation of a photosensitive phase (sample FHS-1/3, Table 15).

TABLE 15
Effect of γ-Irradiation on Photochromic Properties of FHS-1 Glass

Sample Number	γ-Irradiation Dose	Heat Treatment °C, min	D_0	ΔD_3	K_r, %
1/1	—	620, 90	0.09	0.60	55
1/2	9×10^5	620, 90	0.07	0.56	59
1/3	3×10^6	620, 90	0.07	0.55	60
2/1	—	640, 40	0.15	0.95	16
2/2	10^4	640, 40	0.09	0.98	28
2/3	2×10^4	640, 40	0.08	0.97	34
2/4	4×10^4	640, 40	0.05	0.87	28
2/5	7×10^5	640, 40	0.04	0.81	24
3/1	—	620, 120	0.04	—	—
3/2	10^4	620, 120	0.05	0.02	19
3/3	2×10^4	620, 120	0.12	0.12	11
3/4	4×10^4	620, 120	0.07	0.70	24
3/5	6×10^4	620, 120	0.05	0.82	16

Examination of the results presented in Table 15 shows that in the case of the first group of samples subjected to γ-irradiation there is observed an insignificant shift of the absorption edge toward the UV end of the spectrum that leads to an increase in the integral transmittance of the initial nonirradiated glass (D_0) and a decrease of the coloration (ΔD_3). These changes, logically, can be attributed to decreasing microcrystal size that is connected with the growth of nucleation center concentration.

Largely similar phenomena, although enhanced, are observed at γ-irradiation of FHS-1/2 glass before its heat treatment (Table 15, Figure 61). It is seen that, although opalescence is typical for the nonirradiated glass, as the irradiation proceeds, this opalescence disappears, whereas the absorption edge shifts toward the long wavelength end of the spectrum. Such a feature is observed until a certain dose is accumulated (10^5 R, in this case). Further increasing of the dose does not affect the position of the absorption edge.

One can see the effect of nucleation center concentration on the size and concentration of the photosensitive phase precipitated at the heat treatment of glass FHS-1/3 (Table 15, Figure 62). This nucleation center concentration varies from zero in the glass that is heated without irradiation up to the saturation level, when the further increase of the exposure to γ-radiation does not affect the properties of the precipitated photosensitive crystalline phase.

Glasses of the FHS-1/3 type are of extreme interest from a practical viewpoint because they allow different thermal influences that are necessary for the manufacturing of products of various shapes and sizes and do not bring about crystal phase precipitation. Also, such glasses can be used relatively easily for the fabrication of products that have only some separate parts with photochromic properties in them.

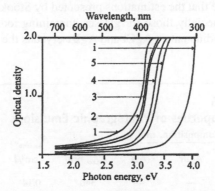

FIGURE 61 Absorption spectra of FHS-1/2 glass samples (thickness is 5 mm). Parameters of γ-irradiation and heat treatment are in Table 15, (i) is the nontreated initial glass.

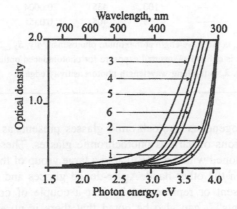

FIGURE 62 Absorption spectra of FHS-1/3 glass samples (thickness is 5 mm) Parameters of γ-irradiation and heat treatment are in Table 15, (i) is the nontreated initial glass, (6) irradiated with $2 * 10^5$ R, nontreated.

6.2.2 SILVER BROMIDE

To solve many practical problems associated with the use of photochromic glasses, a binding requirement is the shifting of the sensitivity edge toward the long wavelength end of the spectrum. It should be noted that in the case of photochromic glasses, their optical sensitization by means of organic pigments widely used in practical photography is impossible. At the same time, the range of inorganic

sensitizers, in terms of the conclusions made in the work by Sviridov[220] and Moser et al.[221] is rather scanty.

In another study[215] it was shown that bromine-containing photochromic glasses were photosensitive up to 500 nm (2.5 eV), whereas iodine-containing ones were photosensitive up to 600 nm (2.1 eV). Table 16 lists some data borrowed from Gorokhovsky[47] regarding the photosensitivity of silver halide photographic emulsions. One can suppose that the estimations presented by Stookey[215] were apparently somewhat high — especially those for glasses containing iodine. Also noteworthy is the fact that when iodine enters **AgCl** and **AgBr** crystals the photosensitivity falls abruptly.

TABLE 16
Some Properties of Photographic Emulsions

| Emulsion Composition, mol % | | | | $S_{\lambda_{max}\cdot10^{-7}}$, | |
AgCl	AgBr	AgI	λ_{max}, nm	cm^2/J	l_b, nm
100	—	—	340	0.14	408
50	50	—	375	0.27	457
—	100	—	385	0.22	475
—	90	10	455	0.11	522
—	70	30	475	0.002	530
—	—	100	435	0.0004	455
95	—	5	405	0.055	475

Note: λ_{max} is the wavelength at maximum photosensitivity, $S_{\lambda_{max}}$. Photosensitivity is defined as inverted exposure for photoinduced optical density of 1.0. λ_b is the long wavelength photosensitivity edge.

Patents on heterogeneous photochromic glasses present, as examples, a large number of compositions of various photochromic glasses. These patents deal primarily with glasses doped with **AgCl(Br)**, and a large group of them present glasses doped with **AgCl**. On the other hand, **AgBr**-doped glasses and glasses containing iodine are either absent or represented by just a couple of compositions in the majority of the patents. It can also be noted that there is no essential difference between **AgCl**-doped glasses and those containing bromine. There are no specific features in the technology of the manufacturing of glasses containing the **AgBr** phase. Higher temperature and longer duration of the heat treatment for **AgBr**-doped glasses should be noted. Similarly, the substitution of bromide for chloride results in an increase of silver losses because of silver reduction, in increasing the photosensitivity in the long wavelength part of the spectrum, and in decreasing the integral photosensitivity.

When bromine is introduced into glass, a relatively sharp growth of silver losses is observed, while the total halide content in the glass, as estimated by analysis, is not essentially changed. Moriya[222] has shown that the ratio **Cl**/(**Cl** + **Br**) determined

from synthesis has not been changed throughout the glass melting phase, whereas the photosensitivity edge has been steadily shifting to the long wavelength end of the spectrum from 410 to 470 nm (3.0 to 2.6 eV) with the decreasing of that ratio. Since glass samples are considered that have been thermally treated under the same schedule, we can state that microcrystals of equal mean size have been obtained in those glasses. The growth of the mean size of photosensitive phase microcrystals makes the absorption edge shift to longer wavelengths (Figure 26) and, thus, the photosensitivity spectrum changes (see Chapter 3).

For a qualitative analysis of the composition of the silver halide phase precipitated in photochromic glasses, Belous et al.[143,210] used the method of low-temperature luminescence that had been described in detail earlier by Meiklyar.[4] Belous et al.[143] investigated photochromic glasses doped with **AgCl** and **AgCl(Br)** at the temperature of 77 K (Figure 63). One can see that there is a band in **AgCl**-doped photochromic glass luminescence spectra, with the peak in the range of 480 to 490 nm (2.5 to 2.6 eV), that is typical for silver chloride (Figure 63, curve 1).[4] In the case in which bromine was added to the glass (Figure 63, curve 2), there is observed the luminescence characteristic for **AgBr** single crystals free from **AgCl**[143] (Figure 63, curves 3 and 4). The latter can be explained by the fact that in **AgCl(Br)** microcrystals distributed in the glass host, at a high concentration of defects, holes are able to move only along the bromide sublattice, as the energy of electron–bromine ion bonding is lower than that of electron–chlorine ion bonding. As a result, the energy will be rendered only to the centers existing in bromide surroundings.

FIGURE 63 Luminescence spectra of: (1) photochromic glasses doped with **AgCl**, (2) photochromic glasses doped with **AgCl(Br)**, (3) **AgBr** single crystals before quenching, (4) **AgBr** single crystals after quenching.

6.2.3 SILVER IODIDE

As we already mentioned, Stookey[215] has assumed that the introduction of iodine into photochromic glasses doped with silver halide must force a shift in the photosensitivity edge to 600 nm (2.1 eV). At the same time, it was noted by Gorakhovskii[47] (see Table 16) that the spectral sensitivity edge of the **AgBr–AgI** mixed phase is located at about 530 nm (2.34 eV). It is also known that **AgI** crystals have a com-

paratively low photosensitivity of their own. For example, Sviridov[220] has shown that an exposure of **AgI** crystals to illumination so intense that **AgCl** and **AgBr** are not only colored but even partially decomposed, will cause just a slightly noticeable darkening of silver iodide.

Some compositions of iodine-containing glasses are given in patents and a few papers (e.g., by Schleifer[223] and Pavlovsky et al.[224]). At the same time, as was noted in Section 6.1, the introduction of **KI** into the batch leads to almost complete loss of iodine in melting. Only a special method, as described in Section 6.1, allows one to keep some amount of iodine (0.06 to 0.1 mass %) in a photochromic glass.

Figure 64 shows the low-temperature luminescence spectra of photochromic glasses doped with iodine by the method described above. The observed green luminescence with λ_{max} = 540 nm (2.3 eV), according to Farnel et al.,[225] in **AgBr(I)**-phosphors is due to the effect of iodine. One can see in Figure 64 that the intensity of green luminescence is proportional to the iodine concentration. This proves that iodine is responsible for this radiation. In addition, as the content of iodine increases, the peak of this luminescence is shifted toward the long wavelength end of spectrum. This is also a typical feature of **AgHal**-phosphors containing iodine (see Belous et al.[226]).

FIGURE 64 Luminescence of photochromic glasses doped with iodine: a) Low-temperature luminescence spectra for iodine concentration, mass %: (1) 0.12 and (2) 0.15. b) Dependence of the luminescence intensity on the iodine content.

Table 17 gives some spectral and photochemical data for FHS-3 photochromic glass and for analogous glasses doped with iodine (iodine content was estimated using a luminescent method). In this particular case, there is no reason to talk about optical sensitization. Moreover, there are reasons to believe that in the case of silver halide photochromic glasses there is no optical sensitization on iodine addition at all.

When manufacturing silver halide photographic emulsions containing iodine, due to the lower solubility of **AgI** in water, the aggregates of **AgHal**-phase solid solution grow on **AgI** crystals. Silver bromide and chloride (having the cubic lattice of the sodium chloride pattern[227]) differ from silver iodide (γ-**AgI** below 137 °C which has the cubic lattice pattern[227] of sphalerite) in their crystal structure. Therefore, such a codeposition will naturally result in a large number of defects and gives rise to the growth of sensitivity of the photographic emulsions (see Novikova[228]). In that very case, when **AgI** microcrystals are segregated on the surface of the **AgHal** phase, an opposite effect is observed, i.e., a decrease in the photosensitivity[220] that is explained by a low photosensitivity of **AgI** crystals.[47] Plausibly, in the case of iodine-containing photochromic glasses, **AgCl** is precipitated upon the AgI microcrystal surface. It could cause the difference in the solubilities of **AgI**, **AgCl**, and **AgBr** in glass similar to photographic emulsions.

TABLE 17
Effect of the Iodine Content in Microcrystals (Tested by the Luminescence Intensity at 540 nm) on Spectral Properties of FHS-3 Type Glass

Sample Number	Luminescence Intensity at $\lambda = 540$ nm	ΔD_3	λ_b, nm	$\lambda_{D=1}$, nm
FHS-3(11)	1	0.55	490	413
FHS-2(12)	0.9	0.50	470	440
FHS-3(13)	0.4	0.40	510	402
FHS-3(14)	0.2	0.44	510	406
FHS-3	0	0.48	510	413

Note: λ_b is the long wavelength photosensitivity edge, and $\lambda_{D=1}$ is the long wavelength absorption edge at which the optical density of a 5-mm thick sample is equal to 1.

6.2.4 COPPER ADMIXTURE

The composition of the additives to a photosensitive phase distributed in a vitreous host affects all photochemical properties of the glass to a great extent. It is known[220] that pure, low-defect crystals of silver bromide and chloride are photosensitive though only at their surface. However, in the case of **AgCl** and **AgBr** crystals grown without contact with air, i.e., when their surface could not have been contaminated by **Ag₂O** traces, both surface and bulk photosensitivity are absent.

Additives of various types considerably enhance silver halide photosensitivity. It is known that the photosensitivity of photochromic glasses can also be increased by adding various dopants that cause partial reduction of silver. For that purpose, photochromic glasses are doped with low-temperature reducing agents, such as **SnO** in the amounts of 0.002 to 0.1%, **FeO** — 0.002 to 0.2%, **As₂O₃** — 0.004 to 0.1%, and **Sb₂O₃** — 0.04 to 0.1%.

In all the works dealing with silver halide photochromic glasses, copper ions played an essential part in the generating of photosensitivity. Copper content ranges in very narrow limits of 0.016 to 0.20 mass %. Our extensive experimental investigations have shown that photochromic properties can also be obtained in glasses containing no copper ions, although the size of **AgHal** microcrystals should exceed 20 to 30 nm. Such glasses exhibit quite an intense opalescence. Copper additives allow one to obtain transparent photochromic glasses with microcrystals of sizes under 5 nm. The addition of copper to such glasses displaces the absorption edge not only of the initial (thermally nontreated) glasses but of those in which the photosensitive phase has already been precipitated (Figure 65).

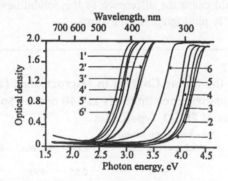

FIGURE 65 Absorption spectra of original glasses before heat treatment (1–6) and of the same glasses after heat treatment (1′–6′) doped with **Cu₂O**, mass %: (1) 0, (2) 0.04, (3) 0.08, (4) 0.15, (5) 0.31, and (6) 0.77. Sample thickness is 5 mm.

Figures 66 and 67 illustrate the effect of copper ions on the photochromic characteristics of glasses doped with **AgCl** (Figure 66) and **AgCl(Br)** (Figure 67). In **AgCl**-doped glasses (Figure 66), as copper content increases, the photosensitivity of the glass grows, which leads to an increase in the coloration value (ΔD_3). On the other hand, the observed growth of the relaxation rate with copper concentration must lead to decreased coloration. The interference of these two factors is the cause of the peak rising in the curve $\Delta D_3 = f[Cu]$. In the case of **AgCl(Br)**-doped glasses, even $K_r = f[Cu]$ dependence is described by a curve with an extremum (Figure 67c, curve 1). As for photoinduced optical density, its dependence on copper content in the glass has three extremum points (Figure 67 a, b).

In the low-temperature luminescence spectra[143] of photochromic glasses doped with **AgCl(Br)** microcrystals (Figure 68), besides the luminescence bands discussed above (Figure 63) in the range of 580 to 680 nm (2.1 to 1.8 eV) that are ascribed to free silver,[229] an additional luminescence is observed with λ_{max} at 740 to 760 nm

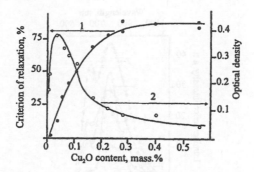

FIGURE 66 Dependence of photochromic properties of glasses $18K_2O-82B_2O_3$ doped with AgCl on copper content (by synthesis). (1) criterion of relaxation (K_{rel}), and (2) photoinduced optical density (ΔD).

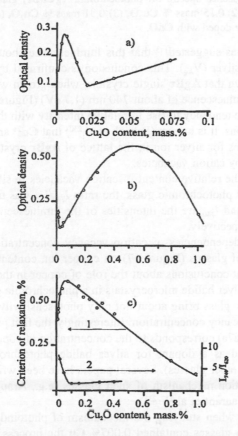

FIGURE 67 Dependence of photochromic properties of $Na_2O-Al_2O_3-B_2O_3-SiO_2$ glasses doped with AgCl(Br) on copper content (by synthesis). a) and b) photoinduced optical density, sample thickness is 5 mm. c) (1) Criterion of relaxation (K_{rel}), (2) ratio of luminescence intensities at 740 and 620 nm I_{740}/I_{620}.

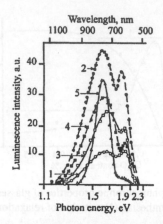

FIGURE 68 Luminescence spectra of: photochromic **AgCl(Br)** glasses doped with: (1) 0.078 mass % **Cu₂O**, (2) 0.15 mass % **Cu₂O**, (3) 0.31 mass % **Cu₂O**, (4) 1.2 mass % **CdO**, (5) single crystal **AgBr** doped with **CdO**.

(1.7 to 1.6 eV). It was suggested[143] that this luminescence should be attributed to cation vacancies of silver (V_{Ag}). This conclusion is confirmed by the results of the work[16] that has shown that **AgBr** single crystals, when grown with **CdO** and **PbO** additives, exhibit luminescence of about 740 nm (1.7 eV) (Figure 68, curve 5). This luminescence has the tendency to rise in relative intensity with the concentration of double-charged cations. It is known (Patrick et al.[230]) that **Cd²⁺** and **Pb²⁺** ions, being isomorphic substitutes for silver ion in the lattice of **AgBr** crystal, compensate for their charge excess by cation vacancies.

To characterize the relative content of cation vacancies in silver halide crystals as microcrystals of a photochromic glass, the ratio I_{740}/I_{620} was used in Figure 67c, curve 3, where I_{620} and I_{740} are the intensities of the luminescence at $\lambda = 620$ nm and $\lambda = 740$ nm, respectively.

Comparing the dependencies of cation vacancy concentration and the photochromic properties of glasses (Figure 67) on copper ion content in glass, one can make some important conclusions about the role of copper in the generation of the photosensitivity of silver halide microcrystals in a photochromic glass. First, copper additives entering the glass bring about not only photosensitivity growth but also a decrease in cation vacancy concentration. Interestingly, the first peak of $\Delta D_3 = f[Cu]$ dependence (Figure 67a) corresponds to the concentration of copper ions, which are most frequently used as a dopant for silver halide photochromic glasses (e.g., Photogray-extra and other glasses). Several papers have been written on the role of copper in the coloration mechanism of such glasses (e.g., Araujo,[185] Marquard,[184] Marquard et al.,[231] Caurant et al.[232, 233]).

Caurant et al.,[233] when studying the mechanism of photoinduced processes by ESR, showed that in glasses contained 0.007% **Cu** the process of coloration was accompanied by the formation of a cation vacancy followed by a complex consisting of a silver vacancy and a double-charged copper ion that was formed by trapping a photoinduced hole. The activation energy of such a process (0.06 eV) was equal to that of interstitial silver migration. Thus, it is assumed that both a [Cu²⁺V_Ag] complex

and an interstitial silver ion are formed simultaneously, making the recombination process slow down. The interstitial silver ion participates in the formation of a metallic silver colloidal particle (color center).

When double-charged additives (Cu^{2+}, Cd^{2+}, Pb^{2+}, etc.) are incorporated into a crystal during its growth, cation vacancies appear that become the cause of probable formation of a neutral $[hV_{Ag}]$ complex. As Malinovsky[234, 235] pointed out, being a deeper trap for a hole than the $[Cu^{2+}V_{Ag}]$ complex, this one drastically slows down the process of fading, as illustrated by the right branch of curve 1 in Figure 67c. The reason the divalent ions slow the fading rate is connected, according to Araujo et al.[236], with the depression of the Fermi level in the silver halide crystal. This increases the gap between the electron energy in the silver colloid and the conduction band in silver halide. Consequently, it decreases the rate of electron tunneling from the silver colloid to cupric ions in silver halide.

Consider one more difference between the effects of copper ions on the photochromic properties of AgCl-doped (Figure 66) and AgBr-doped (Figure 67) glasses. One can see that, for silver chloride glasses, there is no region of reducing rate observed in $K_r = f[Cu]$ dependence with the increase of copper ion content in the glass. The latter may be plausibly connected with the lower solubility of double-charged copper in AgCl than in AgBr. The solubility of Cu^{2+} ions in AgHal crystal is mainly determined by the energy required for the creation of cation vacancies. According to Muller,[237] the energy needed for the creation of cation vacancies in AgCl crystals is 1.53 to 1.44 eV, while that in AgBr crystals is far lower: 1.06 to 1.12 eV.

6.2.5 CATION ADDITIVES

In photochromic glasses, bivalent metal oxides, such as MgO, CaO, BaO, ZnO, and PbO, are used rather frequently (see the survey by Tsekhomsky[238]). It is pointed out that they only slightly affect the photochromic properties and are added mostly for the improvement of the technological characteristics. Small amounts are usually used in order to avoid crystal phase precipitation that would involve bivalent ions. As for cadmium oxide, it is used in silver halide glasses in quite a wide concentration range, while in copper halide glasses it is one of the basic photosensitive components (see the works by Kuznetsov et al.[239] and Morse[240]).

Figure 69 shows the influence of ZnO, PbO, and CdO on the fading rate of soda-aluminum-borosilicate glasses doped with AgCl(Br) and containing 0.4% Ag, 0.3% Cl, 0.8% Br, and 0.06% Cu. The glasses were thermally treated in the same manner: at 650 °C for 3 hours. One can see from the figure that in the series Zn–Pb–Cd the first element is least effective, whereas the third exercises the utmost influence on increasing the darkening degree and decreasing the relaxation rate.

The study of the low-temperature luminescence of similar glasses (Belous et al.[103,241]) has shown (Figure 70) that bivalent ions (Cd^{2+} and Pb^{2+}), when introduced into a glass, cause the long wavelength luminescence to increase. This luminescence is attributed (Chapter 4) to cation vacancies. Consequently, Cd^{2+} and Pb^{2+} enter the lattice of silver halide crystals in the process of heat treatment. The incorporation of these ions into the AgHal lattice is followed by an increase in the concentration

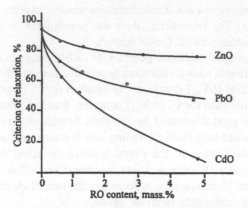

FIGURE 69 Dependence of the criterion of relaxation in $Na_2O-Al_2O_3-B_2O_3-SiO_2$ glasses doped with AgCl(Br) on the content (by synthesis) of double-valence metal oxides.

of cation vacancies. One can notice here a certain correlation between the concentration of cation vacancies (I_{740}/I_{620}) and the photoinduced optical density of photochromic glasses ΔD_3 (Figure 71). The saturation of the photoinduced coloration with **CdO** content growing in the glass can be explained by the decrease of the fading rate.

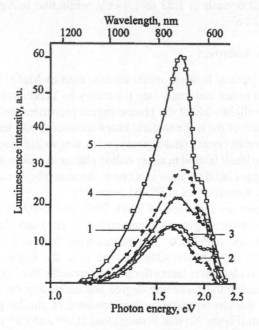

FIGURE 70 Luminescence spectra of $Na_2O-Al_2O_3-B_2O_3-SiO_2$ glasses doped with AgCl(Br) with different **MeO** concentration, mass %: (1) 0% MeO, (2) 1.2% CdO, (3) 0.67% PbO, (4) 1.2% PbO, and (5) 2.4% PbO.

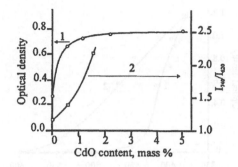

FIGURE 71 Dependence of properties of Na_2O–Al_2O_3–B_2O_3–SiO_2 glasses doped with AgCl(Br) on CdO content. (1) Photoinduced optical density (ΔD_3), sample thickness is 5 mm. (2) Ratio of luminescence intensities at 740 and 620 nm I_{740}/I_{620}.

6.2.6 ANION ADDITIVES

In practical photography so-called sulfide sensitization is widely used (see Mott and Gurney,[1] James,[95] Chibisov[242] and others). An insufficient solubility of silver chalcogenides in silver halides[220] and the comparative readiness of S^{2-} ions to dissolve in oxygen-containing glasses arouses some doubt about the possibility of sulfide sensitization of photochromic glasses. Moreover, silver halide photochromic glasses should usually be melted at a relatively high temperature (1450 to 1500 °C) under oxidizing or neutral conditions, which are necessary for the remaining silver in its ionic state. On the other hand, the preservation of sulfides requires rigorous reducing conditions, as was shown by Vargin.[243]

Nonetheless, Fanderlik[244] and Kawamoto et al.[245] did use sulfur as a sensitizer for the silver halide photosensitive phase in photochromic glass. These works revealed a certain growth of photosensitivity on the addition of sulfur to photochromic glass[245] and, as Fanderlik pointed out,[244] a shift of the edge of the color center generation spectrum to 600 nm (2.1 eV).

Many patents (see, for example, the references in the review of Tsekhomsky[238]) point out that the addition of P_2O_5 is useful for many reasons. It promotes the solubility of the silver halide phase in glass and affects the phase separation process. Hence, phosphoric anhydride, as well as fluoride compounds, can be regarded as a nucleation center of that process. On the other hand, it is known in photography engineering[220] that photographic layers containing Ag_3PO_4 are photosensitive and that their photosensitivity edge falls in the range of 560 to 750 nm (2.2 to 1.75 eV).

Figure 72 shows the results of the study of two photochromic glasses doped with AgCl(Br) microcrystals containing as sensitizers 4.3 mass % CdO (curve 1) and 2.0 mass % P_2O_5 (curve 2). The glasses were selected in a such manner that under standard measurement conditions (IFS-1 testing unit, see Chapter 2) they would have had equal photoinduced optical density ($\Delta D_3 = 1.2$ at the left side of Figure 72). When carrying out these experiments, filters with different cutoff wavelengths were placed into the exciting channel of the device (see Figure 9). The dependence of photoinduced optical density on the cutoff wavelength was measured in these experiments.

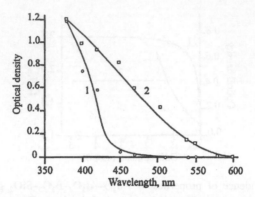

FIGURE 72 Dependence of photoinduced optical density in $Na_2O-Al_2O_3-B_2O_3-SiO_2$ photochromic glasses (thickness is 5 mm) doped with different additives on the position of the cutoff wavelength of filters in the excitation channel of the IFS-1 unit. Cutoff wavelength corresponds to the filter optical density of 0.5. (1) 4.3 mass % CdO, (2) 2 mass % P_2O_5.

It is clear from Figure 72 that, on the addition of P_2O_5, a drift of the edge of the color center generation spectrum to the long wavelength direction for about 100 nm is observed. With that, attention is attracted to the considerable sensitivity of such glasses to radiation with wavelengths above 500 nm (photon energy below 2.5 eV). As for the absorption spectra of these glasses (Figure 73), the introduction of P_2O_5 does not bring about a noticeable shift of the absorption edge to the long wavelength end. One can see an additional absorption in the region of 500 to 600 nm (2.5 to 2.1 eV). Possibly, this particular absorption corresponds to new centers of photosensitivity arising in the glass at the introduction of P_2O_5.

Figure 74 presents the dependence of the photochromic properties on P_2O_5 content in soda-aluminum-borosilicate glasses doped with AgCl(Br) and containing 0.075 mass % Cu_2O. One can see that increasing P_2O_5 content causes an increase in the coloration (Figure 74a), a decrease of the relaxation rate (Figure 74b), and a shift of the edge of color center generation spectrum to the long wavelength side (Figure 74c).

Currently, it is difficult to explain unambiguously the effect of P_2O_5 on the photosensitivity of AgCl(Br) microcrystals distributed in a vitreous host. A sort of attempt to produce such an explanation can be found in the work by Belous et al.[246] In that work, photochromic glasses sensitized with P_2O_5 were studied by the method of low-temperature luminescence (Figure 75). It was found that the introduction of P_2O_5 into the glass is accompanied by a variation in luminescence. Small silver aggregates of atomic or molecular size were considered responsible for these changes. It is interesting to note that, by the estimation of Latyshev et al.,[247] the absorption spectrum of Ag_2 molecules is located in the region of wavelengths shorter than 430 nm (2.9 eV), of Ag_3 molecules — in the range of 435 to 525 nm (2.9 to 2.35 eV), of Ag_4 molecules — in the range of 525 to 706 nm (2.35 to 1.75 eV), and so on. In other words, the growth of glass absorption at the introduction of P_2O_5

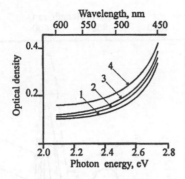

FIGURE 73 Absorption spectra of $Na_2O-Al_2O_3-B_2O_3-SiO_2$ photochromic glasses doped with different amounts of P_2O_5, mass %: (1) 0, (2) 0.5, (3) 1.5, and (4) 2. Samples thickness is 5 mm.

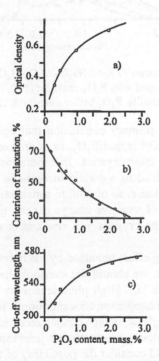

FIGURE 74 Dependence of photochromic properties of $Na_2O-Al_2O_3-B_2O_3-SiO_2$ glasses doped with AgCl(Br) on P_2O_5 content. a) Photoinduced optical density, sample thickness is 5 mm. b) Criterion of relaxation K_{rel}. c) Long wavelength boundary of the color center generation (the cutoff wavelength at Figure 72 that corresponds to photoinduced optical density of 0.1).

(Figure 73) can be, on a certain assumption, associated with such aggregates appearing in the photosensitive phase.

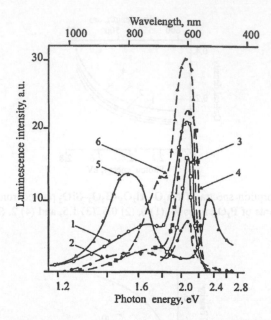

FIGURE 75 Luminescence spectra 77 K of: $Na_2O-Al_2O_3-B_2O_3-SiO_2$ photochromic glasses doped with $AgCl(Br)$ and co-doped with P_2O_5, mass %: (1) 0, (2) 0.12, (3) 0.25, and (4) 1.0; $AgBr$ crystals doped with 0.1 mol % P_2O_5 before quenching (5) and after (6).

On the other hand, the primary conclusion that could undoubtedly be made from the results of the work[246] is that P_2O_5, or, more correctly, PO_4^{3-} anion enters the lattice of silver halide microcrystals. Incorporation of PO_4^{3-} anion into the **AgHal** crystal lattice will lead to a drastic increase in the number of defects in the latter. Then, similar to the case of sulfide sensitization,[220, 242] one can expect that, for the compensation of negative charge excess, the concentration of interstitial silver ions (Ag_i) in the crystals will rise and/or new anion vacancies will possibly appear.

Regarding the sensitizing effect produced by the introduction of P_2O_5 into silver halide photochromic glasses, we should not overlook the important role played by copper in this effect (Figure 76). High photosensitivity was detected only in the presence of sufficiently large copper ion concentration in the glasses (i.e., ΔD_3 grows with P_2O_5 content). In those glasses which contain relatively large amounts of copper ions, not only the **AgHal** phase, where copper ions replace silver ions, is under consideration. We also should consider the possibility of the independent formation of the **CuHal**-phase that apparently is in close interaction with the **AgHal** phase (see Gracheva et al.[248]).

In his unpublished works, Tsekhomsky shows that copper halide photochromic glasses without **CdCl_2** do not really possess photosensitivity unless they contain P_2O_5. As a working hypothesis the idea was proposed that the PO_4^{3-} anion, when replacing the halide ion in the lattice of a **CuHal** microcrystal, compensates negative

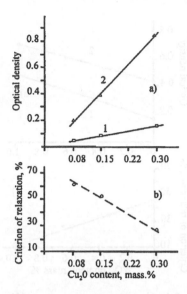

FIGURE 76 Effect of copper concentration on photochromic properties of $Na_2O-Al_2O_3-B_2O_3-SiO_2$ glasses doped with silver halide and co-doped with 1 mass % P_2O_5: a) absorption at samples with thickness of 5 mm: (1) optical density of the nonirradiated glass, (2) photoinduced optical density, b) criterion of relaxation.

charge excess not by the creation of an anion vacancy V_{Hal} but by removing extra oxygen ions O^{2-} from the glass. It was supposed (as Fano[249] did for the other crystals), that oxygen ions create new levels in the **CuHal** crystal energy structure, that cause new channels of excitation energy dissipation.

Therefore, one can suppose that P_2O_5 first of all enhances the photosensitivity of **CuHal** microcrystals. This results in general growth of the photosensitivity of a glass containing both types of microcrystals in interaction with each other.[248] Along with that, the positive influence of P_2O_5 on the photochemical properties of silver and copper halide photochromic glasses opens up opportunities to search for sensitizers among the other acid oxides, such as SO_2, SO_3, V_2O_5, WO_3, MoO_3, etc.

Tomada et al.[250] have shown that photographic layers in gelatin having Ag_2WO_4 and/or Ag_2MoO_4 as basic photosensitive components possess similar photosensitivity as layers with $AgCl$ prepared in the same conditions. The region of photosensitivity of these layers is extended up to 453 nm (2.75 eV).

Figures 77 and 78 illustrate the effect of WO_3 and MoO_3 on the photochromic properties of soda-aluminum-borosilicate glasses doped with $AgCl(Br)$ microcrystals (FHS-3) and treated at 650 °C for 12 hours. One can see that the sensitizing effects of WO_3 and MoO_3 are very similar to that of P_2O_5 while both WO_3 and MoO_3 do not cause any additional shifts of the photosensitivity edge to longer waves, as compared to P_2O_5. One can suppose that this sensitizing effect is due to the increase of defects concentration in the photosensitive crystalline phase.

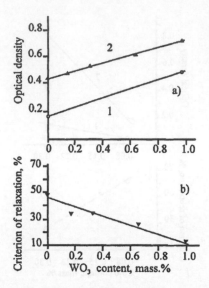

FIGURE 77 Dependence of the photochromic properties of Na_2O–Al_2O_3–B_2O_3–SiO_2 glass doped with $AgCl(Br)$ on WO_3 content. a) photoinduced optical density (thickness is 5 mm): (1) base glass, (2) glass co-doped with P_2O_5; b) criterion of relaxation for glass co-doped with P_2O_5.

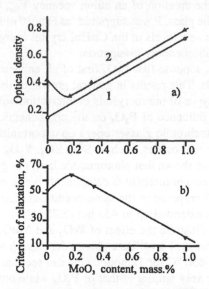

FIGURE 78 Dependence of the photochromic properties of Na_2O–Al_2O_3–B_2O_3–SiO_2 glass on MoO_3 concentration: a) photoinduced optical density (thickness is 5 mm): (1) glass host, (2) glass co-doped with P_2O_5, b) criterion of relaxation for glass co-doped with P_2O_5.

7 Waveguides in Photochromic Glasses

In recent years a new direction has been developed in opto-electronics — integrated optics. The essence of this direction implies that an optical design is created not from a set of bulk optical elements but with the use of coupled planar waveguides, i.e., thin layers with increased refractive index at the surface of a material that provide light propagation in a layer at total internal reflection. For the creation of such waveguides various technological approaches are used depending on the material type and the requirements of the waveguide. In the case of glasses, most widely practiced is manufacturing of planar waveguides by the method of ion exchange.

7.1 OPTICAL PROPERTIES OF PLANAR ION EXCHANGED WAVEGUIDES

The method of ion-exchange diffusion (or simply ion exchange) is the exchange of alkali ions contained in glass with other metal ions contained in salt melts or solutions. It proceeds because of the difference in their chemical potentials. As diffusing ions, those with single-valence are used that possess maximal mobility: Ag^+, Cu^+, Li^+, Na^+, K^+, Rb^+, Cs^+, and Tl^+. Most frequently used salt melts are nitrates of the above listed elements possessing low melting points. Low melting points are essential for the fabrication of waveguides with low light losses. In order to preserve high optical quality of a polished glass surface, ion exchange is usually carried out at temperatures below the glass transition temperature T_g. Such ion exchange is called low-temperature, in contrast to the high-temperature exchange (at temperatures $T > T_g$) that is normally used for the creation of focusing gradient elements.

The variation of refractive index at low-temperature ion exchange may change from 5×10^{-3} for K^+ to 0.1 for Tl^+. Waveguide thickness can vary from a few micrometers in commercial glasses to fractions of a millimeter in specially developed glasses with high diffusion coefficients. The losses in ion-exchange waveguides can be reduced to 0.1 dB/cm and approach those in the original optical glass.

The main peculiarity of a glass layer obtained by an exchange of different ions, i.e., ions with different radii, is its nonrelaxed structure. This leads to the difference between actually occupied volume in the exchanged layer both from the original glass volume and the equilibrium volume of the new glass with its composition modified by the exchange. This difference gives rise to various types of stresses on ion exchange in glasses. We will briefly consider the main properties of ion-exchange

layers using as an example the exchange of sodium from glass with potassium from melt, $Na_{glass} \Leftrightarrow K_{melt}$. This choice is defined by the fact that waveguides exhibiting minimum light losses can be obtained by that very exchange method. It is curious that equimolecular substitution of K for Na in silicate glass will result in a decreasing (but not increasing) of the refractive index.[46] It means that even the existence of such waveguides is caused by the nonrelaxed structure of glass after ion exchange.

Very early Burggraaf[251] noted that alkali ion exchange in glass surface layers brought about macrostresses between the ion-exchanged layer and the substrate. The creation of such stresses at ion exchange can be caused by two phenomena. The first is the difference in the thermal expansion coefficients of the initial glass and the glass resulting from ion exchange. The second cause is the change of glass molecular volume due to the difference in the exchanged ion radii. It was found that at high-temperature ion exchange $(T > T_g)$, a primary role was played by the difference in the thermal expansion coefficients of the initial and modified glasses. In that case, when cooling after ion exchange, tension stresses arose in the surface layer that could attain values of about ≤ 0.1 GPa. Such stresses result in a reduction of the refractive index by a value of $\leq 10^{-4}$ order and, naturally, do not effect noticeably the optical properties of the ion-exchange layer (see the work by Kozmanyan et al.[252]) and cannot create a waveguide medium.

As was shown in the work by Glebov et al.,[253] at low-temperature exchange $(T < T_g)$, macrostresses arise immediately in the process of exchange, as the radii of exchanged ions are different and the glass remains elastic and cannot get relaxed immediately. In the works by Babukova et al.[254] and Glebov et al.[255] it was shown that the magnitude of compression stresses reached ≤ 1 GPa. Such stresses lead to intense optical anisotropy in ion-exchange waveguides — to birefringence. Measuring the difference in the refractive indexes of waveguide modes with polarization orthogonal to each other, $\delta n = \Delta n_{TM} - \Delta n_{TE}$, and knowing photoelastic constants C_1 and C_2 of the glass, one can calculate the variation of the refractive index in the ion-exchange layer caused by macrostresses (t):

$$\Delta n'_{TE} = \frac{C_2 + C_1}{C_2 - C_1} \delta n \tag{70}$$

$$\Delta n'_{TM} = \frac{2C_2}{C_2 - C_1} \delta n \tag{71}$$

It turned out that, even in the complete absence of relaxation, the anisotropic increment of the refractive index calculated in this way explained half of the actually observed increment, while the magnitude of macrostresses attains only half of the calculated value. Babukova et al.[255] have shown that isotropic increment of the refractive index is connected with microstresses arising between the diffusing ion and surrounding nonrelaxed glass on a microscopic scale. Microstresses prevent the ion-exchange layer from extending to the equilibrium state. Therefore the concentration of atoms in the exchange layer grows with respect to equilibrium value and the refractive index increases.

Upon heating the ion-exchange layer to temperatures near T_g, macrostresses are the first to relax and the waveguide becomes isotropic. Then, microstresses relax in their turn and the refractive index of the surface layer becomes less than that of the glass and the waveguide itself disappears. In silicate and borosilicate glasses, the maximum increment of the refractive index caused by the stresses, as a rule, falls within the range of 10^{-3} to 10^{-2}. Refractive index anisotropy is not over $\delta n \leq 2 \times 10^{-3}$.

The creation of a planar waveguide based on photochromic glass was first demonstrated by Petrovskii et al.[257] Since then, ion-exchange waveguides have been created with the participation of the authors of the present book based on the main types of photochromic glasses (FHS-2, FHS-4, FHS-6, FHS-7, see Catalogue[82]) produced in Russia. All the above-listed glasses contain Na^+ ions. Their annealing temperatures are 500 °C and higher. Therefore ion exchange was carried out in **KNO₃** melts at temperatures up to $T = 430$ °C over 0.25 to 6.0 hours. The refractive indexes for waveguide modes were measured by the resonance angles of waveguide excitation by means of prism coupling system at $\lambda = 633$ nm (see, e.g., Tamir's book[258]). Refractive index profiles were calculated according to the Wenzel–Kramers–Brillouin method in accordance with White and Heidrich.[259]

Figure 79 shows the optical properties of the obtained waveguides. It is clear that the refractive index in the surface layer, which is characterized by the refractive index of the zeroth mode of TE-polarization (Figure 79a), grows with the time of ion-exchange treatment for all glasses and saturates in a few hours. The maximum value of the increment is $(3 \text{ to } 8) \times 10^{-3}$ and is determined both by the reached equilibrium concentration of K^+ in the surface layer and by some relaxation of the stresses in the heat treatment process. The increase in the refractive index of the glass and of ion-exchange layer thickness leads to an increasing number of waveguide modes for both polarization types. It is shown in Figure 79b for FHS-4 glass. One can see that the refractive indexes for TM-modes ($\delta n = n_{TM} - n_{TE} > 0$). Such optical anisotropy indicates compression stresses exist in the surface layer. The birefringence grows in the process of diffusion treatment and becomes saturated (Figure 79c). It is caused, as well as by the absolute increase of refractive index, by the concentration of the diffusing ion reaching equilibrium and by the relaxation of macrostresses. The value of δn reaches 1.0×10^{-3}, that corresponds to surface layer stresses of the order of 0.5 GPa. The other glasses behave similarly.

Figure 80a shows the refractive index profile of the ion exchanged layer of FHS-4 glass treated in the melt for 6 h. (It corresponds to the last right column of points in Figure 79b.) It can be seen that the profile represents a steadily decreasing function. The depth of the exchange layer in the studied glasses attained 10 to 15 µm. Figure 80b presents the profiles of electric fields of waveguide modes corresponding to the refractive index profiles shown in Figure 80a. It is important that waveguide modes of different numbers propagate at different distances from the surface. Moreover, the optical anisotropy of a waveguide results in the fact that the modes of the same numbers but different polarizations also have significant differences in the spatial distribution of their fields.

It can be seen from the comparison of curves 1 and 2 in Figure 80a that the birefringence decreases as the distance from the surface increases. This is connected

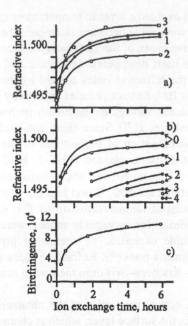

FIGURE 79 Optical properties at $\lambda = 633$ nm of ion-exchange waveguides on photochromic glasses: a) dependence of effective refractive index of the zero-modes of TE polarization on ion-exchange time (T = 430 °C) for the glasses: (1) FHS-2, (2) FHS-4, (3) FHS-6, (4) FHS-7, n at t = 0 is refractive index of substrate; b) dependence of effective refractive index of waveguide modes of TE (circles) and TM (crossed circles) polarization on ion-exchange time for a waveguide on FHS-4 glass; numbers at curves correspond to the waveguide mode numbers; c) dependence of the fundamental mode birefringence ($n_{TM} - n_{TE}$) on ion-exchange time for a waveguide on FHS-4 glass.

with the reduction of macrostresses whose profile is similar to that of diffusing ion concentration. It is clear that this effect must lead to a decrease of the anisotropy of higher-order waveguide modes that propagate at a greater depth. One can clearly see this in Figure 79b, which compares the refractive indexes of TE and TM modes for the maximal duration of ion exchange.

7.2 EFFECT OF ION EXCHANGE ON PHOTOCHROMIC PROPERTIES

It has been shown in the foregoing sections that the photochromic properties of heterogeneous glasses are very sensitive to secondary heat treatment. In view of this, an important task was to define how the processes of coloration and fading of photochromic glasses in waveguide layers vary after ion-exchange treatment. More than that, it was pointed out in Chapter 5 that colored photochromic glasses were sensitive to the stimulation by visible light that can either bleach or additionally color a sample (see the works by Ashkalunin et al.[260] and Glebov et al.[261]).

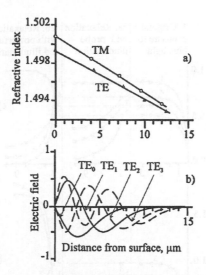

FIGURE 80 Parameters of ion exchanged layer on FHS-4 glass: a) refractive index profiles for TE and TM polarization; b) waveguide mode electric field profiles.

In order to compare the photosensitivity, the relaxation, and the photostimulation of the glasses in their bulk and waveguide configurations, a measurement unit was created that would provide the identity of irradiation and photoinduced absorption measurements in both cases (see Glebov et al.[262]). As actinic radiation, the emission of a **He-Cd** laser was used ($\lambda = 440$ nm, $I = 5$ mW/cm^2) and as probing and stimulating radiation, a **He-Ne** laser was used ($\lambda = 633$ nm). Power density (intensity) and stimulation time were chosen so as not to affect the kinetics of coloration and bleaching. In the case of bulk samples, actinic and probing (or stimulating at $I = 1.0$ W/cm^2) radiation were directed coaxially to a sample positioned normally to the axis. In the case of waveguides, actinic radiation was also directed normally to the sample surface while probing (or stimulating at $I = 200$ W/cm^2) radiation was directed as TE_0 modes along the sample surface.

The experiment was carried out as follows (Figure 81). A completely decolorized sample had been exposed to actinic radiation for 5 min at room temperature and photoinduced (additional) absorption ΔD_A was measured in the process of exposing (column 1). Hereafter ΔD is counted from the optical density level of completely decolorized glass. In the first 5 min, photoinduced optical density was measured in the relaxation process, also at room temperature. The relaxation was studied under two schedules. First (column 2a), thermal relaxation was measured using weak pulses of probing light that did not affect the kinetics of color center decay (ΔD_T). Second (column 2b), after an identical exposure to actinic radiation, the relaxation was measured using probing radiation pulses sent in short breaks in the actinic radiation (ΔD_S). The measurements described allowed the authors to determine the thermal relaxation coefficient in a way similar to Chapter 2, Equation (5):

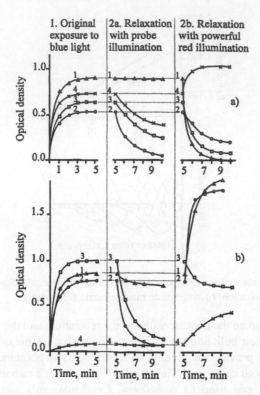

FIGURE 81 Comparison of photochromic phenomena in bulk samples (a) and waveguides (b) (thickness in the direction of light propagation is 10 mm): Column 1 — Dependence of photoinduced optical density on time of exposure to radiation with $\lambda = 440$ nm (2.8 eV), Column 2a — Dependence of photoinduced optical density on time of relaxation in darkness at room temperature, Column 2b — Dependence of photoinduced optical density on time of long wavelength stimulation with $\lambda = 633$ nm (1.98 eV), (1) FHS-2, (2) FHS-4, (3) FHS-6, and (4) FHS-7.

$$K_{Tr} = \frac{\Delta D_A - \Delta D_T}{\Delta D_A} \qquad (72)$$

and also the relaxation coefficient under optical stimulation:

$$K_{Sr} = \frac{\Delta D_S}{\Delta D_T} \qquad (73)$$

The physical meaning of K_{Sr} is the variation of relaxation kinetics due to the interaction of stimulating radiation with color centers. $K_{Sr} = 1$ when there is no stimulating radiation or no interaction with color centers. If $K_{Sr} < 1$, optical bleaching takes place, and when $K_{Sr} > 1$, an additional coloration is observed. The nature of this additional color will be discussed in Chapter 8.

The results of the comparison of photochromic glass coloration and relaxation in bulk and waveguide configurations are presented in Figure 81; the relaxation coefficients are in Table 18. One can see that in a bulk sample, the lower the relaxation rate (i.e., the less thermal relaxation coefficient K_{Tr}, see Table 18), the greater the value of photoinduced absorption at the exposition (Figure 81, columns 1 and 2a). This result is understandable, as the value of photoinduced absorption is the result of dynamic equilibrium between color center generation and decay.

TABLE 18
Relaxation Coefficients for
Bulk and Waveguide Samples of
Photochromic Glasses

Glass Brand	Bulk Sample		Waveguide	
	K_{Tr}	K_{Sr}	K_{Tr}	K_{Sr}
FHS-2	0.0	0.0	0.05	2.7
FHS-4	0.8	2.0	0.9	23.1
FHS-6	0.6	0.2	0.9	7.5
FHS-7	0.4	2.6	0.0	6.2

It was found that after exposure to UV radiation coloration was observed in all of the waveguides examined. This means that photosensitivity centers are not destroyed in glasses in the process of ion exchange treatment and ion exchange technology can be used for the fabrication of planar photochromic devices. There is no correlation between the relaxation coefficient and photoinduced absorption value in waveguides (compare columns 1 and 2a in Figure 81b, Table 18). The photosensitivity of FHS-7 copper halide glass has changed the most. The comparison of thermal relaxation coefficients in bulk samples with those in waveguides reveals (see Table 18) that, for all silver halide glasses, K_{Tr} in waveguides increases, but for FHS-7 it decreases. It seems legitimate to suppose that such an abrupt change in the photosensitivity and relaxation for different glasses may be connected with the variation in photosensitive phase composition at ion-exchange.

To verify that supposition, Glebov et al.[263] studied the dependence of photoinduced absorption on waveguide mode number in FHS-4 glass (Figure 82a). It is clear that for waveguide modes of large numbers, the induced absorption increases. It follows from Figure 80b that the modes of large numbers propagate at a greater depth. In this case, the obtained result means that the photosensitivity of photochromic waveguides is falling as the surface comes nearer.

It was shown in Chapter 6, Section 6.2.4, that photochromic glass photosensitivity grows in the long wavelength part of UV radiation at the introduction of Cu^+ ions into the glass. By means of microprobe analysis,[263] it has been found that copper ion concentration in subsurface layers goes down after $Na_{glass} \Leftrightarrow K_{melt}$ exchange has proceeded. This allows us to believe that at ion-exchange processing not only does the exchange of ions of the glass and nitrate melt take place but also ion exchange

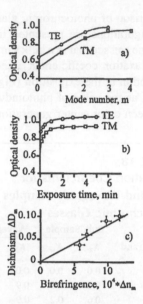

FIGURE 82 Anisotropy of photoinduced absorption in waveguides on FHS-4 glass. Waveguide length 1 10 mm. a) Dependence of photoinduced optical density for TE and TM polarization on the waveguide-mode number (the points on the graph are connected for clarity, since only whole numbers have physical meaning for the waveguide modes), b) dependence of photoinduced optical density for fundamental modes TE and TM polarization on exposure time, c) correlation between birefringence ($n_{TM} - n_{TE}$) and dichroism ($\Delta D_{TE} - \Delta D_{TM}$) for the waveguide modes.

between the glass host and the photosensitive crystalline phase occurs. It has been shown in Chapter 3 (Figure 21) that the melting point of photosensitive microcrystals is below 400 °C, i.e., below the ion exchange temperature. Consequently, microcrystals melt under heat treatment, and the ion exchange between halide melt droplets and the glass takes place (Figure 83). This exchange results in a variation of the composition of the microcrystal phase formed at cooling and changes the photosensitivity and relaxation characteristics.

It has been pointed out in Chapter 2 that the coloration of photochromic glasses proceeds inhomogeneously with respect to sample thickness because of the nonuniform absorption of actinic radiation. The typical scale of that nonuniformity measures in millimeters. There is also a nonuniformity observed in photochromic waveguides. However, this one is connected with a photosensitivity gradient in the micrometer region of distance from the surface. This gradient, as was shown by Glebov et al.,[264,265] can be used for the selection of waveguide modes propagating at different depths, i.e., in layers with different copper concentration. Indeed, it is clear from Figure 84 that the difference in attenuation of modes with different numbers in a waveguide colored by external radiation can reach 15 dB/cm even without undertaking special measures to increase the copper concentration gradient.

One can see from Figure 81a, column 2b that the stimulation of a colored glass by visible light leads to an essential alteration of the kinetics of relaxation. It can

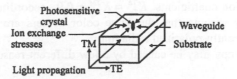

FIGURE 83 Sketch of orientation of stresses caused by ion exchange in a surface layer of glass substrate; shape of pressed photosensitive microcrystal, and direction of waveguide modes propagation with TE and TM polarization.

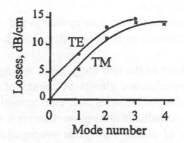

FIGURE 84 Photoinduced losses for modes of TE and TM polarization in a waveguide on FHS-4 glass vs. the mode number.

be concluded from the comparison of the figure with the data in Table 18 that the stimulation of silver halide glasses with low copper content results in bleaching, whereas glasses with high copper content become additionally colored under the stimulation. At the same time, in waveguides $K_{Sr} > 1$ for all the glasses listed, even for a waveguide made of FHS-6 glass, where the absorption decreases in the process of stimulation, the bleaching is slowed down owing to the additional coloration by stimulating radiation. In Chapter 8 it will be shown that the coloration under optical stimulation proceeds as a nonlinear process dependent on the squared power of radiation. In this case, the difference in the photostimulation of bulk samples and waveguides is explained first of all by decreasing the beam cross section entering a waveguide by several orders of magnitude and, accordingly, increasing the intensity. This results in a substantial increase in the efficiency of nonlinear processes in waveguides.

7.3 ANISOTROPY OF PHOTOCHROMISM

As was mentioned in Section 7.1, one of the essential properties of waveguides is optical anisotropy caused by diffusion-generated stresses in the glass surface layer. Glebov et al.[264,265] found that the absorption induced in anisotropic ion-exchange waveguides with birefringence ($\delta n = \Delta n_{TM} - \Delta n_{TE} > 0$) created by compression stresses performs dichroism of the opposite sign, $\delta D = \Delta D_{TE} - \Delta D_{TM} > 0$ (compare Figures 79b, 79c, and Figures 82a, 82b). At the same time, the shape of the relaxation curves of induced absorption does not depend on the direction of polarization or

on thermal relaxation coefficients $K_{Tr}^{TE} = K_{Tr}^{TM} = 0.9$, according to Table 18. Consequently, we may assume that the same color centers are responsible for the absorption of differently polarized radiation.

Such an anisotropy may be caused by a few different reasons:

1. The anisotropy of radiation propagation in a waveguide of isotropic material connected with the geometrical anisotropy of the waveguide
2. The anisotropy of actinic radiation polarization in the direction of light propagation in the waveguide
3. Orthogonal orientation of the polarization of probing and actinic radiation, with respect to each other
4. Orientation of photosensitive microcrystals in the waveguide layer
5. The effect of mechanical stresses on color centers.

To check the correctness of the first suggestion, waveguides of the same shape were fabricated from photochromic glasses by means of ion exchange $Na_{glass} \Leftrightarrow Ag_{melt}$, but free from mechanical stresses and, consequently, from birefringence. It was found that there was no induced absorption dichroism in such waveguides. This means that the geometry of planar waveguide propagation is not responsible for dichroism. To verify the second suggestion, actinic radiation was polarized circularly, which did not make induced absorption dichroism disappear. The third suggestion was tested by the measurement of induced absorption in bulk samples at orthogonal probing. It was found that, in that case, no dichroism was manifested. So, the first three reasons cannot explain the dichroism.

The fourth suggestion is based on the results obtained by Anikin et al.[122] and Seward[266] on the presence of dichroism of the absorption induced in oriented crystals of an anisotropic shape. It was found that maximal absorption by color centers was observed at the coincidence of the direction of light wave electric vector with the major axis of a microcrystal. Since halide microcrystals are molten at the temperature of ion exchange, compressive diffusion stresses can orient liquid droplets and, consequently, also crystals perpendicularly to the surface (Figure 83). However, one can see (Figures 82b) that the maximal absorption is observed for TE polarization, the electric vector of that is directed along the waveguide plane. It should be emphasized that the anisotropy of crystal shape causes the anisotropy of photosensitivity but not the anisotropy of coloration. This allows us to consider that crystal shape anisotropy is not the cause of induced absorption dichroism in photochromic waveguides.

The comparison of birefringence δn and induced absorption dichroism δD reveals their good correlation (Figure 82c). This allows us to deduce that color center dichroism in photochromic waveguides at isotropic excitation is caused by diffusion stresses and to assume that those stresses directly affect color centers. In this case, color center dichroism can be connected with either a particular direction appearing in isotropic centers or the orientation of anisotropic centers. As was discussed in Chapter 4, the ensemble of color centers in heterogeneous photochromic glass may be presented as the assemblage of anisotropic shaped particles orientated at random.

One can suppose that color center dichroism is caused by preferential orientation of anisotropic centers if generated under the effect of external stresses in a glass host.

In addition to the phenomenon of the intrinsic dichroism of ion-exchange photochromic waveguides described above, Dotsenko et al.[267] have carried out a comparative analysis of photoinduced anisotropy of color center absorption in bulk and waveguides of silver halide glass FHS-2 after polarized excitation. It has been found that the maximum change of the induced absorption upon photochromic glass darkening and bleaching is observed when the polarizations of the actinic and probing radiations are identical. The magnitude of the dichroism depends on the irradiation dose and on the wavelength of probing light. In a waveguide, the sign of the photoinduced dichroism is opposite to that in bulk photochromic glass. For thorough comprehension of the mechanism of color center anisotropy formation under the conditions of intense diffusion stresses developed in a waveguide layer, additional research is necessary.

The dichroism of photoinduced absorption in planar waveguides made on photochromic glasses can be employed in the development of various photocontrolled elements of integrated optics (polarization selectors, switches, etc.).

7.4 MODE SELECTION

It is clear that the rates of darkening and relaxation in photochromic waveguides are insufficient to fulfill high-speed operations such as modulation or switching. However, there are operations that do not need high rates. Among them is, first of all, the selection of waveguide modes. Such a selection requires the providing of essentially different losses for different modes. As a rule, that is fulfilled by arranging absorbing layers at the surface (see Bryantseva et al.[268] and Rolke et al.[269]) or in the depth (Zlenko et al.[270] and Akhmediev et al.[271]) of a waveguide. Naturally, the preparation of such layers requires exceptionally high precision of the technological procedure and does not permit readjustment. One possible way to solve this problem is the creation of selectors with the use of photosensitive glasses (see also the survey by Glebov et al.[272]).

In Section 7.2 we pointed out that waveguide photosensitivity changes at the excitation of various modes due to the gradient in copper concentration in a waveguide layer. This permits the creation of waveguide mode selectors similar to those described in Bryanzev et al.[268] and Rollke and Sohler.[269] However, a feature of waveguide radiation such as the discreteness of the waveguide modes spectrum, in combination with the photosensitivity to waveguide radiation, allows one to develop new types of selecting devices controlled by waveguide radiation.

The basic principle of the creation of such waveguide selectors follows (see Glebov et al.[273]). Consider a diffusion waveguide based on photochromic glass in which several modes of the same polarization can propagate (Figure 85). If a mode in such a waveguide (Mode #1 in Figure 85) is excited by actinic radiation, the waveguide will become colored. The spatial profile of induced absorption will be determined by the spatial profile of intensity of the excited mode and by the kinetics of darkening depending on intensity. So, a sort of extended mask will be formed in

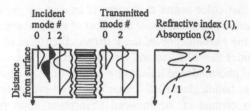

FIGURE 85 Sketch of waveguide mode selector. From left to right: incident mode electric field distribution in a waveguide layer (darkened profile corresponds to exposed mode); view of colored waveguide; transmitted mode electric field distribution in a waveguide layer (exposed mode does not propagate after colored part of waveguide); refractive index (1) and photoinduced coloration (2) profiles in exposed waveguide.

the waveguide whose absorption profile is similar to that of the intensity distribution of photoactinic radiation in the waveguide. Therefore, the losses for the excited mode will grow as the waveguide gains color.

The attenuation of other modes will be determined by the overlap of their fields with the absorption profile of the extended mask, i.e., with the field of the mode which induced this absorption. Because field distributions of the modes with different numbers in planar waveguides essentially differ from each other (see Figure 80b), one might expect that the losses for other modes would grow insignificantly. In this case, after the colored segment has been passed, the intensity of the radiation propagating in a before-excited by actinic light mode must be lower than in other modes. In other words, such a coloration must lead to the selection of waveguide modes.

There is one more problem to solve, since in the process of exploitation an additional coloration of the waveguide will proceed and the latter will lose its selective properties. This problem can be solved in two ways. A selector may be created by means of short wavelength photoactinic radiation, while long wavelength radiation, which does not cause photoinduced coloration, will be selected. However, this approach must fit mode fields for different wavelengths. Although this is feasible in principle, there is a simpler way of exploiting nonlinear coloration of waveguides under the effect of visible radiation (see Chapter 8). The value of additional absorption at nonlinear coloration of waveguides on photochromic glasses FHS-4 and FHS-7 depends on power. For the radiation with $\lambda = 633$ nm, at $I < 10 \, \mu W$ no coloration occurs, while at $I > 1 \, \mu W$ additional absorption density is near saturation and attains the value of $\Delta D \approx 2$ at a waveguide length of about 1 cm. Recording and reading can be done without the destruction of a photoinduced mask at the same wavelength by varying the power of the laser beam used.

To illustrate this phenomenon, the spectra of waveguide modes were measured. This spectrum for the waveguide with prism input and output coupler elements is the dependence of the intensity of the radiation that has passed through a planar waveguide on the angle of incidence onto the input prism. Figure 86a (solid curve) represents the mode spectrum of a 1-cm-long waveguide in the FHS-4 glass ($\lambda = 633$ nm, $I < 10 \, \mu W$). One can see that four TE-polarized modes were excited. Further on, the TE_0 mode was excited in that waveguide and the radiation power was raised to 3 mW for 5 min. After that, the mode spectrum was measured once

FIGURE 86 Effect of exposure to powerful fundamental mode excitation (shown as arrows) on dependence of waveguide (FHS-4 glass) transmission on the angle of incidence onto the input coupler prism (spectrum of waveguide modes): a) TE polarized modes; b) TE and TM fundamental modes. Solid lines = before exposure, dashed lines = after exposure.

FIGURE 87 Dependence of photoinduced losses in waveguide modes on the number of modes exposed to actinic radiation (shown by arrows). The points on the graph are connected for clarity, since only whole numbers have physical meaning for the waveguide modes. a) experiment; b) theory.

more (Figure 86a, dashed curve). It is clear that the intensity of TE_0 mode radiation has fallen abruptly. The value of induced attenuation for that mode attained 10 dB/cm, whereas for the remaining modes it measured 1.5 to 3.5 dB/cm. Hence

the selectivity of the waveguide under investigation was 6.5 to 8.5 dB/cm, depending on mode number.

One can also see from Figure 86b that, for modes of the same number but different polarization, some selectivity is also observed. This is due to the difference in the profiles of the electric fields of modes with different polarization, which is caused by stresses (Figure 80a). Figure 87a shows the dependence of the losses induced in a different mode of waveguide on the number of the mode at which coloration was carried out. It is clear that the selectivity depends strongly on the type of coloring mode. These differences are due to different extents of overlapping between various combinations of mode fields.

In order to study theoretically the phenomenon of mode selection, Glebov at al.[274] and Dotsenko et al.[275] have developed mathematical models describing the process of radiation propagation in a planar waveguide made on photochromic glass. Let us consider the phenomenological description of the process in a photochromic waveguide under the influence of actinic radiation. When the radiation is propagating, electric field $E(r,t)$ forces the dielectric permeability $\varepsilon(r,t)$ of waveguide material to change. Optical properties of such a waveguide in general are described by the equation:

$$\frac{d\varepsilon(r,t)}{dt} = F[\varepsilon(r,t), E(r,t)] \tag{74}$$

The form of function F in the right-hand side of the equation depends on the type of photosensitive material and the accepted model for its description. If the simplest model is applied (glass matrix containing spherical metal particles — color centers), the Maxwell-Garnett approach for the calculation of complex dielectric permeability averaged over the microvolume of composite material can be used.[276] Considering the smallness of the specific volume of color centers in photochromic glass, it is legitimate to write:

$$\varepsilon(r,t) = \varepsilon_m(x) + \varepsilon_{ph}(r,t) \tag{75}$$

where

$$\varepsilon_{ph}(r,t) = 3\varepsilon_m(x)Vc(r,t)\frac{\varepsilon - \varepsilon_m}{\varepsilon + 2\varepsilon_m} \tag{76}$$

Here $\varepsilon_m(x)$ is the diffusion profile of glass matrix dielectric permeability (regarded as real), $\varepsilon_{ph}(r,t)$ is a complex term describing photoinduced changes in material structure, $c(r,t)$ is color center concentration, V is the volume of a single color center, and ε is the complex dielectric permeability of the metal (silver or copper), depending on the type of photochromic glass.

The variation of color center concentration subject to monochromatic radiation can be described by an equation:

$$\frac{dc(r,t)}{dt} = k_a \mid E(r,t) \mid^2 [c * -c(r,t)] - k_f c(r,t) \tag{77}$$

where $c*$ is the concentration of photosensitive microcrystals and k_a and k_f characterize the probabilities of photoinduced formation of color centers and their spontaneous decay, respectively.

The main objective of the calculation is the matrix of photoinduced optical density:

$$D_{ij} = \lg \frac{I_i}{I_{ji}} \tag{78}$$

where I_{ji} is the power of the i-mode propagating in the waveguide colored by excitation of the j-mode up to saturation. I_i is the same power without coloration. The geometry of the problem in question is presented in Figure 85. Now we will examine the propagation of TE radiation mode $E = E_y(x,z,t)e_y$ in a waveguide that is described by the equation:

$$-\Delta E_y + \frac{1}{v_l^2} \frac{d^2}{dt^2} \varepsilon E_y = 0 \tag{79}$$

Finding an approximate solution to the system should take into account the following circumstances: there are, first of all, two time scales present, which define rapid Equation (79) and slow Equation (77) changes in the relevant values. Numerical estimations show that the smallness of the real component, $\mathrm{Re}\varepsilon_{ph}(r,t) \approx 10^{-5}$, compared to the maximum variation of the refractive index of the glass host allows us to neglect the real part, i.e., to consider the effect of the photoinduced processes under examination only on the imaginary part, $\mathrm{Im}\varepsilon_{ph}$. This is in conformity with the experiments that have shown that a waveguide mode spectrum remains the same under photoinduced coloration. The smallness of radiation attenuation defined by the smallness of $\mathrm{Im}\varepsilon_{ph} \approx 10^{-5}$, enables us to separate the rapid oscillations in the direction (z) of radiation propagation. Because of consideration of the stationary problem of coloration, one should be looking for a solution for that $dc/dt = 0$. Under the specified conditions, the solution of the system of Equations (77) through (79) for not very long waveguides, when their length L satisfies the inequality:

$$\mathrm{Im}\varepsilon_{ph} < 1 \tag{80}$$

can be expected to have the form of:

$$E_y(x,z,t) = f(x)\exp[-\Phi(x,z) + i\beta z - i\omega t] \tag{81}$$

where

$$\Phi(x,z) = \int_0^z \alpha(x,z')dz', \quad \alpha(x,z) = \frac{k^2}{2\beta} \operatorname{Im} \varepsilon_{ph}(x,z) \tag{82}$$

Then, Equation (79) can be easily transformed into:

$$\left[\frac{d^2}{dx^2} + k^2\varepsilon_m(x) - \beta^2\right]f(x) = 0 \tag{83}$$

The normalization of function $f(x)$ is defined by the specification of the intensity of radiation propagation along the waveguide:

$$Q = \frac{v_e}{8\pi}\frac{\beta}{k}\int_{-\infty}^{+\infty} f^2(x)dx \tag{84}$$

From Equation (77), for an equilibrium case, it is easy to obtain the equation for optical density distribution:

$$\exp[2\Phi(x,z)] - 1 = 2\frac{k_a}{k_f}f^2(x)[\psi(x)z - \Phi(x,z)] \tag{85}$$

where $\psi(x) = \alpha$ and $c(x,z) = C^*$. Then the elements of the sought matrix of optical density D_{ij} are found by the formula:

$$D_{ij} = -\ln\left\{\left[\int_{-\infty}^{+\infty} f_i^2(x)dx\right]^{-1}\int_{-\infty}^{+\infty} f_i^2(z)\exp[-2\Phi_j(x,L)]dx\right\} \tag{86}$$

From Equation (86) one can calculate the value of photoinduced optical density for different modes of a planar waveguide colored up to saturation by the photoactinic radiation excitation of one of the waveguide modes. In order to interpret the experiment described above, a calculation was carried out for a model "exponential profile" presented in Figure 88a:

$$\varepsilon_m(x) = \varepsilon_1\{1 - \Delta[1 - \exp(-x/a)]\} \tag{87}$$

In this case, the distribution mode fields $f_i(x)$ are expressed in terms of Bessel functions. The solution of the dispersion equation of a waveguide defining β_i, the search for density profile $\Phi_i(x,L)$, and the calculation of the elements of D_{ij} matrix was done numerically.

FIGURE 88 Simulation of the selection process of waveguide modes: a) exponential refractive index profile of a planar waveguide, b) waveguide mode field profiles, the numbers on the curves correspond to the waveguide mode numbers, (c) profiles of photoinduced absorption created by exposure to activating radiation of different modes.

The results of the calculations are presented in Figures 87 and 88. Figure 88b shows the mode fields distributions of a waveguide with an exponential profile. The profiles of photoinduced absorption arising at the excitation of these modes by actinic radiation are given in Figure 88c. One can see that the main maxima for different mode numbers are significantly distanced from each other along waveguide thickness, that results in mode selection in the waveguide. A good agreement between experimental data (Figure 87a) and the calculation (Figure 87b) favors the correctness of the physical assumptions taken at the construction of the theoretical model for real photochromic glasses and chosen conditions of irradiation.

Computer experiments have shown, for instance, that in order to increase the efficiency of the selection of high-order modes, it is helpful to create a gradient of photosensitive properties of photochromic glass along waveguide depth, i.e., $k_a(x)$ in Equation (77). However, the creation of a gradient of photosensitive microcrystals concentration, i.e., $c^*(x)$ in Equation (77), leads to an improvement of low-order modes selection.

The restriction (80) is a consequence of ignoring a distortion of the mode wave front while radiation propagates along a photosensitive waveguide. In the case of visible light range, this corresponds to waveguide length less than 1 cm. At the same time, practical needs dictate usage of waveguides of lengths an order of magnitude as large. Therefore, Dotsenko at al.[275] formulated an algorithm of numerical calculation

of mode fields and mode selection in planar waveguides that did not contain any limitations for radiation path length for its propagation in a waveguide. For the solution of a self-conformable system of nonlinear equations, an implicit two-layer differential scheme was chosen with weight S_w (see Samarsky[277]). After the separation of the real and the imaginary parts of the sought solution, the equations were solved by the method of matrix running. The primary difficulty in the calculation of such problems is to provide the stability of a differential scheme that would exempt the growth of initial errors in computer simulation. It has been found that parameter S_w can be written as:

$$S_w = \frac{1}{2} - \frac{i\beta(\Delta x)^2}{6\Delta z} \tag{88}$$

where β is a radiation propagation constant which provides, together with the stability, a higher order of the precision of the algorithm.

7.5 LIGHT PROPAGATION IN COUPLED PHOTOCHROMIC WAVEGUIDES

As was already mentioned, the main application of the photochromic material is in the modulation of light. However, for the case of homogeneous slabs used to attenuate radiation, the capacities of such a filter are too restricted. Actinic radiation

FIGURE 89 Sketch (a) and simulation (b) of light propagation in periodic structure of layers from photochromic and colorless glasses.

is effectively absorbed in surface layers of such a filter, thus cutting its working thickness. Therefore, there is interest in the development of the methods describing light propagation in a "sandwich" system of thin wafers of photochromic glass separated from each other by colorless wafers. Such a system of coupled waveguides, when placed into a conic reflector (see Figure 89a), is free from the above-mentioned drawback and can effectively attenuate light flow.

Consider a system of planar waveguides shaped as a pile of interchanging layers in the following way: layers of photochromic glass with a refractive index n_1 alternate with layers of colorless glass with a refractive index n_2 (Figure 89b). A homogeneous light beam incidents onto the side surface of the pile at an angle v_0 to the normal to the plane limiting the pile. When treating the refraction at the input into the waveguide system, we deal with beam approximation (for methods of wave problem solution see the works of Dotsenko et al.,[278] Poletaeva et al.,[279] and Flegontov et al.[280]). The flow will be split into three flows: $P*$ — flow captured by the photochromic waveguide, P_1 — flow in photochromic glass layer that has come from the colorless layer with a lower refractive index (because $n_2 < n_1$) and P_2 — flow propagating in a colorless glass layer.

Consider a settled steady picture of transmittance and flow distribution along each of the layers as a function of the Z coordinate. The following approximations are accepted. We describe the distribution of flows in photochromic and colorless layers far enough from the front surface of the pile ($Z \gg d_1, d_2$ in Figure 89b). Then the distribution of intensity between the layers can be considered as a steady-state one. The value of the flow is counted as the average over the thickness of each layer and depends on the Z coordinate only. Since the time of flow propagation along a layer is much less than the time of color center relaxation, the instantaneous state of the medium can be regarded as "frozen" for the time of flow propagation. The resulting absorption in this case is determined by the solution of Equation (77).

If k_a is the effective cross-section of color center formation and k_f is the probability of their spontaneous decay, then the equilibrium color center concentration is:

$$c(z) = \frac{k_a I(z) c*}{k_a I(z) + k_f} \tag{89}$$

where $c*$ is the concentration of photosensitive microcrystals and $I(z)$ is the flow of coloring light. $c*$, k_a, and k_f values are considered to have been specified according to the results of earlier experiments.

The general nonlinear problem of flow transition to a steady state was solved by the iteration method. Time scale t in Equations (77) and (89) is also much greater than the time of light propagation along a layer because it is defined by the relaxation time of the absorption coefficient. Therefore, the process of settling steady light field and the whole pile transmittance was determined successively as the solution of flow evolution equation at the nth step at ε_ϕ counted using the flow value determined at $(n - 1)$th step. The process goes on until a constant flow value becomes steady in every point. This process defines $c(z,t)$ value, that, in a steady state, is determined by Equation (89) and only depends on the Z coordinate.

The equation of flow evolution at each step of the iteration process was derived from the condition of flow balance at the boundary between the layers. Deducing such balance conditions is illustrated by Figure 89b. Let R be the Fresnel reflectance from the boundary, γ_1 and γ_2 — the absorption coefficients in the layers with refractive indexes n_1 and n_2 and thickness d_1 and d_2, respectively. Then, the balance equation for the flows normal to the boundary and far from waveguides' input will have the form of:

$$I_1^{(n)} = I_1^{(n-1)}\gamma_1\gamma_2(1-R)^2 + I_1^{(n)}R + \left(I_2^{(n-1)} + \frac{h_1}{h}\Delta_{n-1}I_2\right)\gamma_2R(1-R)I_2^{(n)}$$

(90)

$$I_2^{(n)} = I_2^{(n-1)}\gamma_1\gamma_2(1-R)^2 + I_2^{(n)}R + \left(I_1^{(n-1)} + \frac{h_2}{h}\Delta_{n-1}I_2\right)\gamma_2R(1-R)I_2^{(n)}$$

Here h is a step in the Z coordinate between two consecutive reflections after which the geometrical path of rays is reiterated with a shift in layer number ($h = h_1 + h_2$, where $h_1 = d_1 tg\,v_1$ and $h_2 = d_2 tg\,v_2$), and n is step number along the Z coordinate of such a periodic structure:

$$\Delta_n I_k = I_k^{(n)} - I_k^{(n-1)}\(k=1,2)$$

$$\gamma_k = \exp\left(\frac{2\pi n_k}{\lambda}\frac{d_k\varepsilon_{ph}^{(k)}}{\cos\vartheta_k}\right)......(k=1,2)$$

(91)

Angles v_k ($k = 0,1,2$) are determined according to the laws of reflection at the boundaries of the corresponding media; angle v_0 is specified by the conditions of flow incidence onto the front of the pile of waveguides.

The flow I^* undergoes total internal reflection at the boundary of a photochromic layer ($n_1 > n_2$) and, therefore, does not take part in the balancing of the flows that cross the boundary:

$$\Delta_n I_1 = [1 - \gamma_1\gamma_2(1-R)]I_1^{(n-1)} + \left(I_2^{(n-1)} + \frac{h_2}{h}\Delta_{n-1}I_2\right)\gamma_2R$$

(92)

$$\Delta_n I_2 = [1 - \gamma_1\gamma_2(1-R)]I_2^{(n-1)} + \left(I_1^{(n-1)} + \frac{h_1}{h}\Delta_{n-1}I_1\right)\gamma_1R$$

As the thickness of each layer is small enough compared to the typical scale at which the flow is measured ($\gamma_k \ll 1$, $h \ll 1$), difference Equations (92) can be replaced by differential ones in the following form:

$$I_1' = \frac{1-\gamma_1\gamma_2(1-R)}{h}I_1 + \frac{I_2 + I_2'h_1}{h}\gamma_2 R$$

$$I_2' = \frac{1-\gamma_1\gamma_2(1-R)}{h}I_2 + \frac{I_1 + I_1'h_1}{h}\gamma_1 R \tag{93}$$

$$(I_k^*)' = \varepsilon_{ph}^{(k)}(I^*,I_k)I_k^* \qquad (k=1,2)$$

However, the system of Equation (93) is unstable because its determinant is small. The stability of the system can be raised by resolving the right-hand sides of the equations in small parameters. Such parameters are:

$$(1-\gamma_k), \quad \varepsilon_{ph}^{(k)}, \quad (1-R), \quad \pi/2 - v_k \qquad (k=1,2) \tag{94}$$

Having limited the equations to the members linear in small parameters (94), we obtain:

$$I' = -A(I,I_1,I^*)I$$

$$I_1' = -B(I,I_1,I^*)I_1 + C(I,I_1,I^*)I \tag{95}$$

$$(I^*)' = -\varepsilon_{ph}^{(k)}(I,I_1,I^*)I^*$$

where

$$I = I_1 + I_2$$

$$A = \frac{(1-R)\varepsilon_\Phi^{(1)}}{(1+\beta)k_0(\beta)}$$

$$k_0(\beta) = 1 - \frac{\beta R}{(1+\beta)^2}$$

$$\beta = \frac{d_2}{d_1}\frac{\sqrt{2}d_2(n_1-n_2)}{n_2(\pi/2-\vartheta)} \tag{96}$$

$$B = \frac{1}{(1+\beta)k_0(\beta)}\frac{1-\gamma_1\gamma_2(1-R)}{hk_0(\beta)} + \frac{\beta R}{(1+\beta)}$$

$$C = \frac{\beta R}{(1+\beta)k_0(\beta)} + \left[\frac{1}{h} - \frac{(1-R)\varepsilon_\Phi^{(1)}}{(1+\beta)^2 k_0(\beta)}\right]$$

It should be noted that the solution of Equation (77) $c(z,t)$ is stabilized in the iteration process for small values of flaw in the form (89) before the stabilization of the flaw itself. It decreases significantly the volume of calculations needed to solve the system (95).

The results of numerical calculation demonstrate that by varying the extent of filling such a "sandwich" construction with photochromic material (designate it G), one can, other things being equal, intensify photoinduced optical density ΔD. In other words, the efficiency of the usage of photochromic glasses is improved by force of a well-designed construction of a relevant component. Estimations have shown that at the optimal value of $G = 0.85$, ΔD value grows by more than 20%.

We should note that the approaches to photochromic planar components discussed above can also be applied to the examination of fiber optical elements based on photochromic glasses. The first publication on the use of photochromic glass fiber was issued in 1967 (Hamman[281]), i.e., about five years after the first report on the preparation of such glasses. The above-mentioned invention pertained to the applications of photochromic glass fiber optical waveguides connecting the light source with the photodetector in logical function generators for the transmission of light energy. In the work by Papunashvili et al.[282] The possibility of creating fiber optical plates based on photochromic glass for designing elements with high optical density was demonstrated. It was noticed that elements could be fabricated in which photochromic glass is used as a material both for a core covered by a clad of colorless optical glass and vice versa.

Mathematically, this problem requires study of radiation propagation in a system of coupled waveguides that was simulated as a periodic structure. In this case, the analog for layer thickness is the length of optical path in the cross-section of the fiber averaged over the angles of beam incidence onto the fiber surface. Dotsenko et al.[278] and Flegontov et al.[280, 283] have proposed an iteration approach to the solution of that problem, which is, generally speaking, nonlinear. Light flows were taken into consideration not only in the photochromic core but also in the colorless clad. It is the flows in the latter that allow radiation to pass throughout the whole plate thickness, thus increasing the efficiency of fiber optical plate illumination as compared to a homogeneous plate of the same photochromic glass at equal thickness of both elements. By varying the extent of filling such fiber optical plates with photochromic glass and of fiber diameter, one can obtain a significant amplification of the effect of light attenuation.

8 Optical Sensitization of Coloration

The stimulation of photochromic glasses by visible radiation has been mentioned several times in previous chapters, and it was reported that under certain conditions an increase in photoinduced absorption is caused by that radiation. Since silver and copper halide crystals, which are the basis of the photosensitive phase of heterogeneous photochromic glasses, do not possess absorption bands in the visible region, the problem of such a coloration is not trivial, and it is important to formulate accurately the assemblage of the observed phenomena.

8.1 EFFECT OF VISIBLE LIGHT ON COLORED PHOTOCHROMIC GLASSES AND WAVEGUIDES

The first question is: "What actually brings about the additional coloration at the stimulation by visible light?" The spectra of additional, or photoinduced, absorption of FHS-7 glass (see Glebov et al.[261]) that was exposed to both short wavelength radiation with $h\nu \geq E_g (E_g = 2.8$ eV for $CuCl$) and long wavelength radiation with $h\nu < E_g$ are presented in Figure 90. One can see (curves 1 through 3) that the shape of the photoinduced absorption spectrum does not depend on the photon energy of exciting radiation, i.e., at any excitation (both in the region of $CuCl$ exciton absorption and in the region of color center absorption), the same color centers are formed. It should be noted that it is extremely extraordinary that when excitation falls in the band of color center absorption, no bleaching is observed, as is expected in both glasses and crystals (see Chapter 1) but, on the contrary, the induced absorption grows.

The dependence of photoinduced optical density in FHS-7 glass after exposure to visible light at 4×10^{14} photon/s cm^2 irradiance for 30 s on exciting photon energy (studied by Ashkalunin et al.[260]) is presented in Figure 90, curve 4. This dependence, to a first approximation, can be considered as the spectral sensitivity of glass to long wavelength radiation. One can see that the efficiency of long wavelength sensitization decreases with the decrease of photon energy in comparison to band gap energy E_g. It should be noted that the shape of the photosensitivity spectrum is close to the shape of the color center absorption spectrum (Figure 90), and one can even see a shoulder in the region of the color center absorption band maximum.

The kinetics of photochromic glass darkening and relaxation under exposure to short wavelength ($h\nu = 2.78$ eV, $\lambda = 440$ nm) and long wavelength ($h\nu = 1.96$ eV, $\lambda = 633$ nm) radiation[261] are presented in Figure 91 for FHS-2 glass. Curve 1 shows the accumulation of color centers in a bulk sample and in planar waveguide under stationary irradiation, and it looks like a usual curve with saturation at a level that

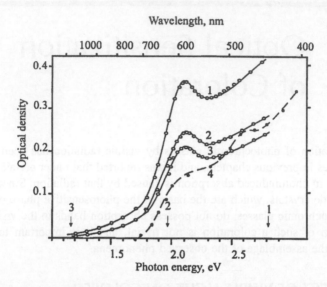

FIGURE 90 Spectra of photoinduced optical density in photochromic glass FHS-7 (thickness is 5 mm) after exposure to radiation at different wavelengths: (1) 440 nm (2.78 eV) **He–Cd** laser, (2) 633 nm (1.96 eV) **He–Ne** laser, (3) 1060 nm (1.17 eV) **Nd** laser. The spectral placement of excitation is shown by arrows with the same numbers. (4) Spectrum of photosensitivity-dependence of photoinduced optical density on photon energy of exciting radiation.

depends on the intensity of the exciting radiation. Curve 2 shows that the bulk sample of FHS-2 does not fade significantly at room temperature. Curve 3 represents isothermal relaxation in waveguide at room temperature with relaxation coefficient $K_{tr} = 0.05$ (see Table 18). Curve 4 shows that the irradiation of colored glass by long wavelength light with the intensity of 1 W/cm^2 speeds up the relaxation due to optical bleaching of color centers. When a waveguide is exposed to radiation with 100 W/cm^2, a phenomenon is observed that was called "optimal sensitization" in Chapter 5 of this book and that demonstrates an increase of photoinduced absorption more than twice as large (curve 5).

A similar picture is obtained for all studied glasses (FHS-2, -4, -6, and -7) and the waveguides produced on them. The effect of optical bleaching at a low intensity of long wavelength radiation is observed for all silver halide glasses. Silver-free FHS-7 glass, which contains copper halide as a photosensitive component, does not exhibit optical bleaching. Optical bleaching in the waveguides was not obtained in the range of intensity used (more than 1 W/cm^2). Dotsenko et al.[267] found that decreasing the intensity up to 10 mW/cm^2 in the waveguide on FHS-2 did not cause optical bleaching. The optical sensitization phenomenon is obtained in all glasses at sufficiently high intensity of long wavelength excitation. The higher the copper concentration in a glass, the greater is the effect of optical sensitization. The sensitization takes effect far more strongly in waveguides than in bulk samples. This can be caused by two phenomena. The first one is the increasing of the intensity when the volume light wave becomes waveguiding because of a significant decreasing of

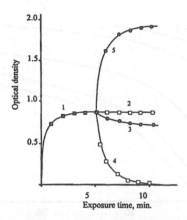

FIGURE 91 Variation of photoinduced optical density at 633 nm in FHS-2 glass bulk sample (squares) and planar waveguide (circles) under the effect of: (1) radiation at 440 nm (2.78 eV) of He–Cd laser, (2) thermal relaxation at room temperature in bulk sample, (3) thermal relaxation at room temperature in waveguide, (4) radiation at 633 nm (1.96 eV) He–Ne laser with irradiance of 1 W/cm², (5) radiation 633 nm (1.96 eV) He–Ne laser with irradiance of 100 W/cm². Thickness of bulk sample was 5 mm, the length of the waveguide was chosen to show the same photoinduced absorption as the bulk sample under the short wavelength irradiation.

the beam cross-section. The second one may be structural transformations of the centers of photosensitivity in the process of waveguide layer creation.

The study of the dependence of color center accumulation kinetics on their initial concentration is illustrated by Figure 92.[267] One can see that at a high initial concentration, the kinetics of coloration shows a routine pattern of monotonous curve with saturation (curves 1 through 4), which is typical for color center generation in crystals and glasses (see Chapter 1, Section 1.2 and Chapter 5), i.e., the maximum rate of color center generation is obtained at the initial moment of stimulation, and then it smoothly decreases to zero. However, as the initial concentration decreases, the kinetics of color center accumulation ceases to be monotonous. Curves 5 and 6 in Figure 92 show distinct stages of coloration rate growth at the beginning of the irradiation process (latent period). That means that, in the process of irradiation, either the number of photosensitivity centers increases or the probability of charge capturing by traps grows.

It has been found that when the initial concentration of color centers decreases as a result of relaxation at room temperature the latent period is extended. Keeping the glasses in darkness at 400 °C for a few hours results in a complete lack of photosensitivity to long wavelength radiation. It is noteworthy that the sensitivity to long wavelength radiation is restored when a glass sample is exposed to room illumination and temperature for as short a time as a few seconds. In this time, the photoinduced absorption Δa in the visible range of the spectrum reaches the value of 0.01 to 0.05 cm⁻¹.

Now let us summarize the whole set of the observed phenomena that need explanation:

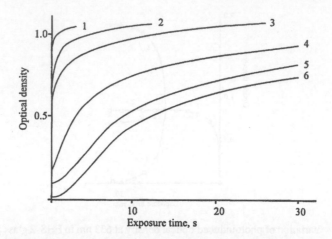

FIGURE 92 Dependence of kinetics of long wavelength stimulated coloration in planar waveguide in FHS-4 glass on the previous coloration by UV radiation. Exposure to radiation of **He–Ne** laser at 633 (1.96 eV) with irradiance of 50 W/cm². The length of waveguide is 1 cm.

- The photochromic glasses doped with microcrystals of copper or silver and copper halides, which was preliminarily colored by short wavelength radiation, can undergo further coloration by the exposure to optical radiation with photon energy insufficient for photosensitivity center ionization (long wavelength stimulation of coloration).
- Long wavelength stimulation of coloration produces the same spectrum of induced absorption as short wavelength irradiation.
- When the initial absorption of color centers is decreased, a latent period appears on the curve of coloration by long wavelength excitation.
- Long wavelength stimulation of coloration is absent if previous coloration is absent.
- Long wavelength stimulation of coloration is not obtained at low intensity of exciting radiation.

8.2 COOPERATIVE BREEDING OF COLOR CENTERS

Several possible mechanisms can be offered for the explanation of long wavelength stimulation of coloration. In the work by Ashkalunin et al.,[260] which was the first description of the phenomenon, it was assumed, that under long wavelength excitation, the ionization of previously created color centers occurs. After that, the released electron generates a new color center while the remaining hole forms a trap, thus restoring the formerly destroyed color center. However, the ionization of color centers cannot be the cause of additional coloration, because the number of newly formed centers will always be equal to or less than the number of those destroyed (ionized).

Dotsenko et al.[284] have used the concept of the latent image developed in the theory of photographic processing (see references 4 and 95) for mathematical

simulation of darkening kinetics of photochromic glasses exposed to pulsed radiation. It was supposed that not only color centers but also precenters can exist in these glasses. These precenters are generated during the first stage of the excitation process but do not reveal themselves in photoinduced absorption spectra because their absorption cross-section is too small. One can also suppose for copper halide photochromic glasses that under long wavelength excitation of these precenters, they generate the same color centers that are responsible for the induced absorption obtained. In the framework of such a simulation, at certain correlation between the parameters, it is possible to obtain a kinetics of long wavelength stimulated coloration exhibiting the latent period similar to that in Figure 92.

Coloration produced by photons with energy that is not enough for photosensitivity center ionization and the dependence of the long wavelength stimulation efficiency on radiation intensity can lead to the assumption of two-photon ionization of photosensitive centers. However, Gagarin et al.[285] have shown that effective two-photon color center formation is observed only at intensities above 1 MW/cm^2. In Chapter 7, Section 7.3 it was pointed out that long wavelength stimulation was observed at intensities 4 to 6 orders of magnitude lower. Besides that, it was found that the efficiency of two-photon ionization depends little on the absorption in the visible region, and the kinetics of two-photon formation of color centers is monotonous.

To explain all features of the long wavelength coloration of photochromic glasses attention can be drawn to another type of nonlinear process observed by Ovsyankin et al.[286,287] in silver halide crystals, namely, the cooperative sensitization of luminescence. The essence of that process is that the molecules of cyanine dyes absorb long wavelength radiation and enter an excited state. The energy from two excited states is cooperatively transmitted to the **AgHal** crystal and the molecules return to their ground states. As a result, a **AgHal** crystal is raised to an upper state and then emits light with a photon energy greater than that of the exciting light.

The assemblage of phenomena obtained for long wavelength stimulation of coloration can be explained if one supposes that two color centers, previously generated under short wavelength excitation, can absorb two visible photons, then cooperatively transfer the energy to a photosensitive center and return to their ground state. This summed energy is sufficient to ionize that center. The released electron creates a new center according to the usual mechanism discussed previously.

To clarify the basic regularities of the performance of cooperative processes in color center formation, we will consider the phenomenological description using a system of balanced equations. It has been shown in Chapter 6 that, under short wavelength excitation, the first stages of color center generation are the absorption of a photon and thermal decomposition of an exciton in **CuCl**. The identity of photoinduced absorption spectra applied with different excitation methods allows us to consider only one type of color center that represents an electron localized at a trapping center. For simplicity, we will not take into account the possible optical bleaching of color centers. In this case, the system of equations describing linear formation of color centers can be put down as follows:

$$\frac{dc_e}{dt} = q_{abs}I_c(c_c - c_n - c_p) + I_T c_n - T_n(c_c - c_n - c_p)c_e - T_p c_p c_e$$

$$\frac{dc_n}{dt} = T_n(c_c - c_n - c_p)c_e - I_T c_n \qquad\qquad (97\text{--}99)$$

$$c_p = c_n + c_e$$

where q_{abs} is the intensity of absorbed exciting radiation, c_c, c_n, c_p, and c_e are the concentrations of copper Cu^+ in a photosensitive crystal, electron color center Cu^0, hole color center $(Cu^+)^+$ and free electron, respectively, I_c and I_T are the probabilities of thermal ionization of exciton and thermal ionization of color centers, respectively, and T_n and T_p are the probabilities of electron trapping by copper ion and hole center, respectively. For the standard approximation, where the lifetime of an electron in a conduction band is much less than those in traps, i.e., $c_n \approx c_p$, it is possible to show that, at any relation of the parameters in the system of Equations (97) through (99), the second derivative of color center concentration is negative. Hence, the rate of color center formation dc_n/dt is maximum at the initial moment of time and decreases to zero while the irradiation proceeds. The stationary solution of the system (97) through (99) shows that c_n decreases to zero for decreasing intensity and increasing color center thermal decomposition probability. Thus this comparatively simple simulation correctly represents the basic characteristics of usual short wavelength coloration of photochromic glasses.

Now we write a similar system to describe only the long wavelength radiation effect with the consideration of cooperative transfer of two quanta of energy from the excited color center to the photosensitive center:

$$\frac{dc_e}{dt} = Sq^2\sigma_n^2 c_n^2(c_c - c_n - c_p) + I_T c_n - T_n(c_c - c_n - c_p)c_e - T_p c_p c_e$$

$$\frac{dc_n}{dt} = T_n(c_c - c_n - c_p)c_e - I_T c_n \qquad\qquad (100\text{--}102)$$

$$c_p = c_n + c_e$$

where σ_n is the cross-section of color center absorption, S is the probability of cooperative transfer of two quanta of the excitation energy from color centers to a photosensitive center. First we will consider the stationary solution of the system, when the derivatives are zero. Unlike the case of linear ionization (97) through (99), at cooperative excitation, the stationary solution is written as follows:

$$c_{n,st} = 0, \quad \text{for } c_{n,0} = 0$$

$$c_{n,st} = 0, \quad \text{for } c_{c,0} > 0, q < q_{thr}$$

$$c_{n,st} = \frac{c_c}{2}\left(1 - \frac{q_{thr}}{q}\right), \quad \text{for } c_{n,0} > 0, q > q_{thr} \qquad (103\text{--}106)$$

$$q_{thr} = \sqrt{\frac{T_p I_T}{\sigma_n^2 c_c^2 T_n S}}$$

where $c_{n,0}$ and $c_{n,st}$ are the concentrations of color centers at the beginning of the long wavelength exposure and at the steady state, respectively, q_{thr} is the threshold intensity of the exciting radiation. One can see that there are two solutions in the stationary case. First, color center concentration is always zero if the initial concentration is zero, i.e., color centers cannot be generated in the cooperative process without previous coloration. Second, at nonzero initial concentration, the stationary solution possesses a threshold character. If the radiation intensity was below the threshold value, the stationary concentration is zero, i.e., the rate of color center generation is less than the rate of their thermal fading. The dependence of color center stationary concentration on normalized intensity is presented in Figure 93 (curve 1). The stationary concentration tends toward photosensitive center concentration, i.e., to complete coloration at the growth of radiation power and at the decrease of thermal fading probability.

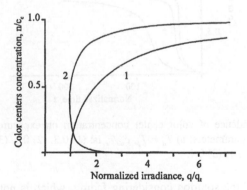

FIGURE 93 Calculated dependence of stationary concentration of color centers for cooperative breeding on the intensity of long wavelength excitation: (1) two-photon process, (2) three-photon process.

Although the general solution of the system (99) through (101) is cumbersome, for the case of no fading and setting $c_c = 1$, the solution can be put in a relatively simple form:

$$\left(\frac{c_c}{c_{n,0}} - \frac{c_c}{c_n}\right) + \frac{2T_p}{T_n}\left(\frac{1}{1-\dfrac{2c_n}{c_c}} - \frac{1}{1-\dfrac{2c_{n,0}}{c_c}}\right) + 2\left(1+\frac{T_p}{T_n}\right)\ln\frac{\dfrac{c_c}{2c_{n,0}}-1}{\dfrac{c_c}{2c_n}-1} = Sq^2\sigma_n^2c_c^2t$$

$$(107)$$

The dependencies of color center relative concentration vs. normalized time, $\tau = Sq^2\sigma_n^2c_c^2t$ for different initial concentrations are shown in Figure 94. One can see that with a decrease of initial concentration, a latent period appears when the generation rate is growing as the irradiation proceeds. Physically, this is connected with the fact that in this particular case, color centers (whose concentration is growing while irradiation), themselves, are the analogs of photosensitive centers.

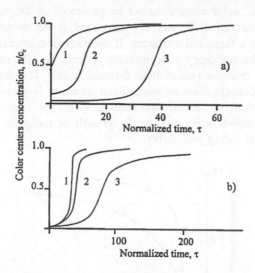

FIGURE 94 Dependence of color center concentration on exposure time calculated by Equation (106) with parameters: a) $T_n = T_p$, c_{n0}/c_c is: (1) 0.3, (2) 0.1, (3) 0.03, b) $c_{n0} = 0.03$ c_c, T_n/T_p is: (1) 10, (2) 1, (3) 0.1.

The analysis of the solution considering fading, which is not given here, shows that, at $q < q_{thr}$ (see Equation (106)) color centers are destroyed and the system comes to the uncolored state. At $q > q_{thr}$, first, the coloration proceeds at a growing rate, then the rate starts to slow down, and the final state is defined by dynamic equilibrium between cooperative generation of color centers and their thermal (or linear optical) bleaching.

It can be shown, by solving system (100) through (102), that the derivative of color center concentration at the initial moment of time at $q \gg q_{thr}$ and $c_n \ll c_c$, is put as:

$$\left.\frac{dc_n}{dt}\right|_{t=0} = Sc_c\sigma_n^2q^2c_{n,0}^2$$

$$(108)$$

It can be seen from Equation (108) that the initial rate of color center formation depends on the square of the initial color center concentration and on the intensity of stimulating radiation.

It is clear that Equation (108) can be used for the experimental verification of the offered simulation. We should stress that, in order to keep the conditions for which Equation (108) is derived, the time of registration was necessarily reduced to 200 ms. The dependencies dc_c/dt on He–Ne laser intensity and on the initial photoinduced absorption measured in this way are shown in Figure 95. One can see that initially both dependencies plotted in logarithmic coordinates really have slopes nearly equal to 2.

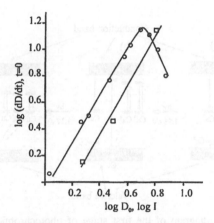

FIGURE 95 Dependence of initial coloration rate for exposure to radiation of He–Ne laser 633 nm (1.96 eV) on: (1) initial absorption at 633 nm, (2) intensity of incident radiation, plotted in logarithmic coordinates.

Therefore, the proposed model describes the entire set of experimental results of the long wavelength ($hv < E_g$) stimulation of coloration of photochromic glasses that have been collected to date and consists of the following (Figure 96):

- Two color centers generated by previous short wavelength irradiation absorb two photons of long wavelength radiation and are raised to an excited state
- These centers simultaneously transfer the accumulated energy to a photosensitive center and return to their ground state
- The photosensitive center is ionized and a mobile electron is released
- The released electron is localized at a trap that is the first stage in a process of new color center generation.

Such a mechanism may be called cooperative sensitization of color center generation or cooperative breeding of color centers. Leaving aside the processes of the aggregation of atoms at the creation of color centers, for the description of

cooperative breeding of color centers at $1.4\,eV < h\nu < 2.8\,eV$, we can write the following photochemical reaction:

$$2Cu^+ + 2Cu^0 + 2h\nu \Rightarrow 2Cu^+ + 2(Cu^0)^*$$
$$\Rightarrow (Cu^+ + (Cu^+)^*$$
$$+ 2Cu^0 \Rightarrow Cu^{2+} + 3\,Cu^0 \qquad (109)$$

It is important to emphasize that, both by the equation form and by its physical essence, cooperative breeding represents a typical chain reaction where the products of the reaction are used to accelerate the reaction.

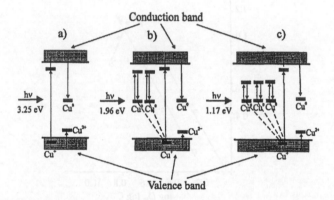

FIGURE 96 Energetic diagram of the first stage of photochromic glass coloration at: a) short wavelength coloration; b) two-photon cooperative breeding; and c) three-photon cooperative breeding.

The study of photochromic glass coloration under long wavelength radiation has shown that, at least for copper halide glasses, the long wavelength part of the photoinduced absorption spectrum in the visible region is not the long wavelength edge of photosensitivity. Glebov et al.[288] have found that under neodymium pulse laser irradiation with photon energy of $h\nu = 1.17\,eV$ ($\lambda = 1.06\,\mu m$), at pulse irradiances of 10 to 100 MW/cm², an additional absorption is induced in FHS-7 glass. The spectrum of that photoinduced absorption is shown in Figure 90, curve 3. One can see that the spectrum is similar to those induced by UV and visible radiation. Consequently, in this case too, identical color centers are formed.

Study has shown that features of IR coloration are similar to that of visible light, i.e., the photosensitivity is lost after annealing in darkness and at a low extent of previous coloration the latent period is observable. This allows us to assume that the mechanisms of coloration are also analogous to each other though, in this case, three particles and three photons must participate in the process, since $2h\nu < E_g = 2.8\,eV < 3h\nu$. To clear up the basic regularities, it is necessary to solve a system similar to (100) through (102), where the probability of cooperative transfer of the excitation energy to a photosensitive center would be expressed as $Sq^3\sigma_n^3c_n^3$. The

rate of the photoinduced absorption growth at the initial moment of time can be written as:

$$\frac{dc_n}{dt}\Big|_{t=0} = Sc_c\sigma_n^3 q^3 c_{n,0}^3 \tag{110}$$

The measurements of coloration rate in the initial part of exposure, depending on previous absorption and on radiation intensity, have confirmed the three-photon cooperative mechanism of coloration. The stationary solution for the case of the three-photon process is of great interest. A trivial solution is similar to (103) and shows that, when the initial concentration is zero, the breeding of color centers is impossible. A nontrivial solution will be written as follows:

$$\frac{c_n}{c_c}\left(\frac{c_c}{c_n} - 1\right)^{2/3} = \frac{q_{thr}}{q} \tag{111}$$

where q_{thr} has a form as in (106), the degrees altered from 2 to 3. This dependence is illustrated in Figure 93 (curve 2). One can see from the figure that, as it is for the two-photon process, the stationary solution at $q < q_{thr}$ provides complete transmittance of the glass. However, at $q > q_{thr}$, the stationary solution exhibits two branches. This means that there are two possible stationary solutions in this case: one for nearly complete transmittance and the other for nearly complete coloration. In other words, under the same exposure, the system may arrive at different states depending upon the original conditions. In the same way as for two-photon, three-photon cooperative breeding of color centers can be presented in the form of the following reaction (Figure 96c):

$$2Cu^+ + 3Cu^0 + 3h\nu \Rightarrow 2Cu^+ + 3(Cu^0)^*$$
$$\Rightarrow Cu^+ + (Cu^+)^*$$
$$+ 3Cu^0 \Rightarrow Cu^{2+} + 4Cu^0 \tag{112}$$

where $0.9\ eV < h\nu < 1.4\ eV$.

8.3 RECORDING AND AMPLIFICATION OF IMAGES AT LONG WAVELENGTH SENSITIZATION

Some features of the coloration of photochromic glasses under long wavelength sensitization that open new opportunities for writing and processing of images should be stressed here. First, absorption of photochromic glasses, even colored, is significantly less in the visible and IR regions than in the UV. This allows us to produce coloration in depths up to 1 cm by visible sensitization and up to 10 cm by IR sensitization. Second, the rate of coloration depends nonlinearly on intensity of

stimulating radiation. The latter fact allows one to produce coloration in the places of maximum intensity of radiation only.

Then, because of the very small absorption coefficient of colored glass at the wavelength of neodymium laser and cubed dependence of coloration efficiency on intensity, it is possible to create coloration at an arbitrarily chosen point in the bulk of a glass slab, where laser radiation will be focused. This allows one to record information (an image or an amplitude hologram) at any point in the sample. Besides, this effect can be used for the visualization of IR laser radiation.

The next feature of long wavelength coloration can be obtained in accordance with the mathematical model of three-photon cooperative breeding which, formally, yields solutions corresponding to a bistable regime. This phenomenon needs both theoretical and experimental study. Here we only illustrate the non-single-valued feature of a photochromic waveguide coloration.

An ion-exchange waveguide on FHS-7 glass was exposed to two types of radiation: one short wavelength with $h\nu_1 = 2.78$ eV ($\lambda = 440$ nm) and the other long wavelength with $h\nu_2 = 1.96$ eV ($\lambda = 633$ nm). The processes of coloration of this sample are shown in Figure 97. Originally the sample is in state "0." Under the exposure to short wavelength radiation $h\nu_1$, the waveguide is colored and rises to state "1." Under exposure to long wavelength irradiation $h\nu_2$, the waveguide is colored and rises to state "2." The value of the photoinduced optical density is higher in this case because the length of the interaction between visible radiation and waveguide is longer than that for the UV radiation. Under the simultaneous effects of $h\nu_1$ and $h\nu_2$ radiation, the waveguide is colored more intensely and rises to state "4." The transition to state "4" takes place disregarding the sequence of $h\nu_1$ and $h\nu_2$ switching: the sole fact of their coupled action is important. Interestingly, at $h\nu_1$ switching off, the system relaxes from state "4" not to state "2" but to the state "3." In order to drive the system to state "2," the excitation should be switched off completely so that the system would get decolorized; only after that should long

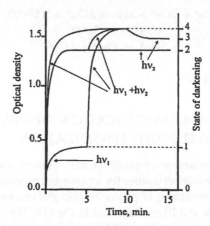

FIGURE 97 Planar waveguide on FHS-7 (length 1 cm) coloration kinetics under exposure to short wavelength ($\lambda_1 = 440$ nm, $h\nu_1 = 2.78$ eV) and long wavelength ($\lambda_2 = 633$ nm, $h\nu_2 = 1.96$ eV) radiation.

wavelength $h\nu_2$ radiation be turned on. Thus, depending on whether a short wavelength signal was put on the waveguide or not, it will be colored under long wavelength irradiation to different states. It is clear, that a similar phenomenon is interesting both from the point of view of the study of nonlinearity at cooperative sensitization and of possible applications in optical logic devices.

Ashkalunin et al.[289] discussed one more feature of long wavelength sensitization — the opportunity for amplification of the image written by short wavelength radiation. The main idea of this particular approach is that the dependence of the efficiency of a long wavelength sensitization on the value of the initial absorption allows one to divide actinic radiation into two types. The first is that the short wavelength radiation possesses a complicated spatial distribution that is a carrier of information. The second is the homogeneous long wavelength radiation that is used only to enhance the effect of the first one. In this case, the image created by short wavelength radiation can be considered as a latent image similar to the photographic process. Then the long wavelength sensitization can be considered as developing it.

It was shown by Ashkalunin et al.[289] that in this approach a UV exposure of 100 μJ/cm² is enough to create a photoinduced optical density $\Delta D = 1$. This is two orders of magnitude less than the usual exposure of photochromic glasses described above. Moreover, this photosensitivity is close to the photosensitivity of silver halide photographic emulsions.

It should be noted that information, written by UV radiation as a latent image, remains in glass for a long time. For example, the value of maximum coloration by visible light in glass FHS-7, exposed to UV radiation, was not varied after one year storage at room temperature. It is shown in Table 18 that after 5 min aging at room temperature the photoinduced optical density of FHS-7 glass decreases by a factor of two. The heat treatment at 400 °C for several hours followed by slow cooling restores the optical and photochemical properties of the sample completely. Thus, the phenomenon of optical sensitization in copper halide photochromic glass allows us to develop the latent image written by UV radiation not by chemicals but by effect of "cheap" visible radiation.

To illustrate this conclusion, Ashkalunin et al.[289] tried to write and amplify the image of a test object. A metal screen 13 mm in diameter with square holes of 0.2 mm was used as a test object. Recording of the latent image was made in FHS-7 glass by exposure to radiation of a mercury lamp at 385 nm (3.2 eV) for 100 μJ/cm². No image was observed in the exposed glass wafer. Reproduction and amplification of the latent image was performed with a slide projector. Radiation of the lamp was passed through the yellow filter, which cut off the short wavelength part of the spectrum. The exposed sample of glass was placed in the position of the slide. Then the image of the glass wafer was projected on the screen. Photographs of the screen were made at a number of times after the projector was cut in (see Figure 98). For the first several seconds one can see nothing. It is clear that later the contrast of the original image is varied strongly from the absence of the image in the beginning to the absorption of 90% of light after several minutes of "developing."

It can be supposed that this phenomenon of "optical developing," especially in combination with the above-mentioned writing in an arbitrary point of the glass slab, can be successfully used in devices of optical information processing and storage.

FIGURE 98 Photographs of the image of the test object in photochromic glass FHS-7 in the consequent moments of "optical developing."

References

1. Mott, N. F., Gurney, R. W., *Electronic Processes in Ionic Crystals,* Oxford, 1940.
2. Luschik, Ch. B., Study of trapping centers in alkali-halide crystals (in Russian), in *Proceedings of Institute of Physics and Astronomy of Estonian Academy of Sciences,* IFA, Tartu, 1955.
3. Fowler, W. B., *Physics of Color Centers,* Academic Press, London, 1968.
4. Meiklyar, P. V., *Physical Processes Creating Latent Photographic Image* (in Russian), Nauka, Moscow, 1972.
5. Silin, A. R., Trukhin, A. N., *Point Defects and Elementary Excitations in Crystalline and Vitreous* SiO_2, Zinatne, Riga, 1985 Chap. 4.
6. Glebov, L. B., Dyachkova, Yu. V., Payasova, L., Petrovskii, G. T., Savel'ev, V. L., Trukhin, A.N., and Tolstoi, M.N. Effect of leaching on the reflection and luminescence spectra of $Na_2O*3SiO_2$ glass the fundamental-absorption region, *Sov. J. Glass Phys. Chem.,* 11, 217, 1985.
7. Urbach, F., The long-wavelength edge of photographic sensitivity and of the electronic absorption of solids, *Phys. Rev.,* 92, 1324, 1953.
8. Glebov, L. B., Lunter, S. G., Popova, L. B., and Tolstoi, M. N., Change in valence state of iron in silicate glasses subjected to UV irradiation, *Fiz. Khim. Stekla* (in Russian), 1, 87, 1975.
9. Mahr, H., Absorption band shape and Urbach's rule of localized excitons, *Phys. Rev.,* 132, 1880, 1963.
10. Glebov, L. B., Dokuchaev, V. G., and Petrovskii, G. T., Absorption spectra of high-purity glasses with different concentrations of Fe^{3+} colored by gamma radiation, *Sov. J. Glass Phys. Chem.,* 11, 61, 1985.
11. Glebov, L. B., Dokuchaev, V. G., and Petrovskii, G. T., Change in absorption under the action of radiation of high-purity sodium calcium silicate glasses in the near-IR region of the spectrum, *Sov. J. Glass Phys. Chem.,* 12, 374, 1986.
12. Glebov, L. B., Dokuchaev, V. G., Petrov, M. A., and Petrovskii, G. T., UV-absorption spectra of chemically and radiation- reduced iron in a sodium silicate glass, *Sov. J. Glass Phys. Chem.,* 13, 97, 1987.
13. Byurganovskaya, G. V., Vargin, V. V., Leko, N. A., Orlov, N. F., *Effect of Ionizing Radiation on Non-Organic Glasses* (in Russian), Atomizdat, Moscow, 1968.
14. Brekhovskih, S. M., Viktorova, Yu. N., Landa, L. M., *Radiation Induced Phenomena in Glasses* (in Russian), Energoizdat, Moscow, 1982.
15. Mackey, J. H., Smith, H. L., and Halperin, A., Optical studies in X-irradiated high purity sodium silicate glasses, *J. Phys. Chem. Solids,* 27, 1759, 1965.
16. Glebov, L. B., and Tolstoi, M. N., Formation of unstable color centers in UV-irradiated silicate glasses, *Sov. J. Glass Phys. Chem.,* 2, 340, 1976.
17. Glebov, L. B., Radiation coloring in the 600-1000 nm region of high purity sodium calcium silicate glass, *Sov. J. Glass Phys. Chem.* 9, 242, 1983.
18. Glebov, L. B., Dokuchaev, V. G., Petrov, M. A., and Petrovskii, G. T., Structure of the UV-absorption spectra of γ-colored sodium silicate high purity glasses, *Sov. J. Glass Phys. Chem.,* 13, 226, 1987.

19. Glebov, L. B., Dokuchaev, V. G., Petrov, M. A., and Petrovskii, G. T., A new type of intrinsic color centers in sodium silicate glasses, *Sov. J. Glass Phys. Chem.*, 13, 310, 1987.

20. Glebov, L. B., Dokuchaev, V. G., Petrov, M. A., and Petrovskii, G. T., Electron color centers with 3.7 eV absorption band in sodium silicate glasses, *Sov. J. Glass Phys. Chem.*, 14, 180, 1988.

21. Glebov, L. B., Dokuchaev, V. G., Petrov, M. A., and Petrovskii, G. T., Absorption spectra of color centers in alkali silicate glasses, *Sov. J. Glass Phys. Chem.*, 16, 31, 1990.

22. Glebov, L. B., Dokuchaev, V. G., Petrov, M. A., and Petrovskii, G. T., E'-centers in alkali silicate glasses, *Sov. J. Phys. Chem.*, 16, 339, 1990.

23. Stroud, J. S., Color centers in a cerium-containing glass, *J. Chem. Phys.*, 37, 836, 1962.

24. Weller, J. F., Ultraviolet radiation damage in silicate glass containing iron, *J. Appl. Phys.*, 40, 3407, 1969.

25. Glebov, L. B., Grubin, A. A., and Tolstoi, M. N., On the nature of the spectrum of the formation of color centers in silicate glass, *Fiz. Khim. Stekla*, (in Russian), 1, 313, 1975.

26. Arbuzov, V. I., Tolstoi, M. N., and Elerts, M. A., Effect of Fe^{3+} on the formation of color centers by the UV irradiation of a $Na_2O-3SiO_2$ glass, *Sov. J. Glass Phys. Chem.*, 11, 344, 1985.

27. Feofilov, P.P., Phototransfer of an electron in MeF_2:Eu,Sm monocrystals. *Opt. Spectroscopy*, 12, 296, 1962.

28. Arbuzov, V. I., Vitol, I. K., Grabovskis, V. J., Nikolaev, Yu. P., Rogulis, U. T., Tolstoi, M. N., Elerts, M. A., Degeneracy of activator energy levels with glassy matrix intrinsic states, *Phys. Stat. Sol. (a)*, 91, 199, 1985.

29. Arbuzov, V. I., Nikolaev, Yu. P., Raaben, E. L., Tolstoi, M. N., Elerts, M. A., Spectral, luminescent and photoinduced properties of silicate glasses doped with Fe^{2+} and Fe^{3+}, *Fiz. Khim. Stekla* (in Russian), 13, 625, 1987.

30. Arbuzov, V. I., Nikolaev, Yu. P., and Tolstoi, M. N., Mechanisms of the formation of intrinsic and impurity color centers in sodium silicate glasses containing two activators, *Sov. J. Glass Phys. Chem.*, 16, 20, 1990.

31. Arbuzov, V. I., Nikolaev, Yu. P., and Tolstoi, M. N., Effect of the composition of a glass on the relative arrangement of the energy levels of the activator and the intrinsic states of the matrix, *Sov. J. Glass Phys, Chem.* 16, 91, 1990.

32. Robinson, C. C., Excited-state absorption in fluorescent uranium, erbium and copper-tin glasses, *J. Opt. Soc. Amer.*, 57, 4, 1967.

33. Landry, R. J., Snitzer, E., Lell, E., Ultraviolet-induced transient and stable color centers in self-Q-switched laser glass, *J. Appl. Phys.*, 42, 3827, 1971.

34. Glebov, L. B., Dokuchaev, V. G., Petrov, M. A., and Petrovskii, G. T., Optical orientation of hole color centers in sodium silicate glass, *Sov. J. Glass Phys. Chem.*, 15, 259, 1989.

35. Glebov, L. B., Kanunnikov, L. A., Tolstoi, M. N., Shekhmamet'ev, R. I., High-temperature thermoluminescence in glass with composition $Na_2O-3SiO_2$., *Sov. J. Glass Phys. Chem.*, 4, 159, 1978.

36. Cohen, A. I., Smith, H. L., Variable transmission silicate glasses sensitive to sunlight, *Science*, 137, 981, 1962.

37. Swarts, E. L., Pressau, J. P., Phototropy of reduced silicate glasses containing the 570 nm color center, *J. Amer. Ceram. Soc.*, 48, 333, 1965.

38. Hosono, H., Abe, Y., Photosensitivity and structural defects in dopant-free ultraviolet-sensitive calcium aluminate glasses, *J. Non-Cryst. Solids.*, 95-96, 717, 1987.

39. Bukharaev, A. A., Yafaev, N. R., Study of the EPR and optical absorption spectra of a light-sensitive glass, activated by iron, *J. Appl. Spectrosc.*, 24, 727, 1976.

40. Nizovtsev V.V., Shishmentseva E. V., Solinov V. F., Spectral characteristics of photochromic alkali-silicate glasses, *J. Appl. Spectrosc.*, 22, 66, 1975.

41. Nizovtsev V. V., Shishmentseva E. V., Solinov V. F., Reduced alkali silicate glass as a photochromic material, *Inorg. Mater.*, 12, 638, 1976.

42. Caslavska, V., Strickler, D., Roy, R., Optimization of properties of photo conductive oxide glasses. *J. Amer. Ceram. Soc.*, 52, 359, 1969.

43. Zyabnev, A. M., Kraevskii, S. L., Makedontseva, O. S., Solinov, V. F., Concentration limit of photosensitivity of glasses doped with cadmium, *Fiz. Khim. Stekla* (in Russian), 14, 293, 1988.

44. Choundhury, V., Photochromic cadmium borosilicate glasses, *Indian Ceram.*, 17, 385, 1974.

45. Meiling, G. S., Photochromism in cadmium borosilicate glasses, *Phys. and Chem. Glasses,*. 14, 118, 1973.

46. Demkina, L. I., *Physical and Chemical Principles of Manufacturing of Optical Glass* (in Russian), Khimiya, Leningrad, 1976.

47. Gorokhovskii, Yu. N., *Spectral Study of Photographic Process*, Moscow, Khimiya, 1960, chapter 4.

48. Smith, G. P., Photochromic glasses: properties and applications, *J. Mater. Science.*, 2, 139, 1967.

49. Araujo, R. J., Photochromic glass, *Feinwerktechn. Micron.*, 2, 52, 1973.

50. Tsekhomsky, V. A., Photochromic oxide glasses, *Sov. J. Glass Phys. Chem.*, 4, 1, 1978.

51. Megla, G. K., Photochromic glasses: optical properties and application, *Appl. Opt.*, 5, 945, 1966.

52. Ayrapetyanz, A. V., Soboleva, V. V., Tsekhomsky, V. A., Spectral study of photochromic glasses doped with silver halides, *Zh. Nauchn. Prikl. Fotogr. Kinem.* (in Russian), 17, 27, 1972.

53. Gracheva, L. V., Peshkov, N. M., Spectrosensitometer for photochromic materials, *Sov. J. Opt. Technol.*, 46, 148, 1979.

54. Kawamoto, T., Kikuchi, R., Kimura, Y., Photochromic glasses containing silver chloride. Part 1. Effect of glass composition on photosensitivity, *Phys. Chem. Glasses*, 17, 23, 1976.

55. Kaplun, V. A., Peshkov, N. M., Standardization of the parameters of photochromic glasses, *Sov. J. Opt. Technol.*, 46, 400, 1979.

56. Frank, J., Rabinowitch, E., Some remarks about free radicals and the photochemistry of solutions, *Trans. Farad. Soc.*, 30, 120, 1934.

57. Dotsenko, A.V., Tsekhomsky, V.A., Correlation of light scattering in heterogeneous photochromic glasses with optical properties and size of photosensitive microcrystals for various glass matrixes, *Fiz. Khim. Stekla* (in Russian), 11, 247, 1985.

58. Van de Hulst, H. Q., *Light Scattering by Small Particles*, NY, 1957.

59. Volkova, V. V., Dotsenko, A. V., Zakharov, V. K., Ovcharenko, N. V., Chebotareva, T. E., Yakhkind, A. K., Silver halide photochromic glasses based on tellurium oxide, *Sov. J. Glass Phys. Chem.*, 11, 76, 1985.

60. Armistead, W. H., Stookey, S. D., U. S. Patent N 3 208 860, 350-160x, 1965; Brit. Pat. N 950 906, CO3b,c, 1964; France Pat. N 1 311 557, CO3c, 1964.

61. Glimeroth, G., Fototropes Glas mit guenstiger Kinetik des phototropen Prozesses, *Glass-Email-Keramo-Technik* (in German), 19, 269, 1968.

62. Vargin, V. V., Kuznetsov, A. Ya., Stepanov, S. A., Tsekhomsky, V. A., Silver chloride photochromic glasses, *Sov. J. Opt. Technol.*, 35, 38, 1968.
63. Tsekhomsky, V.A., Tunimanova, I. V., Photochromism and immiscibility in glasses, in *Phenomena of Phase Separation in Glasses* (in Russian) Nauka, Leningrad, 1969, 132.
64. Glimeroth, G., Mader, K. H., Phototropes glas, *Angew. Chem.*(in German), 82, 139, 1970.
65. Fanderlik, J., Prod'homme, L., Separation de phases observee per diffusion de la lumiere dans un verre photochrome, *Verres et refract.* (in French), 27, 97, 1973.
66. Wakim, F. G., Some properties of photochromic borosilicate glass, in *Recent Advances in Scientific and Technological Material*, NY, 1974, v. 2, 123.
67. Tsekhomsky, V. A., Papunashvili, N. A., Phase separation and photochromism in alkali-borate glasses. *Fiz. Khim. Stekla* (in Russian), 1, 212, 1975.
68. Shaw, R. R., Uhlmann, D. R., Subliquidus immiscibility in binary alkali borates, *J. Amer. Ceram. Soc.*, 51, 377, 1968.
69. Andreev, N. S., Boiko, G. G., Effect of lithium, potassium and cesium oxides on phases separation in sodium silicate glasses, in *Phenomena of Phase Separation in Glasses* (in Russian) Nauka, Leningrad, 1969, 48.
70. Araujo, R. J., Borrelli, N. F., Photochromic glasses, in *Optical Properties of Glass*, Uhlmann, D. R., Kreidl, N. J., Eds., Westerville, OH, 1991, 125.
71. Bray, P. J., Nuclear magnetic resonance studies of glass spectra, *J. Non-Cryst. Sol.*, 73, 19, 1985.
72. Araujo, R.J., Statistical mechanical model of boron coordination, *J. Non-Cryst. Sol.*, 42, 209, 1980.
73. Araujo, R.J., Influence of host glass on precipitation of cuprous halides, submitted to *J. Non-Cryst. Sol.*, in press, 1997.
74. Morimoto, S., Mashima, M., Effect of composition on darkening and fading characteristics of silver halide photochromic glass, *J. Non-Cryst. Sol.*, 42, 1231, 1980.
75. Fanderlik, I., Prod'homme, L. Separation de phases observee per diffusion de la lumiere dans un verre photochrome. *Verres et refract.* (in French), 27, 97, 1973.
76. Fanderlik, I., The study of phase separation in photochromic glasses by electron microscopy technique, *Sklar i Keram.*(*Czech. J. of Glass and Ceram.*), 23, 165, 1973.
77. Paskov, P., Gutsov, I., Modeling study of silver halide photochromic phase in glass-forming systems, *Izv. Khim. Bulg. Akad. Nauk* (in Bulgarian), 13, 569, 1980.
78. Golubkov, V. V., Ekimov, A. I., Onushchenko, A. A., and Tsekhomsky, V. A., Growth kinetics of CuCl microcrystals in a glassy matrix, *Sov. J. Glass Phys. Chem.*, 7, 397, 1981.
79. Lifshitz, I. M., and Slyozov, V.V., Kinetics of diffuse decomposition of supersaturated solid solutions, *Sov. Phys. JETP*, 35, 331, 1959.
80. Yin, B., Shen, Y., Study of photochromic glass by SAXS, *Glastech. Ber.*, 56, 986, 1983.
81. Golubkov, V. V., Tsekhomsky, V. A., Phase changes in copper halide photochromic glasses,. *Sov. J. Glass Phys. Chem.*, 8, 416, 1982.
82. Filter optical glasses and special glasses. Catalogue, edit. — Petrovskii, G.T., Moscow, 1990.
83. Golubkov, V.V., Tsekhomsky, V. A., Role of sodium chloride in the formation of a light-sensitive phase in copper halide photochromic glass, *Sov. J. Glass Phys. Chem.*, 12, 111, 1986.
84. Golubkov, V. V., Tsekhomsky, V. A., Composition and structure of photochromic phase, in *Proc. XV International Congress on Glass*, Leningrad, 1989, 196.

85. Golubkov, V. V., Titov, A. P., Poray-Koshits, E. A., Low-angle X-ray apparatus for studying glasses at high temperatures, *Instrum. and Exp. Tech.,* 18, 250, 1975.

86. Lorenz, R., Her, W., Uber die Warmeausdeung geschmolzener Salze, *Z. anorg. Chem.*(in German), 147, 135, 1925.

87. Kulinkin, B. S., Petrovskii, G. T., Tsekhomsky, V.A., Shapov, M. F., Effect of hydrostatic pressure on exciton absorption spectrum of CuCl microcrystals in photochromic glasses, *Fiz. Khim. Stekla* (in Russian), 14, 470, 1988.

88. Vasilev, M. I., Grigorev, N. A., Kulinkin, B. S., Tsekhomsky, V.A., Effect of hydrostatic pressure on exciton absorption spectra of CuI and CuBr microcrystals in heterogeneous glass, *Fiz. Khim. Stekla* (in Russian), 17, 594, 1991.

89. Glebov, L. B., Dokuchaev, V. G., Nikonorov, N. V., Petrovskii, G. T., Change in the volume of glass with the formation and bleaching of color centers, *Sov. J. Glass Phys. Chem.,* 12, 194, 1986.

90. Ekimov, A. I., Onushchenko, A. A., Tsekhomsky, V. A., Exciton absorption of CuCl microcrystals in glass host, *Fiz. Khim. Stekla* (in Russian), 6, 511, 1980.

91. Nikitin, S., Exciton spectra in semiconductors and ionic compounds, in *Progress in Semiconductors,* 1962, v.6, 269.

92. Podorova, E. E., Tsekhomsky, V. A., Features of the heat treatment of copper halide photochromic glasses, *Sov. J. Glass Phys. Chem.,* 16, 298, 1990.

93. Gorbatova, S. V., Zyabnev, A. M., Kraevsky, S. L., Thermochromism of heterogeneous glasses, *Sov. J. Glass Phys. Chem.,* 19, 132, 1993.

94. Bershtein, V. A., Dotsenko, A. V., Egorova, L. M., Egorov, V. M., Tsekhomsky, V. A., Submicron crystals of a photochromic phase in glass analyzed using differential scanning calorimetry, *Sov. J. Glass Phys. Chem.,* 18, 333, 1992.

95. James, T. H., *The Theory of the Photographic Process,* Macmillan Publishing Co., NY, 1977.

96. Galakhova, G. S., Pavlushkin, N. M., Artamonova, M. V., The effect of glass forming type on photosensitive components in glass, in *Proc. Mendeleev Technological Institute* (in Russian), Moscow, 1969, 8.

97. Dotsenko, A. V., Zakharov, V. K., Krasikov, V. K., Tsekhomsky, V. A., The dependence of silver halide photochromic glasses spectra on heat treatment, *Fiz. Khim. Stekla* (in Russian), 6, 252, 1980.

98. Van de Hulst, H. G., *Light Scattering by Small Particles,* NY, 1957.

99. Shepilov, M. P., Bochkarev, V. B., Numerical modeling of crystal volume distribution in a crystallized medium. *Fiz. Khim. Stekla* (in Russian), 15, 152, 1989.

100. Pekhovsky, T. S., Potekhina I. Yu., Dotsenko, A. V., Size-quantized Faraday effect in polydispersed heterogeneous glasses, *Opt. Spectroscopy,* 74, 427, 1993.

101. Barachevsky, V. A., Lashkov, G. I., Tsekhomsky, V. A., *Photochromism and Its Application,* Khimiya, Moscow, 1977.

102. Dotsenko, A. V., Papunashvili, N. A., Tsekhomsky, V. A., A study of the effect of copper ions on the relaxation properties of photochromic glasses, *Sov. J. Opt. Technol.* 41, 395, 1974.

103. Belous, V. M., Dolbinova, E. A., Orlovskaja, N. A., Tsekhomsky, V. A., Investigation of the luminescence of photochromic glasses based on a silver halide, *J. Appl. Spectrosc.,* 20, 752, 1974.

104. Moser, F., Nail, N. R., Urbach, F., Note on the darkening of silver chloride, *J. Phys. Chem. Sol.,* 3, 153, 1957.

105. Hamilton, J. F., The silver halide photographic process, *Adv. in Phys.,* 37, 359, 1988.

106. Bach, O. H., Gliemeroth, G., Phase separation in photochromic silver halide containing glasses, *J. Amer. Ceram. Soc.,* 54, 528, 1971.

107. Hilsch, R., Pohl, R. W., Photochemistry of alkali halide and silver halide crystals, *Z. Phys.* (in German), 64, 606, 1930.

108. Savostjanova, M. V., On the nature of latent photographic image, *Uspekhi Fiz. Nauk* (in Russian), 2, 451, 1931.

109. Filippov, B. V., Zakharov, V. K., Dotsenko, A. V., A theoretical study of the darkening and relaxation kinetics in photochromic glasses based on silver halides, *Sov. J. Glass Phys. Chem.*, 2, 73, 1976.

110. Dotsenko, A. V., Zakharov, V. K., Calculation of light attenuation spectra by coloration centers of photochromic glass based on a silver halide, *J. Appl. Spectrosc.*, 21, 1654, 1974.

111. Johnson, P. B., Christy, R. W., Optical constants of the noble metals, *Phys. Rev. B*, 6, 4370, 1972.

112. Kawabata, A., Kubo, R., Electronic properties of fine metallic particles. II. Plasma resonance absorption, *J. Phys. Soc. Jap.*, 21, 1765, 1966.

113. Moriya, Y., Effects of crystal size, crystal compositions and irradiation condition on the UV-induced absorption spectra in the photochromic glass, *J. Ceram. Soc. Jap.*, 83, 75, 1975.

114. Bennert, H., Hempel, G., Darkening and fading kinetics of silver halide photochromic glasses in wide temperature range, *Silikattechnik*, 26, 368, 1975.

115. Abramov, A. P., Abramova, I. N., Tolstoi, M. N., Tsekhomsky, V.A., Coloration kinetics of photochromic glass exposed to pulse radiation, Photochromic glasses darkening kinetics under impulse irradiation, *Zh. Nauchn. Prikl. Fotogr. Kinem.* (in Russian), 20, 121, 1975.

116. Adamyan, V. M., Glauberman, A. E., Theory of electron photoemission from small quasimetallic centers, *Sov. Phys. Solid State*, 13, 1392, 1971.

117. Cherdyintsev, S. V., Optical and photochemical properties of colloidal centers in silver halide crystals, *Zh. Fiz. Khim.* (in Russian), 15, 419, 1941.

118. Stookey, S. D., Araujo, R. J., Selective polarization of light due to absorption by small elongated silver particles in glass, *Appl. Opt.*, 7, 777, 1968.

119. Skillman, D. S., Berry, C. R., Effect of particle shape on the spectral absorption on colloidal silver in gelatin, *J. Chem. Phys.*, 48, 3297, 1968.

120. Bohren, K., Haffman, J., *Absorption and Scattering of Light by Small Particles*, Wiley, NY, 1982.

121. Jones, R. S., Bird, G. R., Effect of aggregation on the absorption of particles of silver, *Photogr. Sci. Eng.*, 16, 16, 1972.

122. Anikin, A. A., Zhdanov, V. G., Malinovsky, V. K., Weigert effect in photochromic glasses, *Awtometriya* (in Russian) 4, 88, 1976.

123. Moriya, Y., A speculation on an absorption center induced in the photochromic glass containing silver halide crystals, *J. Ceram. Soc. Jap.*, 84, 46, 1975.

124. Borrelli, N. F., Seward III, T. P., Photoinduced optical anisotropy and color adaptation in silver-containing glasses, *J. Appl. Phys. Lett.*, 34, 395, 1979.

125. Nolan, D. A., Borrelli, N. F., Schreurs, J. W. H., Optical absorption of silver in photochromic glasses: Optically induced dichroism, *J. Amer. Ceram. Soc.*, 63, 305, 1980.

126. Seward III, T. P., Coloration and optical anisotropy in silver-containing glasses, *J. Non-Cryst. Sol.*, 40, 499, 1980.

127. Dotsenko, A. V., Zakharov, V. K., Structure of color centers in silver halide photochromic glasses, *Sov. J. Glass Phys. Chem.*, 5, 79, 1979.

128. Borrelli, N. F., Chodak, J. B., and Hares, G. B., Optically induced anisotropy in photochromic glasses, *J. Appl. Phys.*, 50, 5978, 1979.

129. Nolan, D. A., Borrelli, N. F., Marguardt, C. L., Formation on metallic silver on silver-halide surfaces, in Proc. of *Int. Cong. of Photogr. Science*, Ed. by K. Lassiter, W., D.C., 1978, 83.

130. Brinckman, E., Delzenn, G., Poot, A., Willems, J., *Unconventional Imaging Processes.*, Focal Press, London- NY, 1978.

131. Beresin, I. V., Vannikov, A. V., Kartuzhansky, A. L., Lashkov, G. I., Ljubin, V. M., Parizky, V. V., Sviridov, V. V., Sinzov, V. N., Cherkasov Yu. A., *Nonsilver Photographic Processes* (in Russian), Leningrad, Khimiya, 1980, chap. 1.

132. Ekimov, A. I., Onushchenko, A. A., Plyukhin, A. G., and Efros, Al. L., Size quantization of excitons and determination of the parameters of their energy spectrum in CuCl, *Sov. Phys. JETP,* 61, 891,1985.

133. Vasilev, M. I., Pshenitsina, V. V., Tsekhomsky, V. A., Spectral properties of CuCl microcrystals distributed in glass matrix, *Sov. J. Glass Phys. Chem.,* 20, 63, 1994.

134. Valov. P. M., Gracheva, L. V., Leiman, V. I., Nagorova, T. A., Exciton-photon interaction in CuCl nanocrystals in glass, *Phys. Solid State,* 36, 954, 1994.

135. Goldman, A., Band structure and optical properties of tetrahedrally coordinated Cu- and Ag- halides, *Phys. Stat. Sol.,* (b), 81, 9, 1977.

136. Lewonczuk, S., Ringeissen, Y., Nikitin, S., Exciton spectra CuBr in comparison with CuCl, *J. Appl. Phys.,* 32, 941, 1971.

137. Efros, Al. L., Onushchenko, A. A., Yekimov, A. I., Quantum size effect in semiconductor microcrystals, *Sol. St. Comm.,* 56, 921, 1985.

138. Hopfield, J. J., Thomas, D. G., Theoretical and experimental effects of spatial dispersion on the optical properties of crystals, *Phys. Rev.,* 132, 563, 1963.

139. Pekhovsky, T. S., Dotsenko, A. V., Solution of the problem of the light scattering on the shell type particle with an account of the space dispersion. *Opt. Spectroscopy* (to be published), 1997.

140. Masumoto, Y., Unuma, Y., Tanaka, Y., Shionoya, T., Picosecond time of light measurements of excitonic polaritons in CuCl, *J. Phys. Soc. Jap.,* 47, 1844, 1979.

141. Ermoshkin, A.N., Zakharov, V.K., Kuchinsky, S.A., Evarestov, R.A., Self-congruent calculation of local levels of Cu^+ ions in crystals AgBr and AgCl. *Opt. Spectroscopy,* 54, 736, 1983.

142. Ermoshkin, A.N., Evarestov, R.A., Kuchinsky, S.A., Zakharov, V.K., The quasimolecular approach to the electronic structure calculations for silver and copper halides, *Phys. Stat. Sol. (B),* 118, 191, 1983.

143. Dotsenko, A. V., Papunashvili, N. A., and Tsekhomsky, V. A., Study of the effect of copper ions on the relaxation properties of photochromic glasses, *Sov. J. Opt. Technol.,* 41, 395, 1974.

144. Belous, V. M., Dolbinova,E. A., Orlovskaja, N. A., Tsekhomsky, V. A., The role of copper and oxygen ions in the development of the photochromic properties of glasses based on silver halides, *Sov. J. Glass Phys. Chem.,* 3, 56, 1977.

145. Araujo, R.J. Photochromic glass, in *Treatise of Materials Science and Technology,* Academic Press, New York, 12, 91, 1977.

146. Araujo, R.J., Borrelli, N.F., Nolan, D.A., The influence of electrone-hole separation on the recombination probability in photochromic glasses, *Phil. Mag.,* 40, 279,1979.

147. Araujo, R.J., Borrelli, N.F., Nolan, D.A., Further aspects of the influence of electron-hole separation on the recombination probability in photochromic glasses. *Phil. Mag.,* 44, 453, 1981.

148. Itoh, T., Iwabuchi, Y., Kataoka M., Study on the size and shape of CuCl microcrystals, *Phys. Stat. Solidi (b),* 145, 567, 1988.

149. Woggon, U., Henneberger, F., Optical nonlinearities of quantum-confident excitons in CuBr microcrystallites, *J. Phys. Colloq.*, 49, 255 1988.
150. Masumoto, Y., Wamura, T., Iwaki, A., Homogeneous width of exciton absorption spectra in CuCl microcrystals, *Appl. Phys. Lett.*, 55, 2535 1989.
151. Gilliot, P., Merle, J. C., Levy R., Robino, M., Honerlage, B., Laser induced absorption of CuCl microcrystallites in a glass matrix, *Phys. Stat. Sol. (b)*, 153, 403 1989.
152. Bellegie, L., Banyai, L., Theory of exciton population — induced nonlinear absorption in large microcrystallites, *Phys. Rev. B*, 44, 8785, 1991.
153. Zimin, L. G., Gaponenko, S. V., Lebed, V. Yu., Malinovsky, I. E., Germanenko, I. N., Podorova, E. E., Tsekhomsky V.A., Copper chloride nonlinear optical absorption under quantum confinement, *J. Mod. Opt.* 37, 829, 1990.
154. Wamura, T., Masumoto, Y., Kawamura, T., Size-dependent homogeneous linewidth of Z3 exciton absorption spectra in CuCl microcrystals, *Appl. Phys. Lett.*, 59, 1758, 1991.
155. Kippelen, B., Levy, R., Faller P., Gilliot P., Belleguie, L., Picosecond excite and probe nonlinear adsorption measurements in CuCl quantum dots, *Appl. Phys. Lett.* 59, 3378, 1991.
156. Gaponenko, S. V., Germanenko, I. N., Gribkovskii, V. P., Vasilev M. I., Tsekhomsky, V. A., Nonlinear absorption of semiconducting microcrystallites under quantum confinement: coexistence of reversible and irreversible effects, in *Proc. SPIE*, 1807, 65, 1992.
157. Itoh, T., Iwabuchi, Y., Kirihara, T., Size-quantized excitons in microcrystals of cuprous halides embedded in alkali-halide matrices, *Phys. Stat. Sol. B*, 146, 531, 1988.
158. Naoe, K., Zimin, L., Masumoto, Y., Persistent spectral hole burning in semiconductor nanocrystals, *Phys. Rev. B*, 50, 18200, 1994.
159. Gibbs, H. M., *Optical Bistability: Controlling Light with Light*, Academic Press, NY, 1985.
160. Nail, H. F., Nonlinear optical data processing and filtering: a feasibility study, *Trans. Computer*, C-24, 443, 1975
161. Kirkby, G. J. G., Cush, R., Bennion, I., Optical nonlinearity and bistability in organic photochromic films, *Opt. Commun.*, 56, 288, 1985.
162. Dotsenko, A. V., Kuchinsky, S. A., Onushchenko, A. A., Petrovskii, G. T., Potekhina, I. Yu., Semiconductor microcrystal in glass matrix as a new class of optical resonators, *Sov. Phys. Dokl.*, 35, 164, 1990.
163. Leung, K. M., Optical bistability in the scattering and absorption of light from nonlinear microparticles, *Phys. Rev. A.*, 33, 2461, 1986.
164. Dotsenko, A. V., Kuchinsky, S. A., Potekhina, I. Yu., Optical bistability in glasses doped by semiconductor microcrystals, in *Proc. VII Sov. Symp. on Opt. and Spectral Properties of Glasses*, Leningrad, 1989, 331.
165. Fuchs, R., Kliewer, K. L., Optical modes of vibration in an ionic crystal sphere, *J. Opt. Soc. Amer.*, 58, 319, 1968.
166. Jungk, G., Optical bistability in composite media, *Phys. Stat. Sol. (B)*, 146, 335, 1988.
167. Justus, B. L., Seaver, M. E., Ruller, J. A., Excitonic optical nonlinearity in quantum-confined CuCl-doped borosilicate glass, *Appl. Phys. Lett.*, 57, 1300, 1990.
168. Hakamura, A., Yamada, H., Tokizaki, T., Size-dependent radiative decay of excitons in CuCl semiconducting quantum spheres embedded in glasses, *Phys. Rev. B*, 40, 8585, 1989.
169. Ruppin, R., Mie theory with spatial dispersion, *Opt. Commun.*, 30, 380, 1979.
170. Dotsenko, A. V., Kuchinsky, S.A., Potekhina, I. Yu., Inversion of exciton spectra of small particles, *Opt. Spectroscopy.*, 65, 577, 1988.

171. Dotsenko, A. V., Zakharov, V. K., Loiko, V. A., Light scattering by photosensitive centers and color centers in photochromic silver halide glasses, *J. Appl. Spectrosc.*, 32, 201, 1980.

172. Dotsenko, A. V., Zakharov, V. K., Loiko, V. A., Determining the dimensions of light-sensitivity and color centers of silver-halide photochromic glasses from measurements of the angular characteristics of light scattering, *J. Appl. Spectrosc.*, 37, 1180, 1982.

173. Dotsenko, A. V., Zakharov, V. K., Loiko, V. A., Size evaluation of microcrystal in silver halide photochromic glasses, *J. Appl. Spectrosc.*, 40, 503, 1984.

174. Pekhovsky, T. S., Green's function for the problem of light scattering by isotropic homogeneous sphere with spatial dispersion taken into account, *Opt. Spectroscopy*, 72, 251, 1992.

175. Armistead, W. M., Stookey, S. D., Photochromic silicate glasses sensitized by silver halides, *Science*, 144, 150, 1964.

176. Abramov, A. P., Abramova, I. P., Tsekhomsky, V. A., The two stages in the coloring of photochromic glass, *Sov. J. Glass Phys. Chem.*, 2, 441, 1976.

177. Tsekhomsky, V. A., Photochromic glasses based on silver halide microcrystals, in *Proceed. of Intern. Congress on Photographic Science*, Dresden, 2, 17, 1974.

178. Chibisov, K. V., On the nature of photosensitive centers in photographic emulsion, *Uspekhi Khimii* (in Russian), 22, 1226, 1953.

179. Molotsky, M. I., Latyshev, A. N. Silver atoms interaction on the halide surface, in *Proceed. of Intern. Congress on Photographic Science*, Moscow, 143, 1970.

180. Naboikin, Yu. V., Ogurtsova, L. A., Pyshkin, O. S., Tsekhomsky, V. A., Darkening of photochromic silver halide glasses by short light pulses, *Opt. Spectroscopy*, 54, 623, 1983.

181. Naboikin, Yu. V., Ogurtsova, L. A., Pyshkin, O. S., Tsekhomsky, V. A., Temperature dependence of the spectra and density of the additional absorption of photochromic silver glass illuminated in flashes, *Opt. Spectroscopy*, 59, 214, 1985.

182. Naboikin, Yu. V., Ogurtsova, L. A., Pyshkin, O. S., Tsekhomsky, V. A., Temperature studies of the optical properties of silver halide photochromic glasses under pulse laser irradiation by short light pulses, *Ukrainskii Fizich. Zhurnal* (in Russian), 31, 836, 1986.

183. Ogurtsova, L. A., Pyshkin, O. C., Tsekhomsky, V. A., Flash photolysis studies of silver-halide photochromic glass, *J. Non-Cryst. Solids*, 103, 257, 1988.

184. Marquard, C. L., On the role of copper in the darkening of silver halide photochromic glasses, *Appl. Phys. Lett.*, 28, 209, 1976.

185. Araujo, R. J., Kinetics of bleaching of photochromic glass, *Appl. Opt.*, 7, 781, 1968.

186. Fanderlik, I., Kinetics of color formation and destruction in photochromic glasses containing silver halides, *Silikaty*, 14, 197, 1970.

187. Voloshin, V. A., Goihman, V. Ju., Goihman, E. V., Minakov, V. A., On the kinetics of silver halide glasses coloring, in *Steklo* in Russian), Strojizdat, Moscow, 1972, 55.

188. Dotsenko, A. V., Zakharov, V. K., Tsekhomsky, V. A., Determining the constants of the relaxation process in photochromic glasses, *Sov. J. Opt. Technol.*, 40, 687, 1973.

189. Sukhanov, V. I., Sitnik, D. N., Tunimanova, I. V., Tsekhomsky, V. A., Photochromic glasses as hologram recording media, *Sov. J. Opt. Technol.* 37, 796, 1970.

190. Adirovich, E. I., *Some Problems of the Crystal Luminescence Theory* (in Russian), GITTL, Moscow- Leningrad, (Russia), 1951, 350.

191. Kohlrausch, R., Teorie des Elektrische Ruckstandes in des leidener Flaschen. *Ann. Phys. und Chem.* (in German), 91, 170, 1954.

192. Volchek, A. O., Gusarov, A. I, and Mashkov, V. A., Spectra of structural relaxation rates in glasses with a continuous distribution of hierarchy levels, *Sov. Phys. JETP*, 74, 307, 1992.

193. Gusarov, A. I., Dmitrujk, A. V., Kononov, A. N., Mashkov, V. A., Long-term kinetics of the activation spectra of postirradiation relaxation of glasses, *Sov. Phys. JETP*, 70, 289, 1990.

194. Araujo, R. J., Ophthalmic glass particularly photochromic glass, *J. Non-Cryst. Solids*, 47, 69, 1982.

195. Araujo, R. J., Photochromic Glass, in *Photochromism*, Ch. 8, Wiley, NY, 1971.

196. Dotsenko, A. V., Peshkov, N. M., Tsekhomsky, V. A., Formula for calculating the darkening kinetics of silver-halide photochromic glasses, *Sov. J. Opt. Technol.*, 48, 502, 1981.

197. Filippov, B. V., Zakharov, V. K., Dotsenko, A. V., The darkening and relaxation kinetics of silver halide photochromic glasses in the absence of a spread in the size of the color centers, *Sov. J. Glass Phys. Chem.*, 2, 122, 1976.

198. Dotsenko, A. V., Zakharov, V. K., Kinetics of photochromic processes in silver halide glasses, *Sov. J. Glass Phys. Chem.*, 5, 300, 1979.

199. Ashcheulov, Yu.V., Sukhanov, V. I., Activated photochromic glass as three-dimensional holographic media, *Opt. Spectroscopy*, 30, 612, 1971.

200. Dotsenko, A.V., Zakharov, V.K., Kinetics of photochromic processes and ultimate properties of photochromic glasses. *Uspekhi Nauchn. Fotogr.* (in Russian), 21, 193, 1981.

201. Dotsenko, A. V., Zakharov, V. K., Morozov, A. V., Peshkov, N. M., Deviation from the law of mutual substitution in photochromic glasses, *Sov. J. Glass Phys. Chem.*, 7, 240, 1981.

202. Dobrovolskaya, T. L., Dotsenko, A. V., Zakharov, V. K., Morosov, A. V., Pajvin, V. S., Snurnikov, A. S., Kinetics of the photochromic processes in glasses under the action of light irradiation at intensities which vary in time, *Sov. J. Glass Phys. Chem.*, 8, 313, 1982.

203. Dotsenko, A. V. Two-levels kinetic scheme of photochromic glasses darkening under periodic pulses irradiation, *Fiz. Khim. Stekla* (in Russian), 10, 718, 1984.

204. Dotsenko, A. V., Morosov, A. V. On inertia of photochromic glasses darkening under short pulse irradiation, *Fiz. Khim. Stekla* (in Russian), 14, 468, 1988.

205. Besen, N., The heat treatment influence on photochromic glasses transmittance, in *Proc. 11 Int. Congr. on Glass*, Prague, 1977, 11.

206. Shepilov, M. P., Numerical modeling of recondensation kinetics, *Fiz. Khim. Stekla* (in Russian), 14, 770, 1988.

207. Shepilov, M. P., Dotsenko, A. V., On optimization of heat treatment schedules for photochromic glasses, *Fiz. Khim. Stekla* (in Russian), 17, 180, 1991.

208. Mukhin, E. Ya., Gutkina, N. G., *Glasses Crystallization and the Techniques to Prevent It* (in Russian), Gostekhizdat, Moscow, 1960, 124.

209. Pavlovskii, V. K., Tunimanova, I. V., Tsekhomsky, V. A., Application of radioisotopes for determination of silver losses at glass melting process. *Izv. Akad. Nauk SSSR, Ser. Neorg. Mat.*, 5, 1480, 1969.

210. Belous, V. M., Dolbinova, E. A., Orlovskaya, N. A., and Tsekhomsky, V. A., Luminescent study of photochromic glasses based on a silver halide, *J. Appl. Spectroscopy*, 20, 1000, 1974.

211. Artamonova, M. V., Solinov, V. F., Some problems of chemistry and photochemistry of photochromic glasses, *Tr. Inst. Mosk. Khim.-Teknol. Inst.* (in Russian), 128, 3, 1983.

212. Garfinkel, H. M., Photochromic glass by silver ion exchange, *Appl. Optics*, 7, 789, 1968.

213. Vikhrov, M. N., Karapetyan, G. O., Method of producing photochromic gradient layers, *Sov. J. Glass Phys. Chem.*, 5, 539, 1979.

214. Tsekhomskaya, T. S., Roskova, T. P., Vilzen, E. G., Anfimova, I. N., Silver chloride-activated photochromic vicor glasses, *Sov. J. Glass Phys. Chem.*, 18, 82, 1992.

215. Stookey, S. D., How microcrystals work in photochromic glass, *Ceramic Industry*, 4, 97, 1964.

216. Kuchinsky, S. A., Light absorption by Rayleigh particles in glass for the region of abnormal dispersion, *Fiz. Khim. Stekla* (in Russian), 7, 741, 1980.

217. Balta, P., Dollinger, L., Cirstea, M., Phototropic glasses on B_2O_3 basis, *Rev. Roum. de Chemie* (in French), 17, 25, 1972.

218. Stookey, S. D., Beal, G. H., Pierson, J. E., Full-color photosensitive glass, *J. Appl. Phys*, 49, 5114, 1978.

219. Trotter, D. M. Jr., Photochromic and photosensitive glass, *Scientific American*, 264, 56, 1991.

220. Swiridov, V. V., *Photo and Radiation Chemistry of Inorganic Solid*, Minsk, 1964

221. Moser, F., Nail, N. R., Urbach, F., Optical absorption studies of the volume photolysis of large silver chloride crystals, *J. Phys. Chem. Sol.*, 9, 217, 1959.

222. Moriya, J., Composition of silver halide crystals precipitating in the alkali aluminum borosilicate glasses containing Ag, Cl and Br, *J. Ceram. Soc. Japan*, 81, 259, 1973.

223. Schleifer, P., Lightsensitive effects in the photochromic glasses containing AgHal and Ag_2S, *Szklo i Ceram.*, 19, 360, 1968.

224. Pavlovsky, V. K., Tunimanova, I. V., Tsekhomsky, V. A., Photochromic, iodine-containing glasses, *Sov. J. Opt. Technol.*, 38, 37, 1971.

225. Farnel, G. C., Burton, P. C., Hallama, K., The fluorescence of silver halides at low temperatures. Part II: Mixed crystals of silver halides. *Phil. Mag.* 41, 545, 1950.

226. Belous, V. M., Melnichuk, L. P., Chibisov, K. V., Luminescence study of iodine ions role at photographic sensitivity formation of silver bromide emulsion, *Dokl. Akad. Nauk SSSR* (in Russian), 177, 1367, 1967.

227. Seitz, F., *Modern Theory of Solids*, McGraw-Hill, NY, 1940, 66.

228. Novikova, N. R., Iodine influence on properties of fine grain photographic emulsion, *Zh. Nauchn. Prikl. Fotogr. Kinem.* (in Russian), 4, 49, 1959.

229. Orlovskaya, N. A., Belous, V. M., Golub, S. I., Temperature quenching of luminescence and photolysis in AgBr and $AgBr$-Ag_2S phosphors, *Izvest. Akad. Nauk SSSR, ser. Phys.* (in Russian), 31, 1949, 1967.

230. Patrick, L, Lawson, A. W., Thermoelectric power of pure and doped AgBr, *J. Chem. Phys.*, 22, 1492, 1954.

231. Marquardt, C. L., Giuliani, J. F., Gliemeroth, G., A study of copper ions in silver halide photochromic glasses, *J. Appl. Phys.*, 48, 3669, 1977.

232. Caurant, D., Gourier, D., Prassas, M., Electron-paramagnetic resonance study of silver halide photochromic glasses: darkening mechanism, *J. Appl. Phys.*, 71, 1081, 1992.

233. Caurant, D., Gourier, D., Vivien, D., Prassas, M., Bleaching mechanism of silver halide photochromic glasses, *J. Appl. Phys.*, 73, 1657, 1993.

234. Malinovski, I., The role of holes in the photographic process, *J. Phot. Sci.* 16, 57, 1968.

235. Malinovski, I., Latent image formation in silver halides, *Phot. Sci. Eng.*, 14, 112, 1970.

236. Araujo, R. J., Borrelli, N. F., Nolan, D. N., Stabilization of the Fermi level in photochromic glasses, *Phil. Mag.*, 50, 331, 1984.

237. Muller, P., Ionenleitfahingkeit von reinen und dotierten AgBr- und AgCl-Ein Kristallen, *Phys. Stat. Sol.* (in German), 12, 775, 1965.
238. Tsekhomsky, V. A., Photochromic glasses, *Sov. J. Opt. Technol.*, 34, 467, 1967.
239. Kuznetsov, A. A., Tsekhomsky, V. A., Photochromic glasses activated by copper chloride crystals, *Sov. J. Opt. Technol.*, 45, 163, 1978.
240. Morse, D. L., Copper halide containing photochromic glasses, *Inorg. Chem.*, 20, 777, 1984.
241. Belous, V. M., Dolbinova, E. A., Tunimanova, I. V., Tsekhomsky, V. A., Determination of the composition of the light-sensitive solid phase of silver-halide photochromic glasses by the luminescence method, *Sov. J. Opt. Technol.*, 41, 447, 1974.
242. Chibisov, K. V., *The Nature of Photographic Sensitivity*, Nauka., Moscow, 1980, Chap. 3.
243. Vargin, V. V., *Manufacturing of colored glass,* Goslegprom, Moscow, 1940, Chap. 2.
244. Fanderlik, I., Beitrag zum Studium von durch Ag_2S sensibilisierten phototropen Glasern, die silberhalogenid enthalten, *Silicattechnik* (in German), 18, 4, 1967.
245. Kawamoto, T., Kikuchi, R., Kimura, Y., Photochromic glasses containing silver chloride. Part 2. Effects of the addition of small amounts of oxides on photosensitivity, *Phys. Chem. Glas.*, 17, 27, 1976.
246. Belous, V. M., Dolbinova,E. A., Tunimanova, I. V., Tsekhomsky, V. A., Luminescence study of spectral sensibilization mechanism in photochromic glasses based on silver halides, *Zh. Nauchn. Prikl. Fotogr. Kinem.* (in Russian), 20, 302, 1975.
247. Latyshev, A. N., Molotsky, M. I., Spectral properties of small silver particles, In *Proc. Int. Congr. on Photographic Sci.,* Moscow, 147, 1970.
248. Gracheva, L. V., Leiman, V. I., Color centers formation and destruction in silver halide photochromic glasses. *Fiz. Khim. Stekla* (in Russian), 13, 138, 1987.
249. Fano, U., Effects of configuration interaction on intensities and phase shifts, *Phys. Rev.,* 124, 1866, 1961.
250. Tomada, Y., Nakamura, N., Kawasaki, M., Photographic properties of silver tungstate and silver molybdate, *J. Soc. Sci. Phot. Japan*, 21, 138, 1958. (*Chem. Abstr.* 59, 13849, 1959)
251. Burggraaf, A., Mechanical durability of soda-alumo-silicate glasses after ion-exchange, in *Durability of Glasses,.* Stepanov, V.A., Ed., Mir, Moscow, 1969, 239.
252. Kozmanjan, A. A., Sattarov, D. K., Yahkind, A. K., Concentration dependence of the refractive index gradient in ion-exchanged alkali aluminum boro-silicate glass, *Sov. J. Glass Phys. Chem.,* 7, 66, 1981.
253. Glebov, L. B., Nikonorov, N. V., Petrovskii, G. T., On stresses arising in glass during low-temperature ion-exchange, *Fiz. Khim. Stekla* (in Russian), 14, 904, 1988.
254. Babukova, M. V., Glebov, L. B., Nikonorov, N. V., and Petrovskii, G. T., Bend stresses arising from ion-exchange diffusion in glasses. *Sov. J. Glass Phys. Chem.,* 11, 36, 1985.
255. Glebov, L. B., Derzhavin, S. N., Ivanov, A. V., Nikonorov, N. V., and Petrovskii, G. T., Microhardness of layers of glass obtained by low-temperature ion-exchange diffusion. *Sov. J. Glass Phys. Chem.,* 10, 183, 1984.
256. M. V. Babukova, L. B. Glebov, I. S. Morozova, N. V. Nikonorov, G. T. Petrovskii. Effect of the thickness of the substrate on the modification of the refractive index of a glass by low-temperature ion exchange. *Sov. J. Glass Phys. Chem.*, 13, 39 (1988).
257. Petrovskii, G. T., Agafonova, K. A., Mishin, A. V., and Nikonorov, N. V., Optical controlled planar waveguides made of photochromic glass, *Sov. J. Quantum Electron.,* 11, 1387, 1981.

258. Tamir, T., Integrated optics coupling elements, in *Integrated Optics,* Tamir, T., Ed., Springer — Verlag, Berlin-Heidelberg-New York, 1975, Chap. 3.

259. White, J. M., Heidrich, P. F. Optical waveguide refractive index profiles determined from measurement of mode indices: a simple analysis, *Appl. Opt.,* 15, 151, 1976.

260. Ashkalunin, A. L., Valov, P. M., Leiman, V. I., Tsekhomsky, V. A., Optical sensitization of copper halide photochromic glasses, *Sov. J. Glass Phys. Chem.,* 10, 203, 1984.

261. Glebov, L. B., Nikonorov, N. V., and Petrovskii, G. T., A new type of photosensitivity — cooperative multiplication of color centers, *Sov. Phys. Dokl.,* 30, 147, 1985.

262. Babukova, M. V., Glebov, L. B., Nikonorov, N. V., Petrovskii, G. T., and Tsekhomsky, V. A., Development and study of photo-controlled planar waveguides based on photochromic glasses. *Sov. J. Glass Phys. Chem.,* 12, 246, 1986.

263. Glebov, L. B., Nikonorov, N. V., Petrovskii, G. T., and Tsekhomsky, V. A., Anisotropy of the absorption by color centers in diffusion waveguides based on photochromic glasses, *Sov. J. Glass Phys. Chem.,* 12, 298, 1986.

264. Glebov, L. B., Nikonorov, N. V., and Petrovskii, G. T., Selective properties of planar optically controlled waveguides made of photochromic glasses, *Sov. J. Quantum Electron.,* 16, 549, 1986.

265. Glebov, L. B., Nikonorov, N. V., and Petrovskii, G. T., Data storage in planar photochromic waveguides in silicate glasses. *Optoelectronics, Instrumentation and Data Processing,* 5, 34, 1988.

266. Seward, T. P., Photochromic glasses made polarizing by scratching, in *Proc. XI International Congress on Glass,* Prague, 1977, 31.

267. Dotsenko, A. V., Nikonorov, N. V., Kharchenko, M. V., Photoinduced processes in FHS-2 photochromic glass and waveguides based on it, *Sov. J. Glass Phys. Chem.,* 18, 490, 1992.

268. Bryanzev, V. I., Bykovsky, Yu. A., Makovkin, A. V., Smirnov, V. N., Thin-film metallized dielectric waveguides, *Sov. J. Quantum Electron.,* 4, 966, 1974.

269. Rollke, K. H., Sohler, W., Metal-clad waveguide as cutoff polarizer for integrated optics, *IEEE J. Quantum Electron.,* 13, 141, 1977.

270. Zlenko, A. A., Kiselev, V. A., Prokhorov, A. M., Sychugov, V. A., Thin-film mode selector and its potential applications, *Sov. J. Quantum Electron.,* 4, 254, 1974.

271. Akhmediev, N. N., Samoilenko, V. D., Optical waveguides with mode selection, *Opt. Spectroscopy,* 46, 69, 1979.

272. Glebov, L. B., Dotsenko, A. V., Nikonorov, N. V., and Flegontov, Yu. A., Ion-exchange technologies for photocontrollable waveguide structures and modeling of radiation-propagation processes, *J. Opt. Techn.,* 62, 757, 1995.

273. Glebov, L. B., Nikonorov, N. V., and Petrovskii, G. T., Absorbing-mask mode selectors automatically matched to the mode field in photochromic diffusion waveguides, *Opt. Spectroscopy,* 60, 376, 1986.

274. Glebov, L. B., Dotsenko, A. V., Nikonorov, N. V., Tsypljaev, S. A., Mode selection in planar photosensitive wavequides, *Opt. Spectroscopy,* 62, 539, 1987.

275. Dotsenko, A. V., Zvyagintsev, M. A., and Tsypljaev, S. A., Computation of waveguide mode selection in planar photosensitive wavequides of arbitrary length, *Opt. Spectroscope,* 69, 122, 1990.

276. Petrov, Yu. I., *Clusters and Small Particles,* Nauka, Moscow, 1986, Chap. 5.

277. Samarsky, A. A., *Theory of Difference Schemes,* Moscow, 1977, Chap. 4

278. Dotsenko, A. V., Flegontov, Ju. A., Petrova, I. R., Poletaeva, A. I., Cylinder and planar waveguides on the base of photosensitive glass, in *Proc. 11 Int. Conf. Coher. and Nonlinear Opt.,* St.-Petersburg, Russia, 1991, 191.

279. Poletaeva, A. I., Flegontov, Yu. A., Light diffraction by a plate fabricated from a periodic-structure optical material, *Opt. Spectroscopy,* 70, 754, 1991.
280. Flegontov, Yu. A., Petrova, I. R., Diffraction of a wave packet on a fiber-optic plate and calculation of its optical characteristics, *Opt. Spectroscopy,* 71, 402, 1991.
281. Hamann, F., Jolta, L., Photosensitive logic circuitry utilizing light pipe. US Patent 3.304.433, 14 Feb. 1967.
282. Papunashvili N. A., Rjabzeva, V. D., Chibalashvili, Yu. L., Photochromic optical fiber, *Sov. J. Glass Phys. Chem.,* 9, 229, 1983.
283. Flegontov, Ju. A., Dotsenko, A. V., Petrova, I. R., and Poletaeva, A. I., Light propagation in periodic structures based on photochromic glass, *Sov. J. Glass Phys. Chem.,* 9, 19, 1993.
284. Dotsenko, A. V., Morosov, A. V., Tsekhomsky, V. A., Mathematical modeling of the formation of color centers in heterogeneous photochromic glass, *Sov. J Glass Phys. Chem.,* 13, 88, 1987.
285. Gagarin, A. P., Glebov, L. B., Efimov, O. M., and Efimova, O. S., Formation of color centers in sodium calcium silicate glasses with the nonlinear absorption of powerful UV radiation, *Sov. J. Glass Phys. Chem.* 5, 337, 1979.
286. Ovsyankin, V. V., Feofilov, P. P., Two-photon sensibilization of photographic processes in semiconductors, in *Proc. of IX Int. Conf. on Physics of Semiconductors,* Nauka, Leningrad, 1969, 251.
287. Ovsyankin, V.V., Feofilov, P., P., Cooperative sensibilization of photographic and photochemical processes, in *Molecular Photonics,* Nauka, Leningrad, 1970, 86.
288. Glebov, L. B., Nikonorov, N. V., Petrovskii, G. T., Three-photon cooperative multiplication of color centers, *Sov. Phys. Dokl,* 33, 437, 1988.
289. Ashkalunin, A. L., Valov, P. M., Petrovskii, G. T., Tsekhomsky, V. A., Optical "development" of a latent image in copper halide photochromic glasses, *Sov. Phys. Dokl,* 32, 853, 1987

Index

A

Absorbing center, 68
Absorption
 bands, 4, 57
 dopant, 2, 4
 edge, 3
 extrinsic, 2
 impurity, 2
 induced or additional, 2, 6, 53
 intrinsic, basic or fundamental, 1
 nonlinear, 65
 photoinduced, 2, 6, 53
 spectra, 1, 49, 62, 70
 measurement, 25
 modeling, 57
Activators, 4
Additives
 copper, 122
 double-charged, 125
Adirovich theory, 82
Alkali
 -borate glasses, 111
 -earth ions, 34
 -halide crystals, 2, 5
 ion, 34, 134
 metal chlorides, 46
 -silicate glasses, 6, 12
Alkaline metal fluorides, 115
Amplification of images, 165
Anhydride, phosphoric, 127
Anisotropy
 of color center shape, 58
 memory of former photoinduced, 61
 of photochromism, 141
 photoinduced absorption, 140
 of refractive index, 135
Annealing temperature, 101
Arsenic oxides, 109
Attenuation, 52, 70

B

Band gap energy, 155
Base glass, 132
Belt furnace, 106
Belt kiln, design of, 106

Biexciton resonance, 72
Birefringence, 134, 135
Bleaching, 6, 9, 18
 agent, 22
 anisotropic optical, 11
 band, 68
 effect of, 97
 efficiency, 22
 kinetics of, 97
 optical, 18, 60, 156
Borate, 30, 31
Boric anhydride, 30
Boron, trigonal, 31
Borosilicate, 30, 32
Boroxol groups, 31
Bottom-to-top heat treatment, 102
Bougher law, 87
Boundary condition, 88
Bromine losses, 110, 111

C

Cadmium-containing glasses, 14, 15
Cation vacancies, 124, 125
Cell effect, 27
Center of photosensitivity, 17
Centers of nucleation, 102
Chloride complexes, formation of, 33
CNDO, see Complete neglect of differential
 overlapping
Color adaptation, 61
Color center(s), 5, 17, 54, 87
 absorption, 155
 band maximum, 155
 spectrum, 22
 accumulation kinetics, 157
 colloidal silver, 61
 concentration, 23, 87, 161
 decrease of, 92
 dependence of on exposure time, 162
 equilibrium, 151
 photoinduced, 21
 profile, 56, 91
 creation of, 49
 cross-sections of, 18
 decay, 95, 139
 decomposition of, 94

183

T - #0137 - 101024 - C0 - 234/156/11 [13] - CB - 9780849337802 - Gloss Lamination